Sports Illustrated

Tom Brady

CELEBRATING THE GREATEST QUARTERBACK OF ALL TIME

CONTENTS

IN SEARCH OF BALANCE, TOM BRADY FINALLY SAW PEACE IN RETIREMENT *by Greg Bishop*	4
PAT ANSWER *by Michael Silver*	14
FIGHT TO THE FINISH *by Michael Silver*	26
THREE-RING CIRCUS *by Michael Silver*	38
FACE OFF *by Michael Silver*	50
THE ULTIMATE TEAMMATE *by Charles P. Pierce*	56
TOM BRADY IS BACK *by Peter King*	68
TOM BRADY AS YOU FORGOT HIM *by Michael Rosenberg*	76
DEFLATED TO ELATED *by Greg Bishop*	84
ALL ABOUT CONNECTIONS *by Tim Layden*	102
SUSPENDED DISBELIEF *by Greg Bishop*	116
FIVE WILL GET YOU ZEN *by Peter King*	134
LIVING LIKE TOM *by Greg Bishop*	146
LET'S TALK ABOUT SIX *by Greg Bishop and Ben Baskin*	154
2021 SPORTSPERSON OF THE YEAR: TOM BRADY *by Jon Wertheim*	174
TOM BRADY, IN HIS OWN WORDS *by Jon Wertheim*	194
BRADY'S BFFs *by Mark Bechtel*	202
TOM BRADY ANNOUNCES RETIREMENT *by Joseph Salvador*	208
IN RETIRING, TOM BRADY MADE YET ANOTHER SHREWD CHOICE *by Michael Rosenberg*	212
BY THE NUMBERS	220
THE COVERS	224

IN SEARCH OF BALANCE, TOM BRADY FINALLY SAW PEACE IN RETIREMENT

HE IS STEPPING AWAY FROM FOOTBALL.

BUT THAT ISN'T AS IMPORTANT AS WHAT HE'S STEPPING TOWARD

BY
GREG BISHOP

IN SEARCH OF BALANCE, TOM BRADY FINALLY SAW PEACE IN RETIREMENT

THERE WAS ALWAYS SOMETHING ABOUT THE WAY TOM BRADY STOOD THERE IN THE POCKET, feet set just beyond shoulder width, symmetric; spaced perfectly, body upright, straight but fluid; always, both hands on the football. He looked like a statue, or an NFT, less human and more form of art. But Brady wasn't, as they say, born to throw footballs better than anyone on earth. He was born to *pursue throwing them* with every ounce of focus, energy, obsession and delusion he could muster.

I've written about star athletes over the past 20 years and am often asked about others I've profiled. I've fielded more questions about Tom Brady than Aaron Rodgers, Roger Federer, Manny Pacquiao and all the rest combined. They want to know the secrets, the routines, whether he *really* eats avocado ice cream. One prominent NFL quarterback—I didn't clear this with him, so I won't use his name—wondered, simply: Where does Brady find the time?

Funny he should ask. Because lately, when thinking of or speaking about one Thomas Edward Patrick Brady Jr., the concept that keeps surfacing is: *balance*. In some ways—in the pocket, for instance—no one possessed more. On balance, in balance, forever balanced, that was Brady's football career, an ethos. But staying in balance while playing football required an imbalance everywhere else.

Brady went to Tampa three seasons ago at least in part because he wanted to find more balance. He wanted to be closer to his oldest son, Jack, who lives in New York. He wanted to be closer to his then wife's family. He wanted a new balance, wanted to spend more time at home. But then he retired last off-season. Retired when he wasn't certain that he wanted to stop playing. It happens. But many close to Brady saw him stepping away for his family only to change his mind and return for his other family, and they believed—they knew—that it would create problems for him at home.

Confidants are careful in regard to what they want to say about the past six months. Know this: They have been difficult. Brady has feelings, emotions, fears, just like everybody else. He played this season in the most public spaces and with the heaviest of hearts. He played well, too. The long break he took during training camp that seemed unusual? It was. Brady needed to get his mind right to remain at his best for his teammates, the Bucs and everyone depending on him.

Then, divorce. Then, the Bucs' descent, a season lost to injuries and confusion, a mess. For most of the season, Brady just looked sad. He looked tired. He looked like a middle-aged man trying to make sense of what had happened, what had not happened, what he wanted to happen and what would happen. There were so many unknowns.

According to those same people, Brady was weighing whether he would retire, finally, for good, even until this week. He had gone to Tampa to find a better balance and win another ring. He got the latter but not the former. His football pursuits cost him in ways he hadn't truly foreseen. Combine that with not winning or excelling or meeting his own ridiculous standard—let's not get wild here, the dude still finished third in the NFL in passing yards, after only Patrick Mahomes and Justin Herbert—and, eventually, he decided it was time. He called the Bucs early Wednesday morning, around 6, and told them he was done. Other franchises were interested, pursuing him like defensive ends have for more than 20 years, and finding similarly limited success. He would not have gone to San Francisco or Las Vegas, he told friends, or anywhere else except for Tampa, if he played another season. And for what it's worth—this is little more than an educated guess here—he will not.

BRADY IS A present father. He cares deeply about his family and his friends. He built a brand and a business and, eventually, an empire. He's not the gridiron cyborg that often is portrayed. He's a real person, underneath the fame and the frame that grows *skinnier* as he ages. And yet, he also is that, exactly that, when accounting for some nuance. He would never have been *Tom Brady* if he didn't avoid strawberries and other foods he considered inflammatory, if he didn't sleep in recovery pajamas, if he didn't work out until Super Bowl Sunday every season even if he wasn't playing in the game, which wasn't often. His in-season schedule ran through

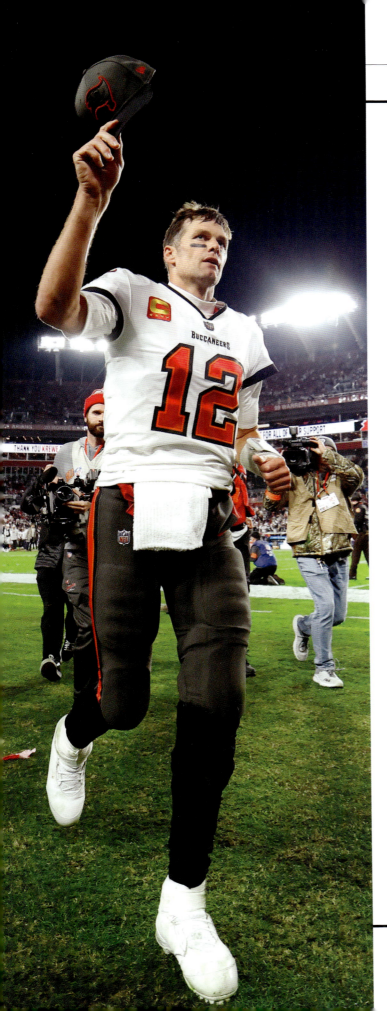

that day, which meant he found a field and met his body coach and did what he has always done. He prepared.

He called his parents Tuesday night and again early Wednesday morning. On the second call he told them, "I'm going to make the announcement this morning."

They responded as parents, because, to them, he's still Tommy, not some sort of football god. "Great," his father, Tom Sr., says he responded. "This is Chapter 2."

It was hard for them to process anything, let alone everything that had transpired. Highs so high—seven rings! Immortality! The GOAT of all GOATs—they sometimes felt like they were living on another planet. Contrasted by lows so low—his mom's cancer; real controversies (Spygate) and dumb ones (Deflategate); the split from New England—they threatened to overwhelm. How could anyone make sense of everything?

Throughout all of that, it seemed like Brady found joy in that process, not to mention fulfillment. Process was his meditation, how he transcended everything and everyone else. His pursuit wasn't for them, or for glory, though. That stuff was secondary. It mattered but not as much as most would think it mattered. Brady pursued perfection because he needed to, had to, somewhere deep, deep, deep inside. This wasn't a pursuit so much as a craft, the *only* way he could exist. Nor was it simply part of him. It was him.

That distinction is important. At least 100 athletes have sat across from me and delivered some version of the same concept. They'll say that their sport does not define them, that they play football/basketball/baseball/tennis, that they drive/race/box. But that's not them, they insist. They're parents, siblings, friends, entrepreneurs, philanthropists. They

Tom Brady left the field for the final time after losing to the Dallas Cowboys 31–14 in the NFC Wild Card playoff game on January 16, 2023.

IN SEARCH OF BALANCE, TOM BRADY FINALLY SAW PEACE IN RETIREMENT

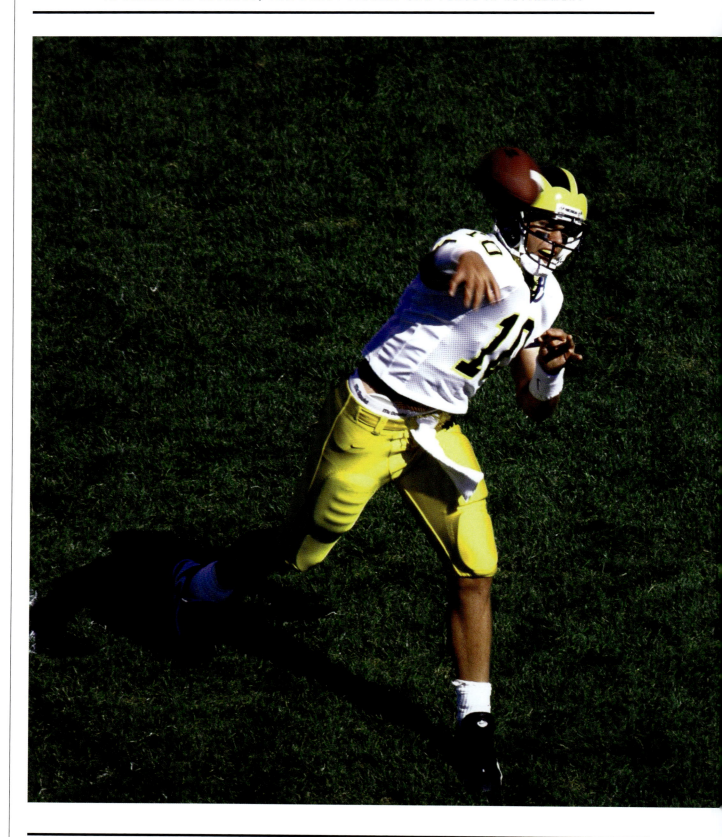

IN SEARCH OF BALANCE, TOM BRADY FINALLY SAW PEACE IN RETIREMENT

just happen to play sports because they're good at them, because turf life beats a cubicle existence.

Brady is all those things. But football *does* define him. Or did, anyway. Perhaps he's different, more fixated, borderline possessed. Or maybe he's the only person willing to tell the truth.

The first time I wrote about Brady's routines, way back in 2014, that body coach, Alex Guerrero, went right at the same notion. TB12 wasn't the sprawling network of centers, books and products it has become. This was the early stage of Brady as TB12, a brand. "Football isn't what Tom does—football is Tom," Guerrero said.

Perhaps that's the only way mere mortals can relate to him. Even Brady must make choices, must consider his life in all facets and how they fit together, weighing what matters now and what will matter later, with pursuits that stand in perpetual contrast. Even Brady is human. He's certainly way more human than he's given credit for. He wants what everyone wants: happiness, gratification, *everything*; a full, well-rounded life.

Brady is also 45 years old, the father of three children and, until last fall, a husband working his ass off, straining his wife's patience and trying to find the time. He was us, people faced with the same factors and struggling to make them fit, to make us whole. And that was weird, because he's him. He turned 45 in August, early into his 23rd and ostensibly final NFL season. At one point, he reminded the journalists who were pestering him about his personal life of his age. As any middle-aged parent knows, Brady was spot on there, too. He said, more or less, s--- happens, to everyone. Amen.

Brady, of course, is not us, not in the most significant way. He has spent more than half his life in pursuit of football glory, trying, then trying harder, then trying something else. What he did tugged at

Brady's college career at Michigan wasn't without its challenges, but the Wolverines went 20–5 with him as the starting quarterback.

IN SEARCH OF BALANCE, TOM BRADY FINALLY SAW PEACE IN RETIREMENT

his soul. It was his soul. But what he wanted to do, later, when he could find the time—which he did find more of over the years—tugged at his soul, too.

The perfectly balanced quarterback never found the perfectly balanced life. Who does? The latter doesn't really exist, even for Tom Brady. His in-pocket balance led to much more than he ever could have reasonably expected, to Lombardi Trophies and championship rings and NFL records that won't be broken, for a long time, if ever. But that football balance cost him, too.

THE VIDEO BRADY posted felt authentic. He looked like a man caught in a moment of great significance, a pivot point between what has fulfilled him and what he hopes will soon. The transfer from one to the other will unfold over the coming weeks, months and years.

Zoom in past the scenic beach background and the windswept hair. What stands out isn't that perfect

at that moment, he saw himself. "The video was real," Smith says. "You could tell this is something that had been weighing on him—and maybe there was some relief in putting it out there."

The hardest part for many, Smith says, is that final moment, when the decision calculus shifts from *maybe I should do this* to *I am going to do this* to *I am definitely retiring*. He imagines that it must have been more difficult for Brady, because of the unprecedented nature of his career and the unprecedented nature of his approach to throwing footballs. Still, Smith understands the burden, what can feel like the world's heaviest weight. Later Wednesday afternoon, he would partake in the Pebble Beach Pro-Am. (See? Retired life ain't bad.) "I'm happy for him," Smith says. "There just seemed to be some closure. Like he was saying goodbye to the game. And I know that was part of my deal."

In recent years, Smith followed Brady's final career stage, the move from New England to Tampa.

EVEN BRADY MUST MAKE CHOICES, MUST CONSIDER HIS LIFE IN ALL FACETS AND HOW THEY FIT TOGETHER, WEIGHING WHAT MATTERS NOW AND WHAT WILL MATTER LATER, WITH PURSUITS THAT STAND IN PERPETUAL CONTRAST. EVEN BRADY IS HUMAN.

jawline or those penetrating eyes that scanned NFL defenses for more than two decades. What stands out is the sadness in his face, which must owe to what football means to him, its intrinsic place in his existence. Beyond the career-over grief, though, there's contentment. "I wouldn't change a thing … love you all," is how Brady seems to give voice to that finality. But his face is more indicative. It says, *It's time.*

"I couldn't be more proud of him or how he comported himself," Brady's father says. "He's such a great son. Such a great guy. Great dad. He's selfless."

Alex Smith woke up to the video Wednesday morning. It transported him back, immediately, to 2021, when, after the greatest comeback from injury in NFL history, he retired after 16 seasons. In Brady,

He saw the seventh title, the seamless transition, the same dominance deployed in a different city and different conference. Brady, he thought, revealed more and more of himself. He came across as funny, self-deprecating, self-aware and, above all, human. In hindsight, maybe that was a sign of the pivot point ahead. The End. No *80 for Brady*, not in real life. More imbalance in his honed and stretched and endlessly hydrated muscles. Less imbalance everywhere else.

It's far easier to embrace this retirement than the last one, and that owes to Brady's expression and the ease in his delivery. The question that lingers: Can he find a better balance? And, if so, how? That search starts now, and, just a guess here, it will start

IN SEARCH OF BALANCE, TOM BRADY FINALLY SAW PEACE IN RETIREMENT

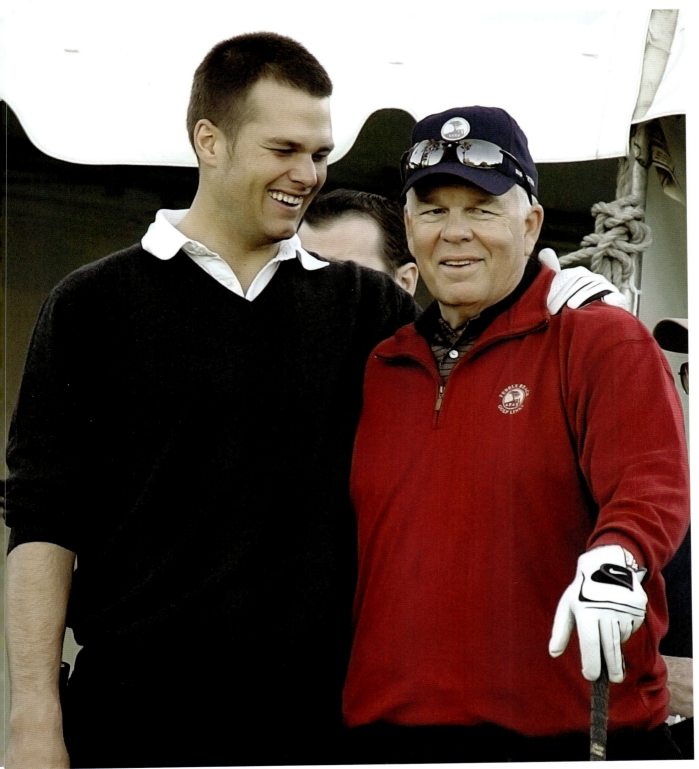

Brady and his father, Tom Sr., shared a laugh during the AT&T Pebble Beach National Pro-Am golf tournament in 2006.

with his idol, parenting model and a main soundboard: his father.

Tom Sr. once told me that, after his son's first Super Bowl triumph, Tommy gave him the ring. Senior gave it back. He was staying with his son but soon left. Tommy called him later and told him to look inside his suitcase. He had packed the ring into his father's carry-on. That moment was pure, in the fathers-and-sons sense, and while Brady gifted his family with moments and memories he will cherish forever, it always seemed like he envied his old man. His grandchildren, Brady Sr. says, provide his son with "great amounts of joy."

Senior heard something recently, on one sports show or another, about how Brady should return to San Francisco, to play for the team he grew up rooting for, with his dad attending home games. Perhaps he could help the 49ers win their first Super Bowl since his childhood. And—his father laughs at this—he could do that in front of his "quite elderly" parents. They would have loved that. But they're glad that he retired, too. They don't want *Tom Brady, seven-time Super Bowl champion*, so much as they want *Tom Brady, happy and at peace with his decision*. More than three decades of football—including 23 in the NFL, five in college, four in high school—is enough.

If anything, they need to figure out what to do on Sundays now in the fall. For decades, Brady's parents watched not just him but followed the rest of the league closely. Every other game impacted their son's chances. "A magical roller coaster," his father calls it—a ride that seems to have, at long last, stopped.

"If I'm being honest, we're going to be totally lost," Senior says. "But that's O.K. Tommy loved football, respected the game and admired his competitors." His father begins to list them: Brees, Manning, the other Manning, Big Ben, Rodgers, Mahomes and the rest. "That's what he does," Senior says. "That's who he is."

THE TEMPTATION HERE is to tally up Brady, to paint him by numbers: seven Super Bowls, three league MVPs, five Super Bowl MVPs, 15 Pro Bowl nods, 89,214 passing yards (most ever), 649 regular-season touchdown throws (same), 13,400 playoff passing yards (same), 88 playoff touchdown passes (same). He had a Hall of Fame–caliber career in each of the past three decades. He ate a lot of avocado ice cream.

But anyone focusing exclusively on Brady's focus—football—is missing what he struggled with these past few years. There *is* more to him than that. He won't "play forever," as he told me back in 2014. But it will seem like he did, as he pivots into his real forever, as he tries to beat not Joe Montana or Peyton Manning but the other Tom Brady, the original, his dad. (By the way, Brady Sr., a chairman of an insurance firm, has not yet retired. Career longevity runs in the family.)

"He's in the right place," Brady Sr. says. "I'm sure that in September, October, November, he's going to really want to play. He'll have some buyer's remorse. I mean, Gronk is talking about coming back! At the same time, he loves his kids and wants to spend time with them."

He pauses, then resumes. "I am pretty certain that there's a finality to his announcement today. He's had a good thing. And now he's gonna move on to another good thing."

I woke up Wednesday morning to something like 500 text messages related to Brady and his

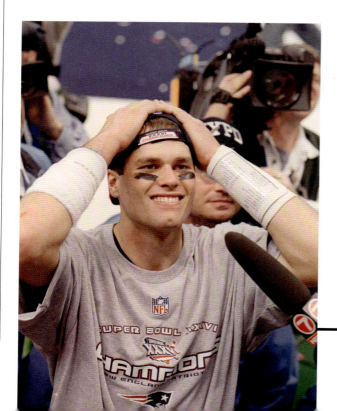

IN SEARCH OF BALANCE, TOM BRADY FINALLY SAW PEACE IN RETIREMENT

retirement. I had to write. But I paused at 7 a.m., when I typically wake up my 5-year-old son. I told him the morning would be dedicated to a work emergency.

"Who is Mr. Brady?" he asked.

"He played football for a long time. As well as anyone who ever played. But this morning, he said he won't play football anymore."

"Why did he play so long?"

"Because he loved it. Because he could. Because it mattered to a lot of people. Because it mattered to him."

Imagine how many parents had that kind of conversation with their children. Imagine how many will.

LEFT A sixth-round pick in 2000, Brady was a Super Bowl MVP after just his second season. **ABOVE** A late-career move to Tampa did little to curb Brady's winning ways.

The best part, though, is that Brady can tell his own kids. He can tell them why he fell so deeply in love with *preparing* to throw footballs. And he can tell them about balance, the kind that's lost and the other kind that's found. Maybe he'll add that, in searching for this elusive concept, he knew he could step away. But stepping away wasn't as important as what he stepped toward. ■

TOM BRADY | 13

Excerpted from SPORTS ILLUSTRATED
February 11, 2002

PAT ANSWER

FOLLOWING THE LEAD OF THEIR TRANSFORMED COACH AND
OH-SO-COOL QUARTERBACK, THE NO-NAME PATRIOTS
STUNNED THE RAMS IN SUPER BOWL XXXVI

BY
MICHAEL SILVER

TAKE A KNEE, BILL BELICHICK THOUGHT. Play it safe, kill the clock and don't put your young quarterback in a position to blow the Super Bowl. This was one option that Belichick, the cerebral coach of the New England Patriots, considered on Sunday night as the Louisiana Superdome shook with energy and the roof seemed ready to cave in on his team.

Then, with 81 seconds left and the Patriots locked in a 17–17 tie with the resurgent St. Louis Rams, Belichick's head deferred to his heart. Although his tired team had squandered a 14-point, fourth-quarter lead, Belichick decided that kneeling was for wimps. Instead his underdog Patriots and their undaunted 24-year-old quarterback, Tom Brady, would deliver one of the most thrilling finishes the sport has known.

As New England prepared to take over at its 17-yard line with no timeouts, Belichick conferred with his offensive coordinator, Charlie Weis, who agreed that an aggressive approach was the right one. "O.K., let's go for it," Belichick said. When Weis relayed the decision to Brady, he could see the surprise in the second-year passer's eyes. There was no fear, however. Brady is so cool that he caught a locker room catnap that ended a mere half hour before kickoff. "With a quarterback like Brady, going for the win is not that dangerous," Belichick explained later, "because he's not going to make a mistake."

What Brady did as those seconds ticked off sent chills through the spines of fans from Cape Cod to Kandahar. Aside from a pair of clock-killing spikes, he completed 5 of 6 passes for 53 yards to set up Adam Vinatieri's 48-yard field goal, which sailed through the uprights for a 20–17 victory as time expired. Brady, whose statistics had been

PAT ANSWER

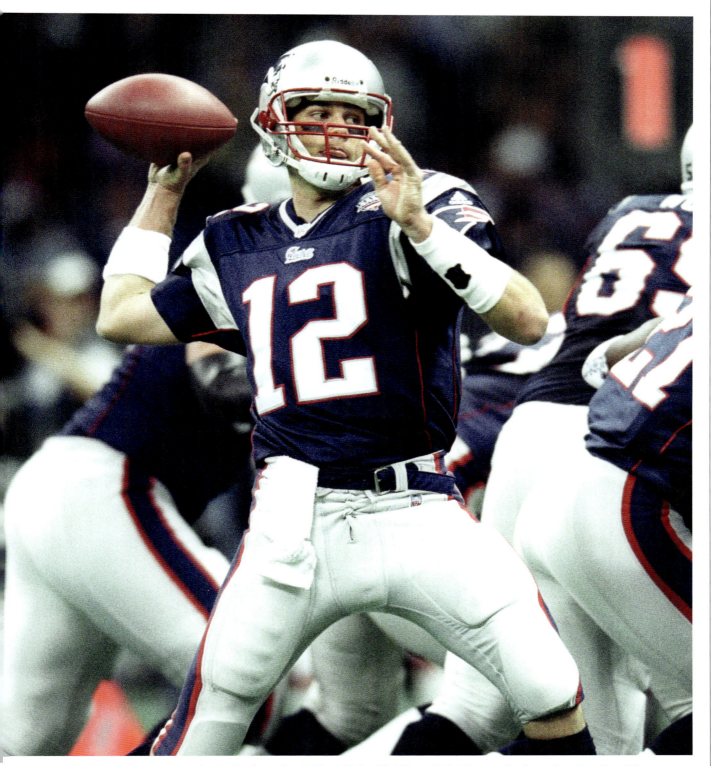

Brady's numbers were modest in his Super Bowl debut (16-for-27, 145 yards), but he was flawless when it mattered down the stretch.

TOM BRADY 15

PAT ANSWER

unimpressive until that final drive, was voted the MVP of what will go down as one of the greatest Super Bowls. Yet this was hardly a one-man show. "A game like this makes you trust in all those corny-sounding cliches," Pats linebacker Mike Vrabel said. "On paper you may not look as talented or as fast or as strong as your opponent, but if you get guys to buy into a system and fight to the bitter end, you can accomplish incredible things."

For patriots and Patriots, this Sunday was as super as it gets: One hundred forty-five days after the Sept. 11 terrorist attacks that stunned a country and stalled an NFL season, the ultimate game provided the ultimate diversion. In beating the vaunted Rams, who were two-touchdown favorites to win their second championship in three seasons, New England completed an amazing journey no reasonable forecaster could have predicted. With chants of U-S-A! filling the stadium, the Pats staged a clinic on the nation's bedrock values—teamwork, bucking the

one by one, the Patriots, as they have for most of the season, simply charged onto the field in a single burst.

"We play together," Law said. "All year we've had a lot of stuff go down that will either cause you to fold or to come together. We've been faced with things that can tear up a team."

The Pats hung tough when quarterbacks coach Dick Rehbein died of a heart attack in training camp, when star wideout Terry Glenn's disruptive antics provoked multiple suspensions and when they lost their first two games and three of their first four. By then the team's $103 million quarterback, Drew Bledsoe, had been hospitalized with a sheared blood vessel in his chest, suffered when he was hammered by the New York Jets.

Brady, a sixth-round draft pick in 2000 who threw only three passes as a rookie, turned out to be a revelation, earning a Pro Bowl spot while leading New England to an 11–5 record and its first AFC

> **IN A GAME IN WHICH THEY WERE OUTGAINED BY 160 YARDS, THE PATRIOTS WON BY OUTHITTING AND OUTHUSTLING THE RAMS, WHO, IN QUARTERBACK KURT WARNER AND RUNNING BACK MARSHALL FAULK, BOAST THE NFL'S TWO BRIGHTEST STARS.**

odds, overcoming adversity and refusing to wilt in the face of danger.

In a game in which they were outgained by 160 yards, the Patriots won by outhitting and outhustling the Rams, who, in quarterback Kurt Warner and running back Marshall Faulk, boast the NFL's two brightest stars. It was the Pats, however, who came up with the biggest plays, beginning with cornerback Ty Law's 47-yard interception return for a touchdown 8:49 before halftime and ending with Vinatieri's bodacious boot. Though most fans don't know the majority of New England's players from Adam, it's not hard to discern the Pats' approach. Consider the pregame introductions: After Warner, Faulk and the rest of St. Louis's offensive starters were called out

East title since 1997. Brady then won over a nation with his gritty performance in the Snow Bowl—New England's 16–13 overtime win over the Oakland Raiders in the divisional playoffs. (Though it should be noted that the Pats' tying field goal drive at the end of regulation was kept alive only after a controversial replay reversal of what appeared to be Brady's game-ending fumble.)

Because of that unlikely escape, some termed New England a team of destiny, but that ignores the hard work and trust that made this triumph possible. After Brady went down with a sprained left ankle late in the first half of the AFC Championship Game, Bledsoe directed the team to a 24–17 upset of the Pittsburgh Steelers. Yet after watching Brady

PAT ANSWER

Brady took over the starting role from Drew Bledsoe in Week 3 of the 2001 season.

PAT ANSWER

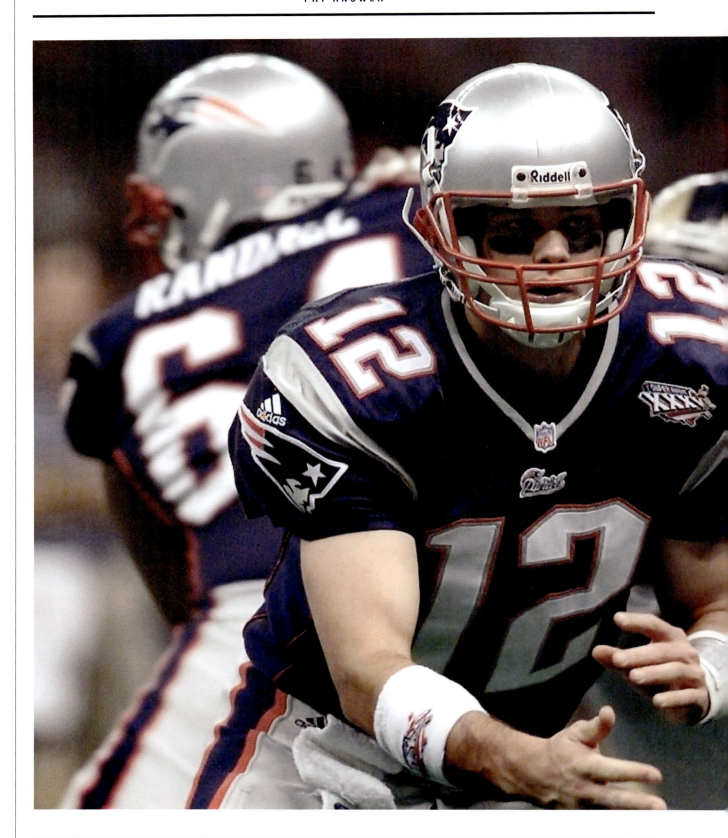

PAT ANSWER

The Patriots rushed for 133 yards against the Rams and won the turnover battle 3–0.

move effectively during practice on the Wednesday before the Super Bowl, Belichick did not hesitate in naming him the starter.

If ever a coach had his finger on the pulse of a team, it was the 49-year-old Belichick, whose firm but unpretentious style helped guide the Pats through a hectic week. While Rams coach Mike Martz allowed his players to roam Bourbon Street, leaving them curfew-free until Friday night, Belichick instituted a midnight bed check beginning on Tuesday. He sold his players on the notion that a sloppy Wednesday practice could cause irreparable harm. St. Louis players, on the other hand, said their Wednesday practice was mistake-filled and disjointed.

Not everything was hunky-dory for the Patriots, though, when Belichick met with his five captains on Tuesday. Living up to his name, strong safety Lawyer Milloy groused to his coach about the hotel room assignments that he and a handful of other veterans had received. "Bill, what's up with our rooms?" Milloy asked. "I think mine came with an oxygen tank, because it makes me so claustrophobic. A lot of the younger guys got suites, and some of us don't think it's fair."

So Belichick took one for the team, switching places with Milloy—from spacious room 692 at the Fairmont Hotel to the cramped quarters of room 533—and persuaded several assistants to do the same for other players. "You think I need a sofa or a dining room table? Who gives a s---?" Belichick said to a reporter, smiling, the day before the game. "Then again, every time I see Lawyer, I ask, 'How's that nice, big room? Are you getting a good night's sleep?'"

The newfound levity displayed by Belichick must stun Cleveland Browns fans, who have endured consecutive Super Bowl bummers. (Last year the reviled former owner of the original Browns franchise, Baltimore Ravens boss Art Modell, hoisted the Lombardi Trophy.) Belichick, however,

TOM BRADY

has come a long way from the unpolished coach who was fired after guiding Cleveland to only one winning season from 1991 through '95. Knowing that his next head job would most likely be his last if he didn't succeed, Belichick walked out on a contractual obligation to replace Bill Parcells as coach of the Jets two years ago. Squeamish over New York's impending ownership change and fearful that Parcells, as the team's director of football operations, might impinge upon his authority, Belichick hastily resigned and soon landed in New England after club owner Robert Kraft sent the Jets a first-round draft choice as compensation.

After New England went 5–11 in 2000, Belichick and player personnel director Scott Pioli—who is married to Parcells's daughter Dallas—made a series of seemingly uninspired off-season moves that set in motion a remarkable transformation. If Washington Redskins owner Daniel Snyder approaches free agency as a Neiman Marcus shopping spree, the Patriots were scrounging through bargain bins at Filene's Basement. "Never mind that talk," Pioli said on Sunday night. "These guys are good players and good people. Football is the ultimate team sport, and these guys fit our system." After Sunday's game three of the free agents the team had signed before this season (there were 17 in all) hugged Pioli and tearfully thanked him for bringing them to New England.

The Discount Dudes were everywhere in the Super Bowl. Vrabel, late of Pittsburgh, set up Law's interception return by blitzing Warner and hitting the quarterback as he was releasing the ball. Fellow outside linebacker Roman Phifer, formerly of the Jets and the Rams, killed a third-quarter drive after harrying Warner into a third-down incompletion. Another former Jet, cornerback Otis Smith, had a 30-yard interception return and played brilliantly all game, while a Buffalo Bills discard, running back Antowain Smith, gained 92 yards on 18 carries. Thirty-one seconds before halftime wideout David Patten, a Browns castoff starting in place of the exiled Glenn, soared to catch an eight-yard fade from Brady in the right corner of the end zone, giving New England a 14–3 lead. It was the first time all season that St. Louis had trailed by more than eight points.

Even before that score, the Pats had achieved an important goal. Two nights before the game Belichick showed his players video clips of games in which turnovers had led to early Rams leads. (Included was the Patriots' last loss, a 24–17 setback against St. Louis in Foxboro, Mass., on Nov. 18.) "If you can get through those first few minutes," he told the team, "you've got a fighting chance." On Sunday, New England controlled the tempo by relying largely on the power running of Smith, a former first-round draft pick who rushed for 1,157 yards in 2001.

PAT ANSWER

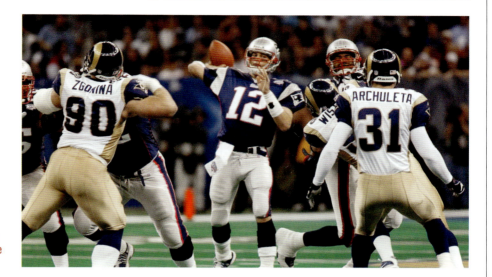

RIGHT Despite his relative inexperience, Brady was cool under pressure against the Rams. **BELOW** David Patten caught a touchdown pass from Brady just before the end of the first half.

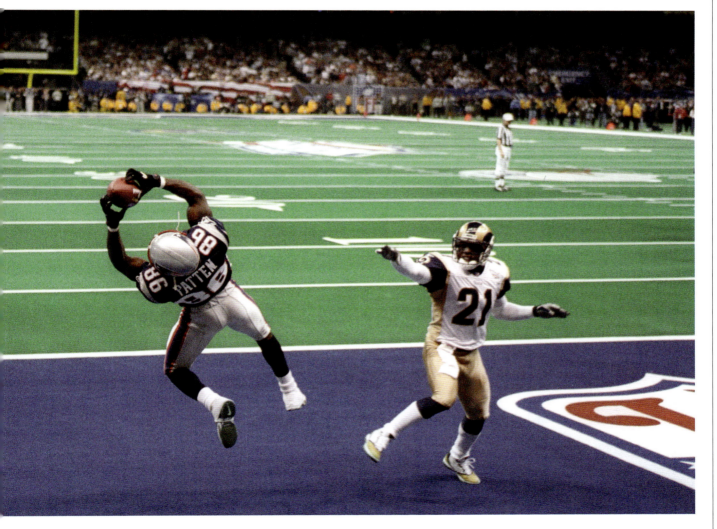

PAT ANSWER

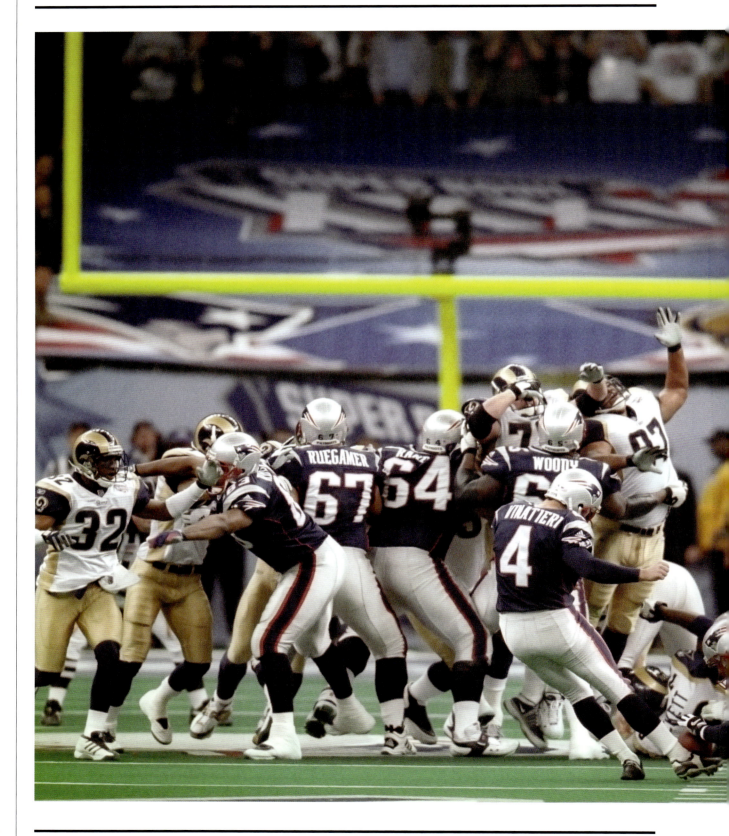

PAT ANSWER

Adam Vinatieri's last-second field goal gave New England its first Super Bowl victory.

The Patriots were equally physical on defense. Belichick, perhaps the best defensive strategist of his generation, and coordinator Romeo Crennel devised a scheme featuring more man-to-man coverage than the team normally deploys. New England's defenders disrupted the timing of the St. Louis receivers by pushing them near the line of scrimmage and then punished them after the catch. In sacrificing pass rushers for as many as seven defensive backs, the Patriots often made Warner (28 of 44, 365 yards) look as uncomfortable as Terry Bradshaw and Paul McCartney did during their excruciating rendition of *A Hard Day's Night* on the Fox halftime show.

Although his numbers paled in comparison, Brady (16 of 27, 145 yards) didn't turn the ball over and shined when his team needed it most. After wide receiver Ricky Proehl's sweet 26-yard touchdown reception tied the game with 1:30 remaining, Brady dodged defenders and moved his team downfield. On three of the winning drive's first four plays he delivered difficult dump-off passes to scatback J.R. Redmond, who, on the last catch—an 11-yard pickup for a first down, during which he dragged a defender past the marker—deftly got out of bounds at the New England 41. "Had either one of those things not happened," Weis said of Redmond's first down and dive for the sideline, "we would have probably killed the clock."

That would have led to the first Super Bowl overtime, but Brady wouldn't let it happen. "You're looking at a team that has some f------ guts, man," Rams defensive end Chidi Ahanotu would say after the game. "Brady never flinched, and they've got one hell of a gutsy coach." After avoiding a blitz by throwing away a first-down pass from the Pats' 41, Brady found Troy Brown (six catches, 89 yards) in a seam underneath the St. Louis zone, and the Pro Bowl wideout sped to the St. Louis 36. A six-yard pass to tight end Jermaine Wiggins and a spike

TOM BRADY 23

PAT ANSWER

followed, and then Vinatieri charged onto the field with seven seconds to go.

Having sported a gruff, unkempt beard throughout the playoffs, Vinatieri, a 1996 free-agent pickup out of South Dakota State, had absorbed his share of ribbing from teammates. "When he walked on the field today, I saw a bunch of security guards move over to check him out," cracked Larry Izzo, the Patriots' special teams captain. "I told him he looked like John Walker, like he was ready to go fight for the Taliban."

What happened next was no joke. Vinatieri—whose 45-yarder through the driving snow sent the playoff game with the Raiders into overtime—nailed one of the biggest kicks in league history, eclipsing, among others, those of Jim O'Brien (a 32-yard game-winner for the Baltimore Colts in Super Bowl V) and Scott Norwood (a 47-yard, last-second miss in the Bills' one-point loss to the New York Giants in Super Bowl XXV). As red, white and blue confetti rained upon the jubilant Patriots, the magnitude of their accomplishment began to sink in: The Rams may be the Greatest Show on Turf, but on this day the greatest team on earth was the one coached by Belichick.

Four hours later, after Super Sunday had morphed into a majestic Monday, Brady paid a visit to room 533. A victory party raged several floors below, but Belichick was busy entertaining family members and sipping a Corona. "Have a beer," Belichick said, handing his quarterback a bottle.

Brady grinned sheepishly. He had been offered the coveted "I'm going to Disney World" TV spot and a trip to Orlando. Nonetheless, as per team rules, he had to get his coach's permission to miss the team flight home. Belichick gave him a perplexed look, and there was a clumsy stretch of dead air. "Of course you can go," Belichick said. "How many times do you win the Super Bowl?"

The answer, for as long as Brady plays and as long as Belichick coaches, will always be this: at least one more than anyone ever imagined. ∎

Brady won his first of five Super Bowl MVP awards.

PAT ANSWER

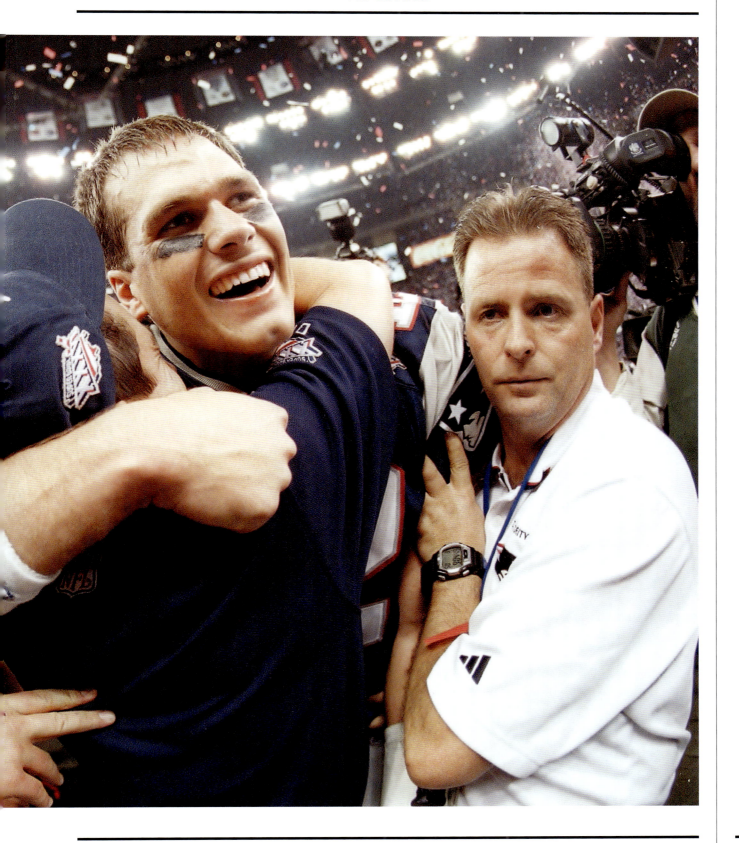

Excerpted from Sports Illustrated
February 9, 2004

FIGHT TO THE FINISH

NEW ENGLAND AND CAROLINA WENT TOE-TO-TOE, BUT TOM BRADY KEPT HIS COOL AND LED THE PATRIOTS TO THEIR SECOND NFL TITLE IN THREE YEARS

BY MICHAEL SILVER

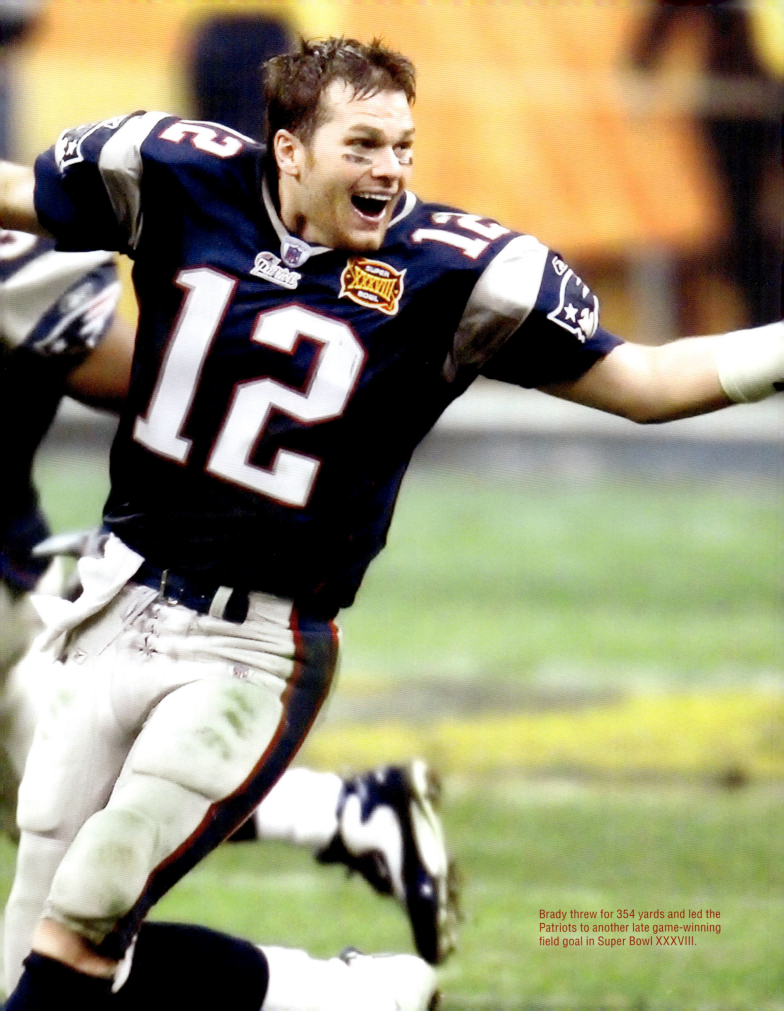

Brady threw for 354 yards and led the Patriots to another late game-winning field goal in Super Bowl XXXVIII.

FIGHT TO THE FINISH

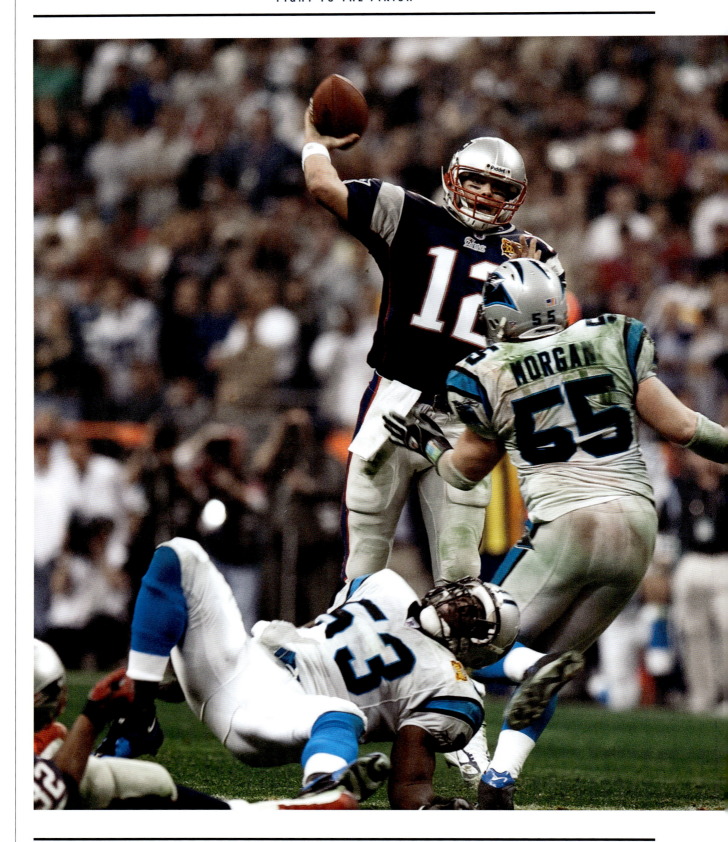

FIGHT TO THE FINISH

TOM BRADY WAS CAUGHT IN A CROWD, YET HE FELT UTTERLY ALONE. The New England Patriots' quarterback was in a ballroom at the InterContinental Hotel in Houston, where in the early-morning hours of Monday a couple thousand people with some connection to the Pats' organization were celebrating the franchise's second Super Bowl championship in three years. Besieged by random admirers seeking his autograph or a snapshot with him, Brady, clad in a Zegna shirt, a platinum bracelet and dark jeans with a bulky pocket chain, looked beleaguered and bewildered. With no security guards or team officials to clear a path, he felt helpless. "I just want to get with my family, O.K.?" Brady kept saying, to no one in particular.

Finally, a friend got through and handed him a gin and tonic, and before taking a sip Brady said, "I hope this s--- is strong. I'm on a mission." Seconds later he was on the move, fleeing the ballroom for an elevator that would take him to the second-floor VIP area. Again, scores of partygoers closed in. Brady winced, and, his voice cracking, said, "This is horrible." Downstairs, Kid Rock joined Aerosmith onstage, ripping through the Boston band's classic "Sweet Emotion," but Brady, to all those who spotted him, was the show.

Such is the life of a man suddenly seen as a Super Bowl immortal. Having already drawn comparisons with his boyhood idol, Joe Montana, the 26-year-old Brady, on the strength of his performance in Sunday's classic at Reliant Stadium in Houston, must come to terms with a new level of celebrity. He is more than a football star now. He is the darling of America's sports fans, the successor to Montana and John Elway, the magical passer who can coolly pull out a victory in the final seconds.

Calm in the pocket, Brady was 32-of-48 with three touchdowns against the Panthers.

FIGHT TO THE FINISH

After picking apart the Carolina Panthers' secondary on two dramatic scoring drives in the last seven minutes to lead the Patriots to a 32–29 victory, Brady was awarded his second Super Bowl MVP trophy, joining Hall of Fame quarterbacks Montana (three), Bart Starr and Terry Bradshaw (two apiece) as the only players to be so honored on multiple occasions. He is the youngest quarterback to have won two Super Bowls, and with his movie-star looks, actress girlfriend, tight-knit family and adoring teammates, Brady's life could not be much sweeter.

All he lacks is peace and perspective, neither of which is likely to come soon. Not after one of the greatest and weirdest Super Bowls ever.

This back-and-forth battle between a pair of flawed but gutty teams was a revelation. Though Carolina quarterback Jake Delhomme provided some stirring moments and New England kicker Adam Vinatieri, as he had two years ago against the St. Louis Rams, nailed the championship-winning field goal in the final seconds, it was Brady (32-of-48 passing for 354 yards and three touchdowns) whose star shone brightest in Space City.

As calm as he was in the game's tensest moments, Brady was drained and out-of-sorts upon its completion. To say that he was awestruck is not an understatement. "Yeah, very," Brady conceded an hour after the game, as he emerged from the shower. "You don't ever dream about this. I mean, you dream about playing football, and you have your fantasies, but you don't dream about winning Super Bowls like this. The way it ended is just incredible."

The use of the second person in interviews was one of Montana's habits, a way of deflecting the attention that his greatness attracted. For Brady, too, the praise will keep coming. Said Patriots linebacker Ted Johnson, "I told Tommy after the game, 'Your

Brady signaled a first down after scrambling late in the second quarter.

FIGHT TO THE FINISH

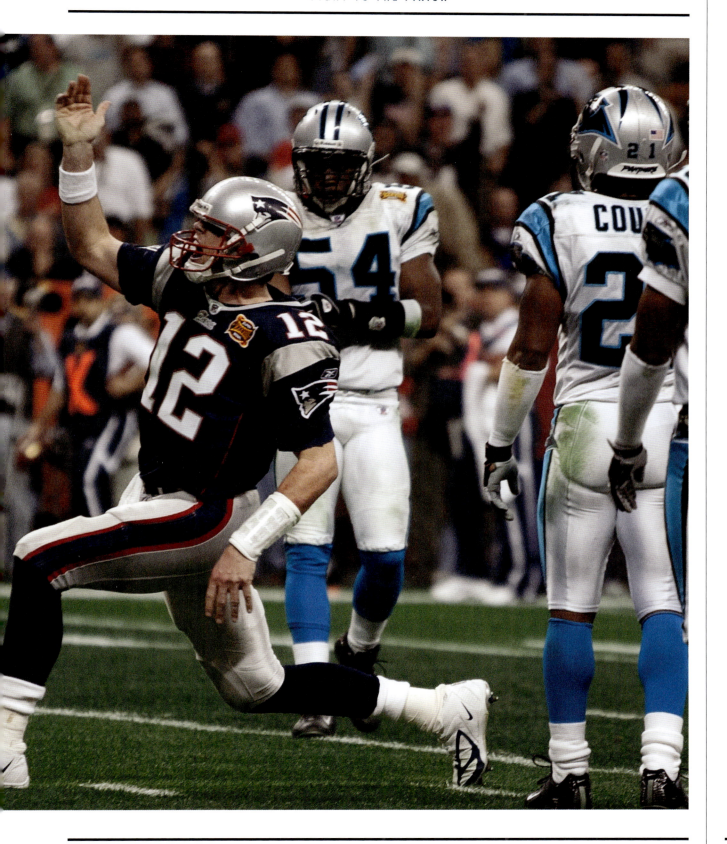

FIGHT TO THE FINISH

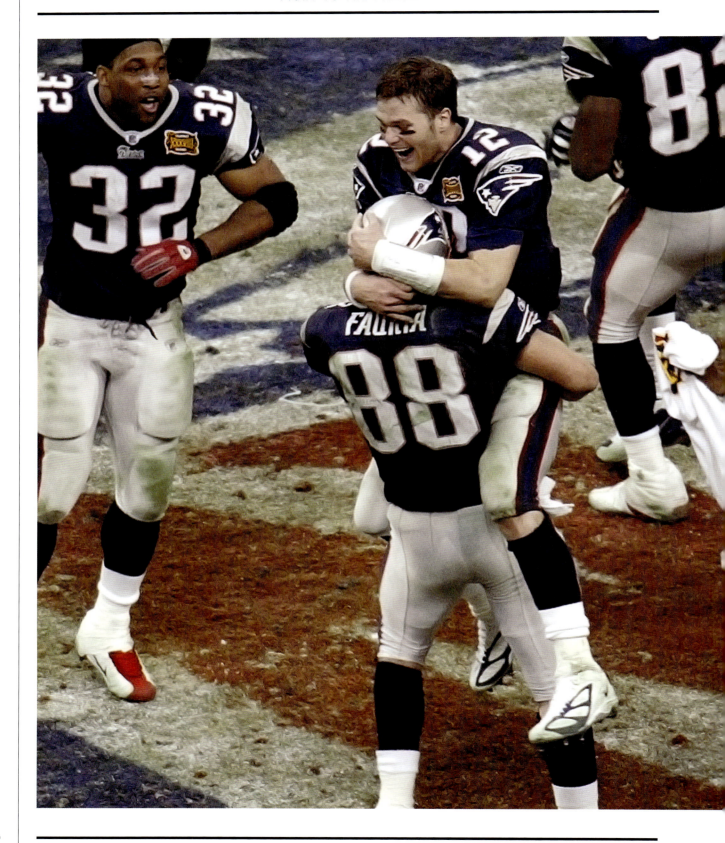

FIGHT TO THE FINISH

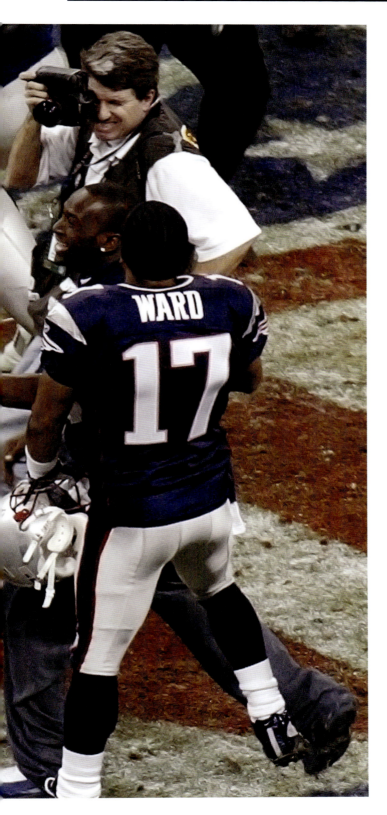

Brady jumped into the arms of Christian Fauria after the Patriots' 32–29 victory.

coattails are getting heavy, and I apologize. Right now I'm hanging on for dear life.'"

It's a gracious sentiment but not an entirely accurate one. These Patriots (17–2), as they were two seasons ago, are a quintessential *team*. Despite the league-high 87 games that its starters lost to injury in 2003, New England won its final 15 games, the second-longest single-season streak in NFL history. The Pats' marquee free-agent signee, linebacker Rosevelt Colvin, played just two games in 2003, yet underrated veterans, such as linebackers Mike Vrabel and Willie McGinest and safety Rodney Harrison (who broke his right arm late in the fourth quarter on Sunday), raised their games to new heights.

Brady may be the team's lone star, but New England's hero in a headset, coach Bill Belichick, is equally indispensable. In addition to being a shrewd talent evaluator, meticulous in his game preparation and the best defensive strategist of his generation, Belichick, 51, has evolved into a stirring speaker—at least when behind closed doors with his players. After giving a bland breakdown of strategic priorities during a team meeting last Saturday night, Belichick mesmerized his troops by holding up the Lombardi Trophy that New England had won two years earlier and placing it on a table. The room went silent for a few seconds, and then Belichick finished by saying, "Look, guys, this is what we're playing for. Let's put this week in perspective: It's not about the parties; it's the trophy. Only 37 teams can say they've owned this. You guys can be the 38th."

For much of the first half, neither team looked worthy of the silver hardware. The game was scoreless for the first 26:55, the longest drought to open a Super Bowl. Carolina (14–6) had minus-seven yards of total offense, and Delhomme had completed 1 of 9 passes for a single yard. New England

FIGHT TO THE FINISH

wasn't much better, having squandered a pair of scoring opportunities when Vinatieri missed field goal attempts from 31 and 36 yards. (The latter was blocked by Shane Burton.)

Somebody needed to make a play, and that person was Vrabel, a 28-year-old linebacker who was the team's regular-season sack leader, with 9½. With 5:22 left in the second quarter, Vrabel steamed around Panthers left tackle Todd Steussie and chopped the ball out of Delhomme's hand. Defensive end Richard Seymour recovered at the Carolina 20. Four plays later Brady, after a convincing play fake to running back Antowain Smith, threw a five-yard touchdown pass to wideout Deion Branch (10 catches, 143 yards), and the bizarre Tale of Two Games had begun: no points in the game's first 26:55 minutes; 61 in the final 33:05 minutes, including 37 points in the fourth quarter.

touchdowns), who nearly eclipsed Brady as a clutch pocket passer.

Down 21–10 following Smith's two-yard touchdown run 11 seconds into the fourth quarter, Delhomme put together a six-play, 81-yard drive culminating in DeShaun Foster's 33-yard touchdown dash down the left sideline. Brady, after driving New England to the Panthers' nine, then made a decidedly un-Montana-like mistake, lobbing a pass into the end zone that was intercepted by cornerback Reggie Howard with 7:38 left. Three plays later Delhomme lofted a beautiful spiral to Muhsin Muhammad (four catches, 140 yards), who caught the ball in stride at the New England 33 and completed an 85-yard touchdown, the longest play from scrimmage in Super Bowl history.

Carolina missed a second consecutive two-point conversion attempt, but suddenly the Pats

BRADY MAY BE THE TEAM'S LONE STAR,

BUT NEW ENGLAND'S HERO IN A HEADSET, COACH BILL BELICHICK,

IS EQUALLY INDISPENSABLE.

This game was full of big hits. Things had gotten nasty during the teams' previous meeting at the end of the 2001 season, a game New England won 38–6. The Pats were heading toward their first Super Bowl, and the Panthers were losing their 15th straight game. There were harsh words and skirmishes, which helped explain why players from both teams engaged in a staredown near midfield before Sunday's game. "They were trying to intimidate us," Johnson said. "That's when you knew it was on."

True to their personality under second-year coach John Fox, the Panthers never gave up the fight in their first Super Bowl. "It was a very physical game," said New England linebacker and special teams captain Larry Izzo, "and, like a bad virus, that team wouldn't go away." The most potent Carolina player was Delhomme (16 for 33, 323 yards, three

were behind 22–21 with 6:53 left, and there were dry mouths along the New England sideline. The Pats hadn't trailed in a game since a Nov. 23 overtime victory over the Houston Texans in the same stadium, but Harrison told cornerback Ty Law, "Hey, man, there's no reason for us to worry. We've got Tom Brady."

On Sunday, Brady looked every bit as unfazed as his idol, Montana, did in rallying the San Francisco 49ers to a last-minute victory over the Cincinnati Bengals XV Super Bowls ago. "He was poised," defensive end Mike Rucker said of Brady, who wasn't sacked by the Panthers. "We hit him a couple of times, but he'd get right back up." On second-and-goal from the one with 2:55 left, New England offensive coordinator Charlie Weis called 136 X Cross Z Flag, and a certain moonlighting tight end got chills: Vrabel, with two sacks and a forced fumble,

FIGHT TO THE FINISH

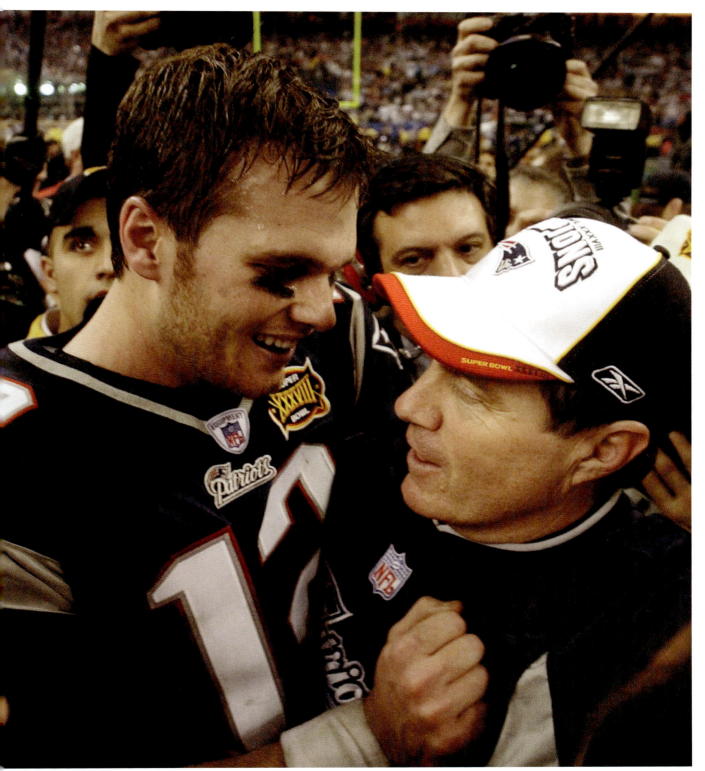

Brady and Bill Belichick celebrated their second Super Bowl championship in three years.

FIGHT TO THE FINISH

FIGHT TO THE FINISH

had already made a huge impact, but now he was about to catch his first pass since September 2002. After a typically smooth play fake to Smith, Brady saw Vrabel flash across the middle and flicked the ball to him. Said Vrabel, a father of two boys, "I held it like it was my third child." The ensuing two-point conversion—Kevin Faulk scored on a run up the middle after taking a direct snap—gave the Pats a 29–22 lead, but the Panthers weren't done.

Seven plays and 80 yards later, Delhomme zipped a 12-yard touchdown pass to wideout Ricky Proehl. Two years earlier, while playing for the Rams, Proehl had tied the Super Bowl on a 26-yard touchdown catch with 1:30 remaining; this time, there was 1:08 left when Kasay's extra point made it 29–29. "I've been in that situation so many times," said Brady, now 26–4 in games played in November or later. "So, yeah, I was calm."

With a huge assist from Kasay, who hooked the ensuing kickoff out of bounds to give New England possession at its own 40, Brady and Vinatieri made hearts flutter again. On third-and-three from the Carolina 40 with 14 seconds on the clock, Brady took a shotgun snap and found Branch down the right sideline for 17 yards. On came Vinatieri, who kicked a 41-yard field goal with four ticks remaining, and it was time to ponder the Patriots' potential for a dynasty and their quarterback's ascent to gridiron icon.

Several hours later at the victory party, Brady's family members and close friends finally reached him, and the quarterback's boy-next-door smile returned. The first of the group to arrive was his current love interest, Bridget Moynahan, who most recently costarred in *The Recruit*. The two hugged and smooched and whispered sweet nothings, and for the first time all night, the masses backed off and gave the quarterback some space.

LEFT Brady shared a moment with owner Robert Kraft, with whom he formed a personal relationship. **TOP** After his second Super Bowl victory, all eyes would be on Brady as the Patriots looked to repeat.

Excerpted from SPORTS ILLUSTRATED
February 14, 2005

THREE-RING CIRCUS

THE PATRIOTS STAKED THEIR CLAIM AS THE CENTURY'S
FIRST DYNASTY AND THE GREATEST SHOW ON TURF, BEATING
THE EAGLES FOR THEIR THIRD NFL TITLE IN FOUR SEASONS

BY

MICHAEL SILVER

BECAUSE THEY DO NOT BEAT YOU OVER THE HEAD WITH THEIR EXCELLENCE OR BEAT THEIR CHESTS IN TRIUMPH, the New England Patriots are forever being cast as commonplace champions. They are great in the way that a chocolate milk shake is great, as poised and proficient as the Beach Boys' doing background harmonies onstage. What we are slowly but surely learning from the Pats as they forge the first football dynasty of the 21st century is that dominance comes in many forms, and that sometimes doing the little things well can provide the biggest satisfaction of all.

As these Patriots keep escaping with three-point victories and kicking dirt on the Super Bowl's heritage of wretched excess, skipping individual pregame introductions and engaging in comparatively low-key locker room celebrations, isn't it time we stop being perplexed by their success? Yes, New England's 24–21 victory over the Philadelphia Eagles in Super Bowl XXXIX on Sunday night in Jacksonville was another testament to teamwork, tenacity and the strategic acumen of coach Bill Belichick and his staff. But in vanquishing a brasher opponent to claim the NFL's ultimate prize for the second consecutive year—and the third time in four seasons, matching the record run of the Dallas Cowboys from 1992 to '95—the Pats' players proved they are even more potent than typically perceived.

"Someday I'm going to have kids and tell them I played on one of the greatest teams of all time, a team with a whole lot of great players," said 11th-year outside linebacker Willie McGinest, whose deployment at defensive end was the key to New England's surprise scheme change for the title game. "You might not call them stars, but they just went out and embarrassed people in the biggest game of their

THREE-RING CIRCUS

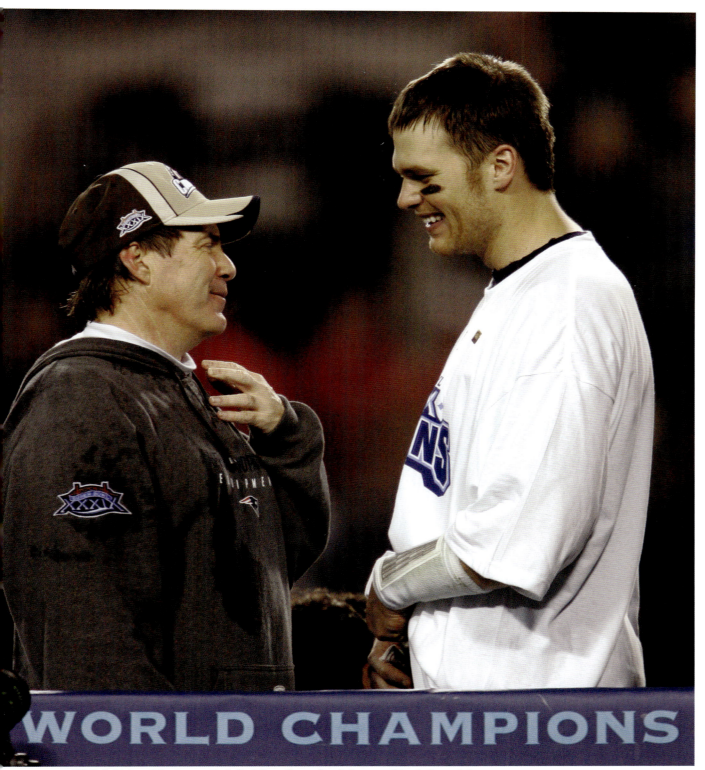

Bill Belichick and Brady won their first three Super Bowls by a combined nine points.

THREE-RING CIRCUS

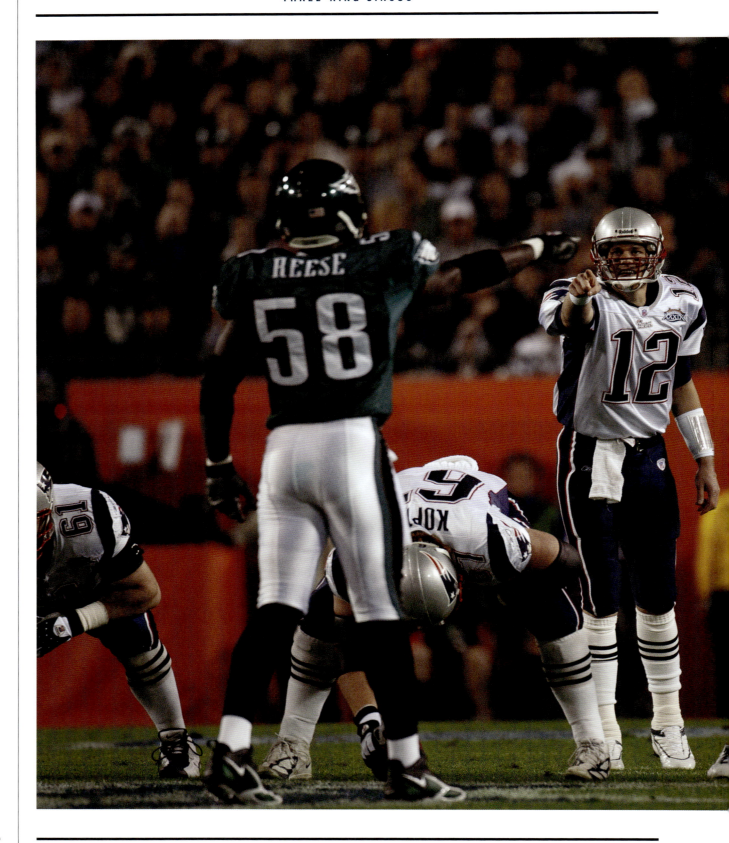

THREE-RING CIRCUS

lives, so why wouldn't they be stars? It doesn't matter if we won by three or 103—we don't give a damn if people downplay our accomplishments, because all we want to do is win."

So before the coronation of the plucky Patriots as the team of the decade, let's get this much straight: As they proved again in front of 78,125 fans at Alltel Stadium and an estimated 80 million television viewers worldwide, the Pats are more than Belichick's brain and quarterback Tom Brady's golden right arm. Defenders like McGinest, fellow linebackers Tedy Bruschi and Mike Vrabel and strong safety Rodney Harrison, whose second interception of Donovan McNabb iced the game with nine seconds remaining, showed that they're elite players, while unheralded wideout Deion Branch seized footballs out of the cool night sky and the MVP award from Brady's grasp.

"It's awesome to see a guy like Deion win it," said Brady (23 of 33, 236 yards, two touchdowns), a two-time Super Bowl MVP. "The guy has done everything he can for this team, and this is a team full of guys who cheer for one another. The MVP is nice, but that's not why you play. I'm playing for that diamond ring that's as big as a belt buckle."

New England's first two titles came courtesy of Adam Vinatieri field goals in the final seconds—and this victory was only slightly less tense. Again, the Pats relied on their patented formula of individual opportunism, selflessness, innovative game-planning and emotion fueled by perceived disrespect. The last of those came after the Patriots received a copy of an email sent from an Eagles official to a member of the Boston Red Sox organization seeking advice on a prospective victory parade, a missive that Belichick milked for maximum effect during his address to the Pats on Sunday morning at the team's hotel in St. Augustine.

After a slow start, Brady led New England to 183 yards of offense in the second half as their defense withstood a late Eagles charge.

TOM BRADY 41

THREE-RING CIRCUS

But it was the Eagles, despite being seven-point underdogs, who supplied the bulk of the pregame bluster, from wideout Terrell Owens's assertion that God would heal his right ankle in time to play to fellow wideout Freddie Mitchell's digs at Harrison and the other New England defensive backs. Even Chuck Bednarik, the 79-year-old Hall of Famer and former Eagle, popped off, saying his bitterness toward the Philadelphia organization would compel him to root for the Patriots. Meanwhile, rowdy Eagles fans, who greatly outnumbered their New England counterparts, flocked to congested downtown Jacksonville.

The Patriots didn't make much noise, but behind the scenes they had issues. In an effort to keep McNabb from scrambling, Belichick and defensive coordinator Romeo Crennel junked their 3-4 set in favor of a 4-3 alignment—the Cali front, so named in honor of California native McGinest—in which the veteran linebacker shifted to pass-rushing end. The idea was to cut off the edges and form a semicircle around McNabb, thus discouraging him from throwing to the inside or running.

Going back to Cali unnerved the Pats, who hadn't practiced that alignment since the preseason. When Crennel streamlined the game plan on the Monday before the game, "there were some raised eyebrows," admitted veteran linebacker Ted Johnson. Practices on Wednesday and Thursday, fellow linebacker Roman Phifer added, were "horrible" for the defense, marred by bad communication, erroneous presnap reads and other frequent mental mistakes.

Rather than rail at his charges, Crennel adhered to the Patriot Method, polling the players on what they thought would fix the situation. The consensus: Simplify the scheme. "If you keep hearing from your players that there are too many checks, that means

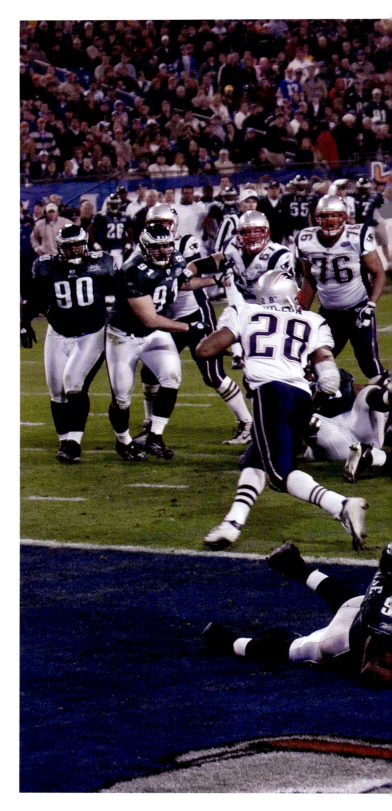

Mike Vrabel caught a two-yard touchdown pass from Brady in the third quarter.

THREE-RING CIRCUS

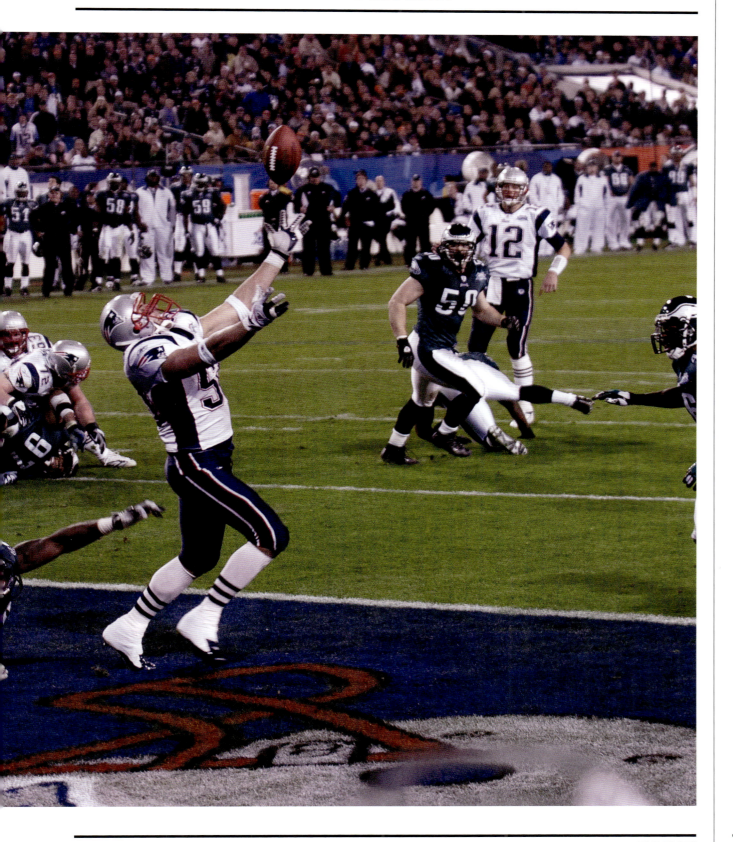

THREE-RING CIRCUS

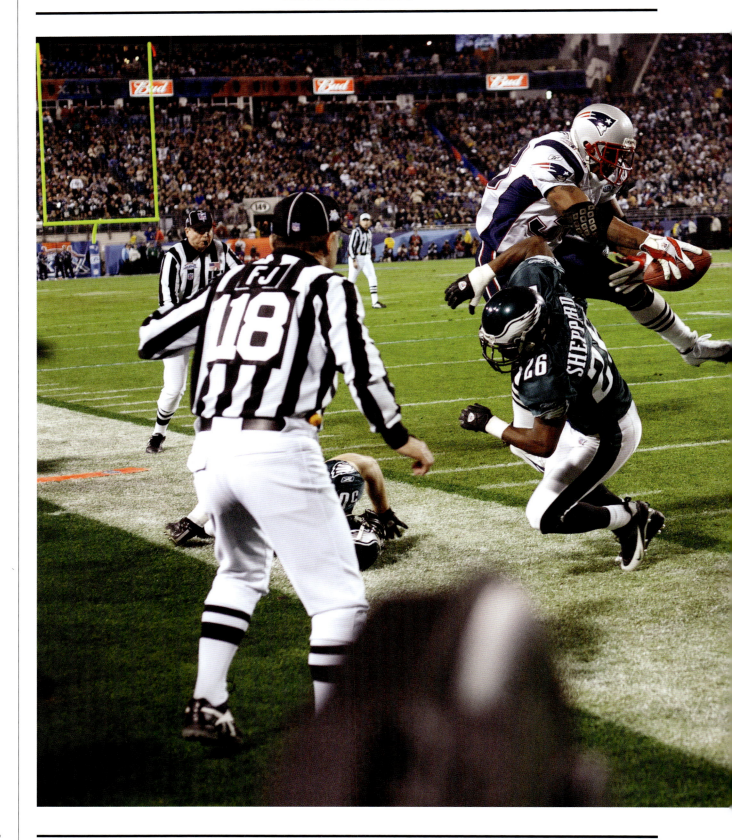

THREE-RING CIRCUS

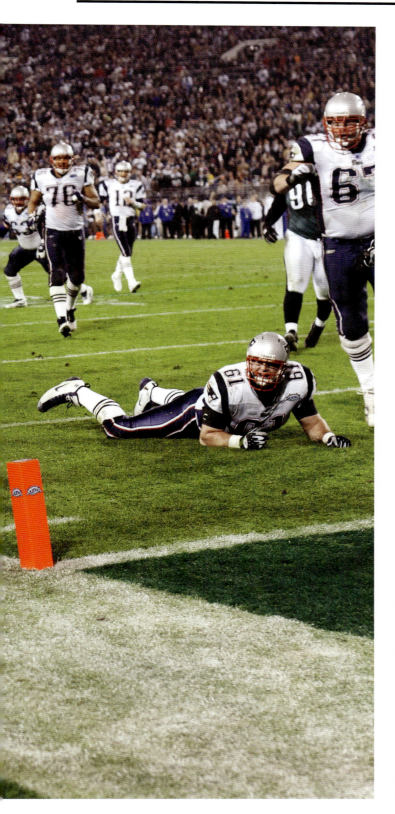

Kevin Faulk caught two passes during a critical third-quarter drive that gave the Patriots the lead.

there probably are," Crennel said. "So we cut it back. After the Friday practice we were able to sleep easier."

While the Pats' defense flustered McNabb (30 of 51, 357 yards, three touchdowns) from the outset, ultimately sacking him four times and intercepting three passes while limiting him to zero rushing yards, New England's offense began the game as if in a slumber. Having fallen behind 7–0 on McNabb's six-yard scoring pass to tight end L.J. Smith with 10:02 left in the second quarter—just the second time in their last 27 games they'd failed to score first—the Patriots drove to the Philly four, only to lose the ball when Brady fumbled after bumping into running back Kevin Faulk on a play-fake.

New England finally tied the game on Brady's four-yard pass to wideout David Givens 1:16 before halftime and took a 14–7 lead with 11:09 left in the third quarter on a two-yard scoring toss from Brady to Vrabel, marking the second consecutive Super Bowl in which the moonlighting linebacker caught a touchdown pass. Yet when McNabb whipped a 10-yard scoring pass to running back Brian Westbrook to tie the game with 3:39 remaining in the third quarter, the raucous Philly fans asserted themselves like Broad Street Bullies.

If the Philly faithful thought Brady would be fazed, they haven't been paying attention the past four years, during which the 2000 sixth-round draft pick has ensured himself a place in the Hall of Fame. Following an emotional week in which his 94-year-old grandmother, Margaret, died, Brady exuded an eerie calm when the situation was most tense. He was 4 for 4 on the Pats' nine-play, 66-yard drive, with running back Corey Dillon providing the go-ahead points on a two-yard run with 13:44 left. On New England's next drive Brady and

THREE-RING CIRCUS

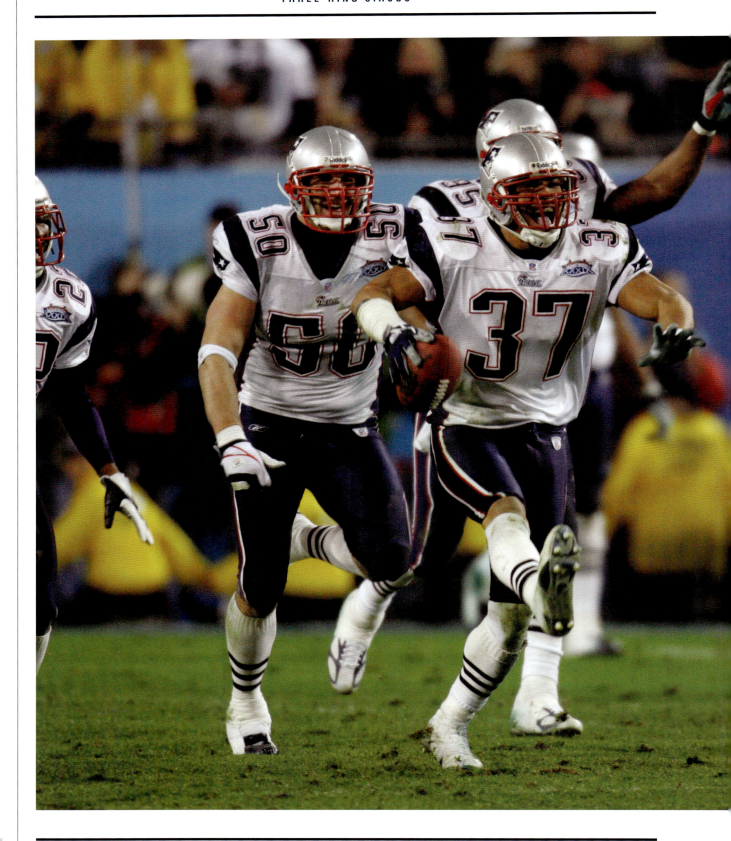

THREE-RING CIRCUS

Branch hooked up on the play of the night, a pass over the middle on which the third-year receiver leaped over the back of Philly cornerback Sheldon Brown to turn a possible pick into a 19-yard reception. Six plays later Vinatieri's 22-yard field goal put the Pats up 24–14.

"Outside of that terrible first quarter, we felt we had the game under control," said Branch, who had 133 receiving yards on 11 catches—tying the Super Bowl record shared by Cincinnati Bengals tight end Dan Ross and San Francisco 49ers wideout Jerry Rice, the last receiver to be named MVP (16 years ago). That followed up a 10-catch, 143-yard effort in New England's 32–29 Super Bowl victory over the Carolina Panthers last season.

Yet for all his brilliance, Branch wasn't the most impressive wideout on the field. That distinction belonged to Owens, who 6½ weeks after surgery on his ankle, responded with a nine-catch, 122-yard show of grit. Alas, the same could not be said for the Eagles' other loudmouth receiver, Mitchell, who had angered the easy-to-rile Harrison in the wake of the Pats' 41–27 victory over the Pittsburgh Steelers in the AFC Championship Game by saying he "had something" for the two-time Pro Bowler and that he didn't know the names of New England's cornerbacks. Though Harrison and his friends in the secondary had hoped to hit Mitchell harder than the media slammed Jacksonville (which was derided all week as a second-rate Super Bowl city), they had to settle for limiting him to a single catch for 11 yards.

"All he does is talk," Belichick said of Mitchell long after the game as he sat in his locker room office, his feet propped on a desk. "He's terrible, and you can print that. I was happy when he was in the game."

The coach undoubtedly was pleased with Eagles coach Andy Reid's curious decision to

Rodney Harrison celebrated after making the game-sealing interception against the Eagles.

TOM BRADY 47

forgo a no-huddle offense while trailing by 10 with 5:40 to go. When the Eagles (15–4) completed a 79-yard scoring drive on McNabb's 30-yard strike to wideout Greg Lewis, only 1:48 remained. After the Pats' Christian Fauria recovered David Akers's onside kick, the Eagles' defense held, but New England punter Josh Miller pinned Philly at its own four with 46 seconds remaining, and Harrison's interception set off a fitting release of red, white and blue confetti.

Belichick, his gray, hooded pullover doused with Gatorade (thanks to Bruschi, who also soaked the coach's 86-year-old father, Steve), celebrated by initiating a hearty group hug with his outgoing coordinators, Crennel and offensive whiz Charlie Weis. Both men were about to become head

again in '05. "Five years ago, when I was about to hire Bill, we were having dinner at the Capital Grille in Chestnut Hill," Patriots owner Robert Kraft recalled after the game. "I said, 'Promise me that when we have success that you won't change,' and he has been true to that promise." The coach demands similar humility from his players, who in the words of backup linebacker and special teams ace Matt Chatham, are "all drinking the Kool-Aid. Everybody buys into the team concept, and we'd be stupid not to."

"When you work together—when you embrace words like *dignity*, *integrity* and *unselfishness*—great things can be accomplished," said Bruschi, who thwarted an Eagles drive with an interception at the New England 24 with 7:20 left. Realizing that

> "WHEN YOU WORK TOGETHER—WHEN YOU EMBRACE WORDS LIKE *DIGNITY*, *INTEGRITY* AND *UNSELFISHNESS*—GREAT THINGS CAN BE ACCOMPLISHED. AND IF YOU'VE GOT SOME BALLERS IN YOUR LOCKER ROOM, YOU'LL WIN A LOT OF SUPER BOWLS." —TEDY BRUSCHI

coaches—Crennel with the Cleveland Browns, Weis with Notre Dame—but first they wanted to savor a second consecutive 17–2 season and the team's historic run. "What did we say, Charlie?" Belichick asked about the words exchanged during the trio's embrace. "I forget."

Weis smiled. "We said we'd been together a long time," he recalled. "We'd had some good times, some bad, but these are moments we'd always have together. And it wouldn't matter that we wouldn't be together anymore. You can be the richest man in the world and not be able to buy moments like this."

Belichick's next challenge will be working with two new coordinators, but enough will be the same in New England to make the Pats the team to beat

he, too, was falling into a familiar trap, the ninth-year linebacker caught himself and laughed. "And if you've got some ballers in your locker room," Bruschi added, "you'll win a lot of Super Bowls."

Several hours later, as the clock struck three at the World Golf Village in St. Augustine, Bruschi beamed as Brady entered the VIP section of the team's victory party. The quarterback got the rock-star treatment as he cruised around the room, pausing with teammates to pose for photos with the Lombardi Trophy. Holding his thumb and pinkie together to signify the Pats' three titles, Brady toted the shiny silver football to Vrabel's table, then took it over to Bruschi.

Before and after another camera clicked, neither star said a word. There was no need to. ■

THREE-RING CIRCUS

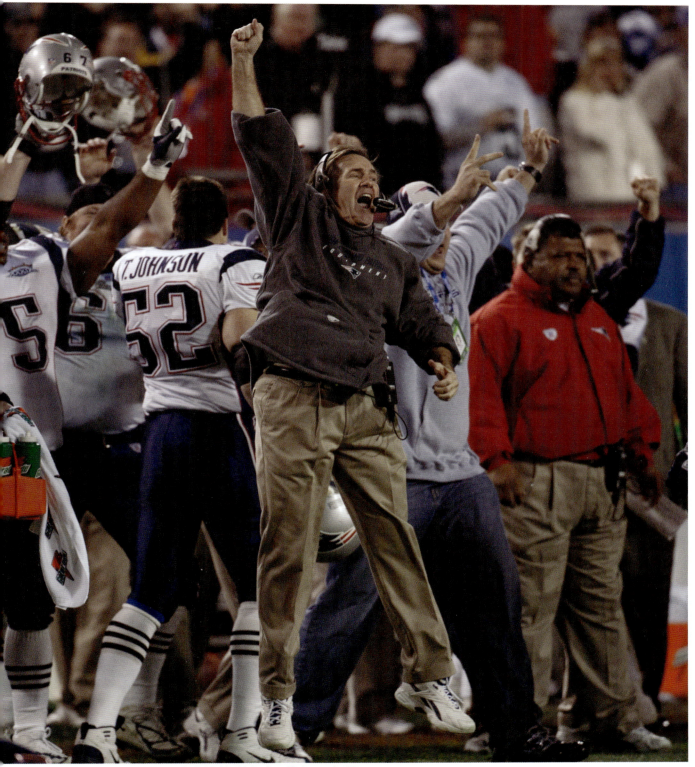

Super Bowl XXXIX was Belichick's 10th playoff victory in 11 games.

Excerpted from SPORTS ILLUSTRATED
November 7, 2005

FACE OFF

TOM BRADY OR PEYTON MANNING? THE NFL'S TWO BEST QUARTERBACKS.
ONE HAS THE STATS, THE OTHER THE TITLES. WHO'S BETTER? AND WHO
WINS MONDAY NIGHT? IT'S THE ULTIMATE FAN DEBATE

BY
MICHAEL SILVER

WHEN PEYTON MANNING GOT HIS FIRST TASTE OF ORGANIZED SPORTS, HE COULDN'T WIN. As a five-year-old in a coach-pitch baseball league in New Orleans, Manning played for a team that routinely was on the wrong end of lopsided scores, which frustrated the already competitive young slugger. What really chafed the middle child of a famous NFL quarterback, however, was the illusory insinuation that he couldn't lose. "They would get hammered by something like 17–1, and then the coach would gather the players after the game and tell them it was a tie," Peyton's father, Archie, recalls. "Then we'd be in the car driving home, and Peyton would say, 'We didn't tie; we got killed!' It wasn't so much the losing that drove him nuts; it was the coach saying it didn't happen. Peyton was one of those kids who always knew the score."

Twenty-four years later, as Manning prepares for another high-stakes matchup with the only other NFL quarterback in his class, he is painfully aware of his record in games against Tom Brady: 0–6, including playoff defeats the past two seasons. Yet Manning has had so many great seasons that the debate about which of the two is the better quarterback rages on. When Brady's New England Patriots host Manning's Indianapolis Colts next Monday night in the most anticipated matchup of the 2005 regular season, it'll be hard to take two steps into a sports bar without hearing someone proclaim one or the other's superiority.

Typically, each is measured by what he supposedly lacks in comparison with the other: Brady, 28, owns three Super Bowl rings but can't match Manning's record-setting numbers and arm; Manning has the stats but can't win the big one. The truth is, they are very much alike in the most

FACE OFF

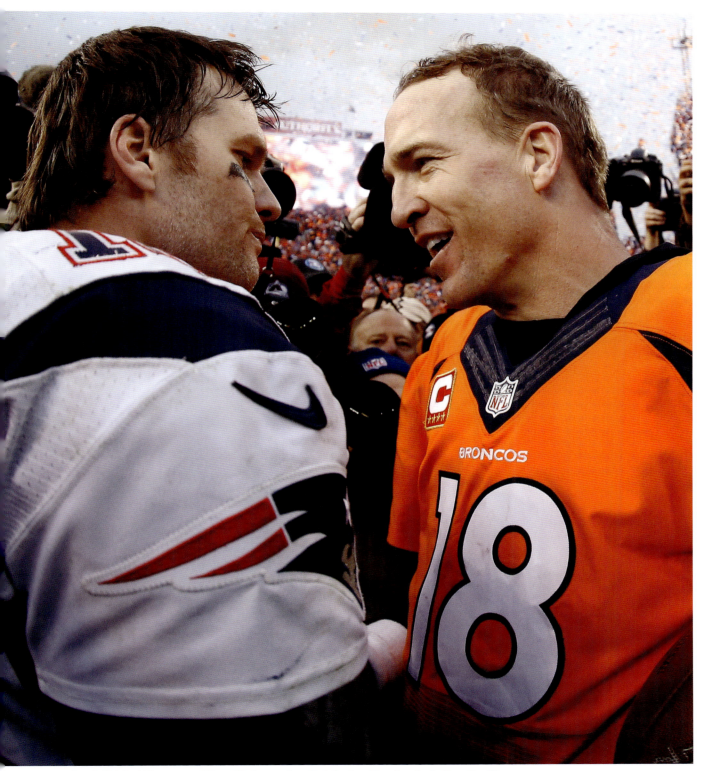

Brady finished his career with an 11–6 record against Peyton Manning, including playoffs.

FACE OFF

important intangibles—toughness, consistent excellence and passion for the game.

"He's similar to me in that he's never really satisfied," Brady says. "It's like, Who cares what you did last week? As a competitor you always want to be the best, but I realize that to be thought of up there with a guy like him is a pretty huge compliment. I'm always interested to see how he's doing, and in a strange way I kind of root for him too."

Each is a good, sincere man who is secure enough to feel a genuine appreciation for a fellow legend in the making. They've bonded over beers and congratulatory emails; they've compared notes on handling the trappings of celebrity; they love each other's work.

Over the summer Brady watched tapes of all of Manning's games from the 2004 season, admiring his NFL-record 49 touchdown passes. Brady also marveled at Manning's commanding performance in the Colts' 2005 season opener, a 24–7 victory over the Baltimore Ravens. Manning has been obsessed with studying professional quarterbacks since he was a kid idolizing Archie, who played 14 NFL seasons, mostly for the New Orleans Saints, after a legendary career at Ole Miss. And he is so respectful of the position that he will stand up for the league's most maligned signal-callers. "Peyton says playing quarterback in the NFL is the toughest job in sports," Archie says. "When a guy like Drew Bledsoe has a couple of rough years and people say, 'He's done,' it really bothers him.

"But he also understands that if you ever forget why you're good—if you think it's just you—you're in trouble. This isn't tennis or golf; playing quarterback is a very dependent position."

That's true, but fans ultimately turn to quarterbacks and drive the arguments over who's better—Montana or Marino? Marino or Elway? Elway or Young? Young or Aikman? Aikman or Favre? This era's top dogs similarly divide the public as they conquer. Manning is the prickly perfectionist whose outrageous productivity, aided by a stellar supporting cast, makes him the darling of the fantasy-football obsessed. Brady is most emblematic of guts and poise under pressure, yet the way he blends into an offense that is otherwise without stars resonates with our commitment to the communal spirit.

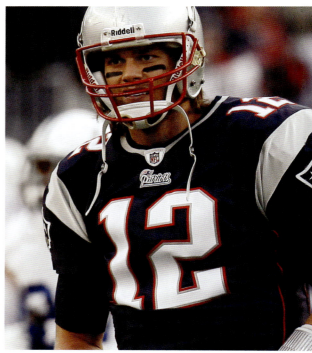

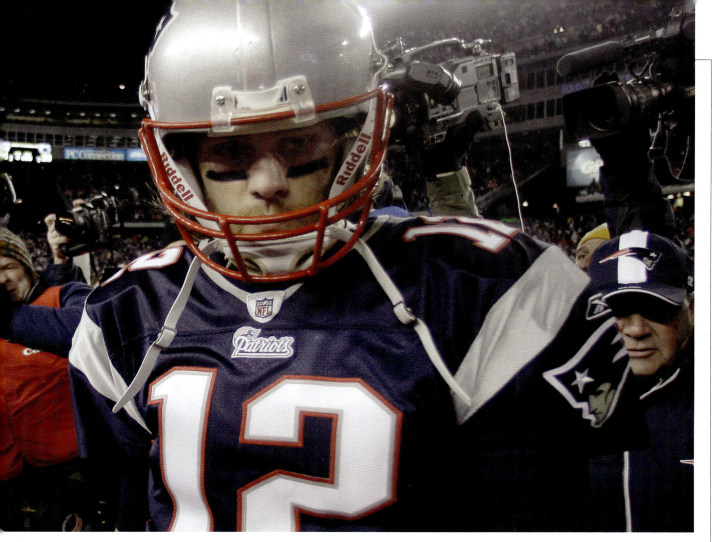

The two quarterbacks went their separate ways after the Patriots beat the Colts in 2010. "[Peyton is] similar to me in that he's never really satisfied," Brady said. "It's like, Who cares what you did last week?"

TOM BRADY 53

Among the many qualities Manning and Brady share is a desire to get out from under their images. Manning, who wants you to know he's more than an automaton, partied with Kid Rock in Nashville after a December 2003 victory over the Tennessee Titans. Brady, who wants you to know he's not a hero without faults, admitted (sort of) to a *GQ* writer last summer that he surfs the Internet for porn.

"Some of that is wanting to let people know they're human," says Pittsburgh Steelers running back Jerome Bettis, who's friendly with both players. "Peyton is like, Hey, I'm not uptight like you think. Brady's saying, I'm not this poster boy. I'm normal."

In fact, each quarterback has unabashedly spoofed himself—Manning in popular MasterCard commercials in which he turns the tables on adulatory fans, and Brady in a surprisingly deft hosting stint on *Saturday Night Live* last April. In the show's last skit Brady gets grief from Manning (played by Seth Myers) and Donovan McNabb's mother, Wilma (played by Kenan Thompson), with the Manning character citing his superior statistics as proof that he should have gotten the hosting gig.

This year, as Brady's father, Tom Sr., points out, "The funny thing is, it's a role reversal. Tommy's got all the yards [2,020 after seven games, third in the NFL], and Peyton has his team at the top of the league."

When I met Manning, in 1999, midway through his breakout second season, he was like that guy in the recent TV ad who, in his first job out of college, answers his cellphone in the elevator and hears his derelict buddies howling, "Schmitty!" Though Manning was still turning his underwear inside out to avoid doing laundry, he had already begun to mature professionally. "I've put a lot of thought into being a leader," he said then, citing, among other things, his insistence on having his locker placed amid those of his offensive linemen.

After emerging from fourth-string obscurity to earn his first of two Super Bowl MVP trophies in February 2002, Brady struck me as a man almost tormented by his exponentially growing fame: It was a blast, to be sure, but every trip on Donald Trump's jet and every beefcake photo spread separated him from the team framework that was at the heart of the Patriots' success. "There's a lot of workmanship in Tommy's approach to being a leader," says his older sister Nancy, a Boston pharmaceutical rep who once moonlighted as Tom's personal assistant. "He consciously makes sure not to put himself above the team. The locker room really is where he's most comfortable—it's probably the one place in the world where he does feel like he's one of the guys, and he finds peace in that."

Brady also put his money where his heart is: Last spring, a year after Manning had signed a seven-year, $98 million deal with Indianapolis (including a $34.5 million signing bonus), Brady agreed to a comparatively discounted six-year, $60 million extension (including a $14.5 million bonus) with New England. "What he wants more than anything is to win about eight Super Bowls," Tom Sr. says of his son, "and you can't be winning eight Super Bowls if you're taking 70 percent of the money."

PAY STUBS, PASSER RATINGS, parades in February—they're all fair game when dissecting the most dynamic duel the NFL has to offer. Choosing one quarterback above the other isn't necessarily the point, so uniquely situated is each player for his particular skills. "I'll give you Magic Johnson and Michael Jordan," says Jacksonville Jaguars linebacker Mike Peterson, who played with Manning in Indy. "Take which one you want." Adds Steelers defensive coordinator Dick LeBeau, "They're two of the very best quarterbacks ever."

"Everybody will probably always compare Tommy to Peyton," Nancy Brady says. "That's the nature of sports; it's where great debates are made." Last month, while attending a Boston Celtics–New Jersey Nets exhibition game at the Mohegan Sun Arena in Uncasville, Conn., Nancy looked across the aisle and noticed a pair of middle-aged women sitting together. One wore a Brady jersey, the other a Manning replica. "I thought it was adorable," she says.

Come Monday there won't be warm and fuzzy feelings coming from the Gillette Stadium sidelines. Bonded by circumstance and mutual appreciation as they might be, Manning and Brady know that in the games that matter, there can be no ties. ∎

FACE OFF

Who was the better QB over 17 Brady/Manning meetings?
Here's head-to-head fodder for both sides of the argument

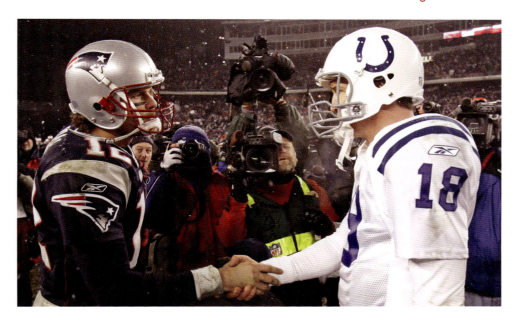

BRADY		MANNING
29.2	POINTS PER GAME	24.2
64.4	COMPLETION %	62.0
32	TOUCHDOWNS	35
15	INTERCEPTIONS	22
95.7	QB RATING	87.5
8–2	HOME RECORD	4–3
5	300-plus-YARD GAMES	9

Brady won the gridiron but not the course.
In 2020 **Manning** teamed with Tiger Woods to beat
Brady and Phil Mickelson 1-up in a charity match

Excerpted from SPORTS ILLUSTRATED
December 12, 2005

THE ULTIMATE TEAMMATE

THE SUPER BOWL RINGS ARE NICE, BUT HIS GREATEST
ACHIEVEMENT GROWS OUT OF A GENEROSITY OF SPIRIT
THAT MAKES HIM A LEADER IN THE TOUGHEST TIMES

BY
CHARLES P. PIERCE

AS IT TURNS OUT, PLATO WAS SMARTER THAN MOST FOOTBALL COACHES, maybe even smarter than Bill Belichick, with whom he at least shared an attitude toward neckties in the workplace. Anyway, back in the day, there were all these athletes running around, and jumping around, and wrestling around, and Plato looked out on all of them—Platonically, perhaps, but who knows?—and realized that every performance is an act of generosity, because of all the solitary effort it takes to make that performance possible. The generosity that begins in the rough draft blossoms in the novel. The generosity that begins in the rehearsal space blossoms on the stage. The generosity that begins on the practice field blossoms in the stadium.

Plato saw something else too. "The mere athlete," he wrote, "becomes too much of a savage." There's generosity in putting yourself through ceaseless preparation, but there must be an end product, an act of public sharing, or all the preparation is sterile. Plato did not anticipate the National Football League, but what he wrote about athletes is more conspicuously true in football than it is in any other sport. Even the best quarterback—even, say, Tom Brady, a quarterback who rose from the Mel Kiper-ish netherworld of the sixth round of the draft to lead his team to three Super Bowl championships in four years—gets to actually play only once a week. The rest of the time is repetition, a Baltimore Catechism with sweat and collisions. The rest is off-season workouts, and voluntary minicamps that aren't voluntary at all, and hours and hours of meetings. Belichick, who's coached Brady through those three Super Bowls, talks about how much he enjoyed going to prep school lacrosse practice

THE ULTIMATE TEAMMATE

Brady was the type of competitor who valued practicing with teammates. "I love seeing us get better," he said, "and I don't think you get better in games."

THE ULTIMATE TEAMMATE

because he got to, you know, play lacrosse. Nobody ever said that about football practice.

Thus is the life of any great quarterback. What makes Brady different is how vividly you can see not only the results of that work every Sunday, but also his innate ability to carry the logic of practice to the conclusion of the game. "I love seeing us get better," Brady says, "and I don't think you get better in games. The improvements come in practice." His high school teammates recall a practice dropback drill called the Five Dots, wherein the quarterback matches his steps precisely to marks on the ground, much in the way Arthur Murray once taught the clumsy how to waltz. Brady marked out a Five Dots course in his backyard and worked on it every day before school.

Even then he knew that preparation and rehearsal, the grinding work of constructing football excellence, pays off in the public performance. Sooner or later, to be complete in what you do and who you are, you have to leave the silence and walk toward the cheers. "I love it so," Brady says. "Just running out there in front of 70,000 people…." And then his voice trails off, as though he's given explanation enough.

YOU WALK TOWARD a huge stadium in Michigan that rises from the earth like a city long-buried and recently excavated. You walk toward lights that illuminate a bend in a river in Jacksonville, and those that shine over a mechanical wonder in the industrial savanna outside Houston. You walk toward a domed stadium in a city now drowned, a place that most recently appeared on television as the vestibule to a graveyard.

But you also walk to a place like this one, tucked into the ridges and hillsides south of Boston, looming above a nondescript piece of

Already a three-time champion in 2005, Brady was not above running through agility drills during practice.

THE ULTIMATE TEAMMATE

THE ULTIMATE TEAMMATE

Brady started 283 regular-season games at quarterback for the Patriots, amassing a record of 219–64–0.

THE ULTIMATE TEAMMATE

highway. And you arrive in games like this one, in which the New England Patriots, now nine months into the defense of their third world championship, play the New Orleans Saints, now two months into their first season in San Antonio. The Saints are 2–7. The Patriots, riddled with injuries, are a ragged 5–4. The match is such an obvious mutt that at least one New England television station is carrying another NFL game. The defending champions are playing an orphan game against an orphan team.

On his first drive of the game Tom Brady takes the Patriots 98 yards in 17 plays. He converts three third downs and a fourth down. On a third-and-10 he throws a deep out to tight end Ben Watson, deftly dropping the ball over Watson's inside shoulder, just past the fingertips of safety Dwight Smith. The

His generosity is not just in the ritual graciousness with which he talks about the Saints, but in the way he brought his talent to bear against them, the way he took everything he'd honed and polished in solitude and put it on display in an orphan game against an orphan team. The generosity lies in the way he gave them his best and cut them to ribbons. Joe Montana would understand. Plato would have thrown him a parade. Or at least handed him an urn.

THESE ARE THE kinds of things you must endure when you are Sports Illustrated's Sportsman of the Year, the 52nd time the award has been given, a line stretching all the way back to Roger Bannister. You've already done *60 Minutes* and *Saturday Night Live*, and here you are, being photographed in the

> [BRADY'S] GENEROSITY IS NOT JUST IN THE RITUAL GRACIOUSNESS WITH WHICH HE TALKS ABOUT THE SAINTS, BUT IN THE WAY HE BROUGHT HIS TALENT TO BEAR AGAINST THEM, THE WAY HE TOOK EVERYTHING HE'D HONED AND POLISHED IN SOLITUDE AND PUT IT ON DISPLAY IN AN ORPHAN GAME AGAINST AN ORPHAN TEAM.

touchdown comes after a play-action fake to full-back Patrick Pass, when Brady drills a pass to Deion Branch in the back of the end zone. There is great dedication in the solitary work it takes to produce this kind of lethal efficiency. But without the risk of the performance, without the willingness to share all that work through public display, the generosity would be desiccated and pointless.

The game hardly lives up to its first five minutes. The Patriots build a 24–7 lead, but their defense is ragged enough in pursuit of Saints quarterback Aaron Brooks that New England doesn't salt the game away, 24–17, until Eugene Wilson intercepts Brooks in the end zone on the last play of the game.

"I think both teams were playing hard," Brady says later. "They have a very physical defensive line. Those guys were playing hard all day. And it is a good group of linebackers."

crepuscular light of the Gillette Stadium press box, and there is also a local film crew on hand. A tiny stylist is fussing with your hair, and someone else is handling your wardrobe. You are being filmed while you are being photographed, but at least nobody has brought a goat for you to hold. "I'm telling you," Brady says to the assembled entourage, "there must have been a thousand goats there."

He is talking about the photo shoot that kicked off the 2005 season for him. Apparently under the impression that Brady had a couple of films debuting at Sundance this winter, *GQ* magazine ran a series of glossy photographs. One of them inexplicably had the quarterback carrying a goat, which is not something that ever happened to Dr. Bannister, who was not noted for his ability to juggle livestock. The overall effect was like seeing Orlando Bloom in the role of Mr. Green Jeans.

TOM BRADY | 61

THE ULTIMATE TEAMMATE

The goat photo was the subject of some hilarity at practice the day after the magazine hit the stands. Center Dan Koppen, one of Brady's best friends, his backgammon rival, and an enormously deft lineman, and offensive tackle Matt Light each wore one of the photos on his back so that, when they lined up at scrimmage, Brady was confronted by the damning evidence as he called signals. Practice broke up for a moment. Brady laughed as hard as his teammates did. What else could he do? If he were them, he'd have been doing some mocking too. There is always a price to be paid for holding a goat.

"All I wanted was the camaraderie, to share some memories with so many other guys," Brady says. "I mean, if you choose to alienate yourself or put yourself apart, you know, play tennis. Play golf."

He has defined himself, always, as part of a team, and that's carried over into this year, when his celebrity caught up with his achievement. He re-signed for considerably less money than the market might've borne so the Patriots would have maneuvering room under the salary cap. When SI's Peter King asked him about it last February, Brady said, "Is it going to make me feel any better to make an extra million? That million might be more important to the team." This isn't sports-talk-radio posturing. That's not the audience at which Brady aimed it. He was talking here to the other people in the New England locker room, none of whom will be making $60 million over the next six years, as he will.

Moreover, it was Brady who insisted that his offensive linemen be his costars in a national credit card commercial, in which the linemen sit with Brady at dinner, in full uniform, and explain to him that they are the "metaphors" for the

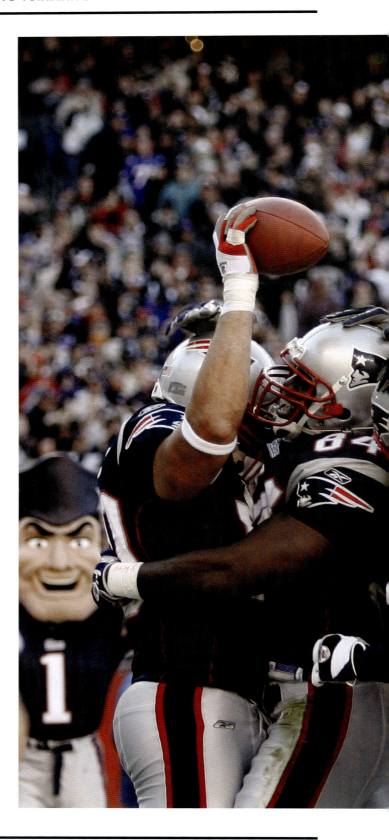

Brady always jumped at the chance to share the spotlight with his teammates.

62 SPORTS ILLUSTRATED

THE ULTIMATE TEAMMATE

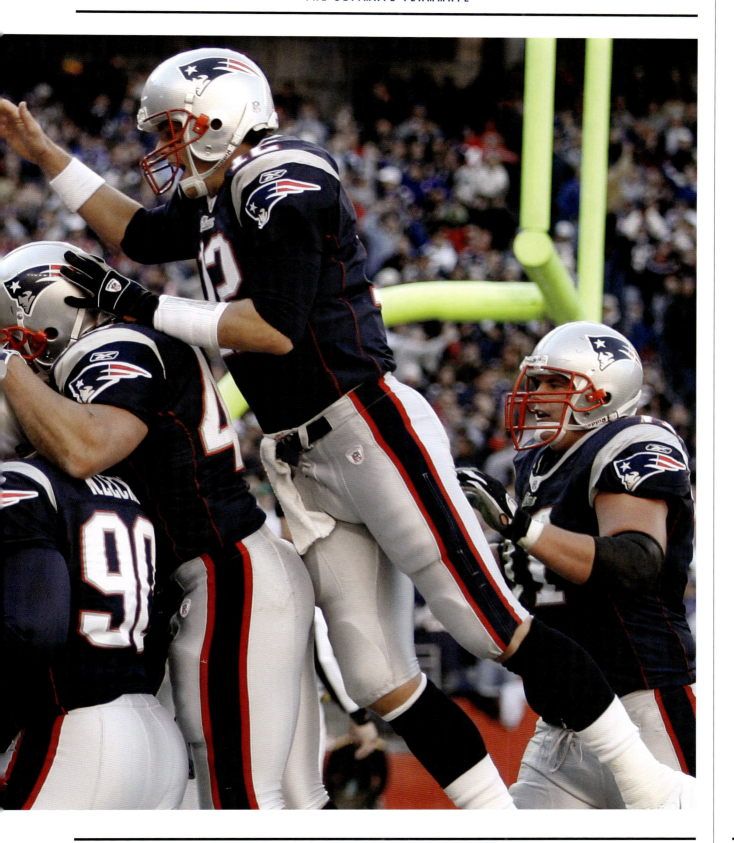

THE ULTIMATE TEAMMATE

The respect Brady won from his teammates made him a commanding presence in the huddle.

THE ULTIMATE TEAMMATE

various features of the credit card. Most critics agree that guard Russ Hochstein steals the show in the role of Fraud Protection.

"The reason for all of this [attention] is the way we've been playing," he says. "I didn't win this [Sportsman] award being Tom Brady the person. I won it because of the way we play football. There have been some great individual rewards, but there's no greater reward than winning the Super Bowl. I'm very proud of that. I look at how far we've come in five years, and it's not because I'm this great player. But I've taken advantage of the opportunities I've had. I've had so much good fortune along the way."

Brady's stardom is unique in Boston, which has never seen an athletic celebrity like this. Ted Williams hated so much about the place that he hardly counted as one of the city's own. Bill Russell never caught on for a number of reasons, quite a few of them involving race. Bobby Orr was a local star, but he played hockey, which, as has become apparent, might as well be played on Neptune. Larry Bird spent much of his time in Boston in seclusion, and much of the rest of the time in southern Indiana, which is the same thing.

But Brady has gone out on the town. At the same time, he's tried to navigate through his personal fame using the polestar of his competitive career—his love of being a teammate. For example, the podium was a big problem for him. Due to the unprecedented media crush that has resulted from his success and that of the team, the Patriots' p.r. staff planted Brady behind a podium in the Gillette Stadium media room for his weekly press conferences.

He hated it. He fidgeted. He grabbed the podium so tightly that it seemed as though his fingers would go right through the wood. Every Wednesday, Tom Brady—NFL superstar and national celebrity—stood behind that podium and looked as comfortable as a reluctant mob witness testifying his way to a new life as a greengrocer in Flagstaff, Ariz. He does the sessions at his locker now. "Some people are comfortable behind the podium, but I don't need to be the showstopper, the entertainer. I'd much rather people assume I'm one of the guys."

Brady becomes a teammate on whatever team he happens to be on. When he hosted *Saturday Night Live* in September, he threw himself into the preparations as enthusiastically as he once threw himself into the Five Dots drill in his backyard. His natural curiosity found new things to study. "He was very interested in the process [of putting the show together]," says Lorne Michaels, the creator and executive producer of *SNL*. "I found him open, thoughtful, and he certainly was game for anything. He came to play, as they say."

He will be as generous with his fame as he can be, as generous as he is with the ball on Sunday. He won't take every nickel he's due. He'll make sure wide receiver Deion Branch gets some face time on *60 Minutes*. He will put the grunts in his commercials. He will make Russ Hochstein a star. For their part, his teammates will protect him from his own ego, and from those forces outside himself that presume to fashion who he is to their own purposes. "I'm not a Boy Scout," he says. "I'm still maturing, and I make plenty of mistakes. Too many times, people paint a picture of me as a guy who always has a big smile on his face, and who's happy-go-lucky and never has a bad day, and that's not me. I'm [like] every other guy."

His teammates will help keep him humble, and will help keep the rest of the world honest. This ability to engage others in a common enterprise is what makes political consultants look at Tom Brady and feel a warm glow deep in their godless souls.

Paradoxically, the Patriots have come to depend on Brady more this season than ever before. The defense is far weaker than it was a year ago, particularly in the secondary. And the offense has been hit with a staggering number of injuries. Since a win over Oakland in the opener, New England has lost for substantial periods of time two of its top three running backs, two of its top three wide receivers and its starting tight end. In addition, four of the five metaphors up front have been lost, including Koppen, whose season ended when he separated his shoulder against Miami on Nov. 13.

As a result, with both his running game and his line decimated, Brady is putting up historic passing numbers. As of the first week in December, he has

TOM BRADY | 65

264 completions for 3,301 yards and 18 touchdowns. He's having the kind of season that Peyton Manning used to have with the Colts, the kind of season that was never enough to get Indianapolis to the Super Bowl, the kind of season that was never enough to beat Tom Brady.

And when he has a bad day, as he did on Nov. 27, when his four interceptions contributed mightily to an ugly loss at Kansas City, there is not much to the New England Patriots at all.

"Oh, man," Brady sighed the next day. "That was a killer. We didn't play the way we're capable of playing. It's not fun when you throw four picks. It's like getting kicked in the stomach, and it doesn't go away for three days. Losing a game like that, you're heartbroken, tearing up on the plane ride back. You let yourself down. You let your teammates down. You let a whole lot of people down. It's not something you get over easily."

He is having an MVP season, but his team is struggling. You get the feeling that he likely doesn't have his own vote.

MIKE RILEY KNEW, but nobody ever listened. There he was, USC's offensive coordinator, dragging himself north from Los Angeles to San Mateo to watch a skinny kid who could throw the deep out with guts and precision and who seemed to think one step ahead of everyone else on the field. Riley couldn't get anyone to listen. USC coach John Robinson had two quarterbacks and didn't need another one. The kid went east to Ann Arbor to play for Michigan.

Five years later, in the spring of 2000, Riley's coaching the San Diego Chargers and he tries to get general manager Bobby Beathard interested in the same player, who led Michigan back from 14 points down twice to beat Alabama 35–34 in the Orange Bowl. Beathard was no more interested than Robinson had been.

A year after that, Riley stands on the San Diego sideline and watches Brady, in his second start as a professional, bring New England back from 10 points behind with less than eight minutes to go and beat the Chargers in overtime, sending the San Diego season into a spiral and sending New England

on to its improbable Super Bowl win over the St. Louis Rams. Mike Riley, Cassandra with a whistle, caught up with Brady at midfield.

"We kind of laughed about it," says Riley, now Oregon State's coach. "We found our history together kind of funny."

By now the story of Brady's apprenticeship is well-worn. At Michigan, first there were Scott Dreisbach and Brian Griese, and then there was Drew Henson, a two-sport star who stepped in line ahead of Brady when, by all rights, the quarterback job should have been his. Michigan coach Lloyd Carr decided to split the job between Brady and Henson. "I don't think either one of them was happy with it," Carr recalls. "Tom, as a captain and a fifth-year senior, clearly, it was tougher on him."

This was a point at which Brady could have gone nuclear and taken the team down with him. He was being denied a job he had every right to believe he'd earned. "There's no question," says Mike DeBord, Michigan's recruiting coordinator, "he could've blown up the team." Instead, he hunkered down and eventually won the starting job back from Henson.

When the Patriots took him in the sixth round of the 2000 draft, there was another Drew in his way. New England had committed to Drew Bledsoe for the long term, but Brady's ability to spread the ball around, to move in the pocket and to move the chains pushed him up the depth chart until New York Jets linebacker Mo Lewis sheared a blood vessel in Bledsoe's chest with an explosive hit in the second game of the season, and Brady took over the job he has never given up.

Perhaps the iconic moment of that season came at the very end of it, after the Patriots' Super Bowl win over the heavily favored the Rams. Brady, transported by what the team had done, at what he had done, grabbed Bledsoe in a ferocious embrace, but Bledsoe's face was such a poignant mask of rueful perplexity that the two men seemed to be touching each other from different emotional dimensions. There was an arrival and a departure contained in that moment. Brady quickly turned away from the awkward embrace and put both hands on his head and smiled, his happiness reaching out to all the dark and distant corners of the Superdome,

THE ULTIMATE TEAMMATE

enveloping all his teammates, even the one who had to be left behind.

ADAM VINATIERI IS not one of the metaphors, but no player has benefited more from Tom Brady's generosity, nor has anyone—other than Brady himself—played a bigger role in Brady's success. It was Vinatieri's kicks that provided the winning margin in all three Super Bowls. And it is Brady's command of the final moments of a game that may one day enable Vinatieri to enter the Pro Football Hall of Fame. Just this season, Vinatieri has won games in the waning moments against both Pittsburgh and Atlanta after Brady moved the offense to get him into position. There has not been a relationship so mutually beneficial to a kicker and a quarterback since the last time George Blanda practiced alone.

a cold Sunday. The fake scoreboard running down the way the real one will, one day, in Pittsburgh or Atlanta, in Indianapolis or Foxborough, when the night begins to fall and the kicking team jogs onto the field one last time.

"He always gives us a shot," Vinatieri says.

Great careers are formed by such moments, and such intimate intertwinings of teammates and identities. The arc of Brady's career was shaped by his own hands, but also by offensive tackles and weakside linebackers, and a placekicker too.

The very best among us, like Brady, instinctively see the Platonic arc of it, and where it must lead. He has always known that solitary practice is only worth it if it leads to something that can be shared, with teammates, first, and then with the world, on the biggest stages, in the loudest arenas. "The

> THE VERY BEST AMONG US, LIKE BRADY, INSTINCTIVELY SEE THE PLATONIC ARC OF IT, AND WHERE IT MUST LEAD. HE HAS ALWAYS KNOWN THAT SOLITARY PRACTICE IS ONLY WORTH IT IF IT LEADS TO SOMETHING THAT CAN BE SHARED, WITH TEAMMATES, FIRST, AND THEN WITH THE WORLD, ON THE BIGGEST STAGES, IN THE LOUDEST ARENAS.

These two men are defined—together—by their first two Super Bowls. On both occasions Brady led a drive that gave Vinatieri a chance to win the game with a field goal, thereby making it possible for Vinatieri to build a reputation as the greatest clutch kicker in the history of the NFL. Brady's résumé, of course, would be considerably less gaudy if Vinatieri had shanked those kicks. That reciprocity is where true generosity flowers. Those moments were forged in the grind of practice, when everyone goes off and plays only pieces of the game. All those deep out-patterns, thrown over and over again after practice on Wednesday so that they will be able to keep the clock alive on

perfect game's got to be for the highest stakes," Brady says, "and it's got to come down to the end. You don't remember the ones you win 35–12. You remember the ones you win 38–35, the dogfights. Those are the ones that are memorable. Who wants everything to come easily?"

Plato knew that the generosity of athletics can take you off the goat paths and onto a higher road. But only if you are willing to leave the solitude and walk toward the crowd. Leave the silence and walk toward the cheers. Leave the shadows and walk toward the brightest lights you can see.

And bring some metaphors along, just to be on the safe side. ∎

TOM BRADY

Excerpted from SPORTS ILLUSTRATED
June 1, 2009

TOM BRADY IS BACK

EXUDING CONFIDENCE IN HIS SURGICALLY REBUILT LEFT KNEE,
THE PATRIOTS' TOM BRADY IS SO ANXIOUS TO PLAY AGAIN THAT
HE LOOKS FORWARD TO THE GRIND OF TWO-A-DAYS

BY
PETER KING

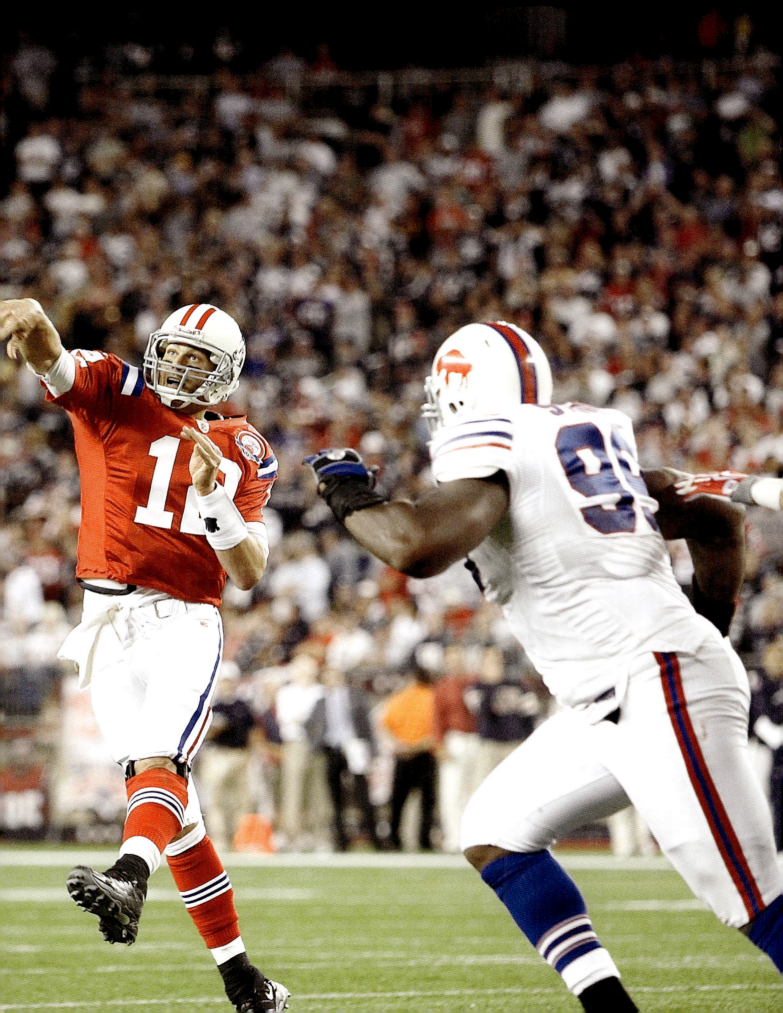

TOM BRADY IS BACK

FOR ONE MORNING LAST WEEK THE FIELD HOUSE NEXT TO GILLETTE STADIUM WAS TOM BRADY'S PERSONAL PLAYGROUND. Joining the 31-year-old quarterback were the four receivers he hopes will be on the field with him for the Patriots' first series of the 2009 season, on Sept. 14 against the Bills. Brady split Randy Moss and Joey Galloway outside the numbers and lined up Wes Welker and Greg Lewis in the slots, then they jogged through some of the new pass plays that New England will be installing in training camp. It had been 32 weeks since Brady's left knee was surgically reconstructed, and he moved straight ahead, laterally and backward with no pain. No one brought up the injury. Brady didn't stop to think, *Hey, my knee feels great.* They just worked through the routes, and Brady wondered, *When we run this play against Buffalo, how will the defense respond?*

"Come on!" Moss said before Brady called the last of the 25 or so plays they ran. "Make this a hard one!"

Moss likes to be challenged, and he's one of the best in the game at reading his quarterback's subtle signals. Moss showed that in the fourth quarter of Super Bowl XLII when, after seeing a simple nod from Brady, he adjusted his route, cut inside the cornerback and caught a six-yard touchdown pass to put the Patriots up 14–10 over the Giants. This time Brady called one of the new plays with a hand signal; to further test Moss, he quick-snapped and backpedaled, seeing if his receivers would figure out what to do.

Moss guessed wrong, walking off the line of scrimmage confused. "What are you doing?" Brady yelled.

"I don't know," Moss said. "What [play] is it?"

Brady called out the name, then said, triumphantly, "I'm going home! I got Moss today! *I got you!*"

Even Moss had to laugh.

THIS WEEK, WHEN New England starts full-roster organized training activities (OTAs), Brady will step into the huddle with the entire offense for the first time since he tore his left anterior cruciate ligament and

Brady and Randy Moss connected for 40 total touchdowns as Patriots teammates.

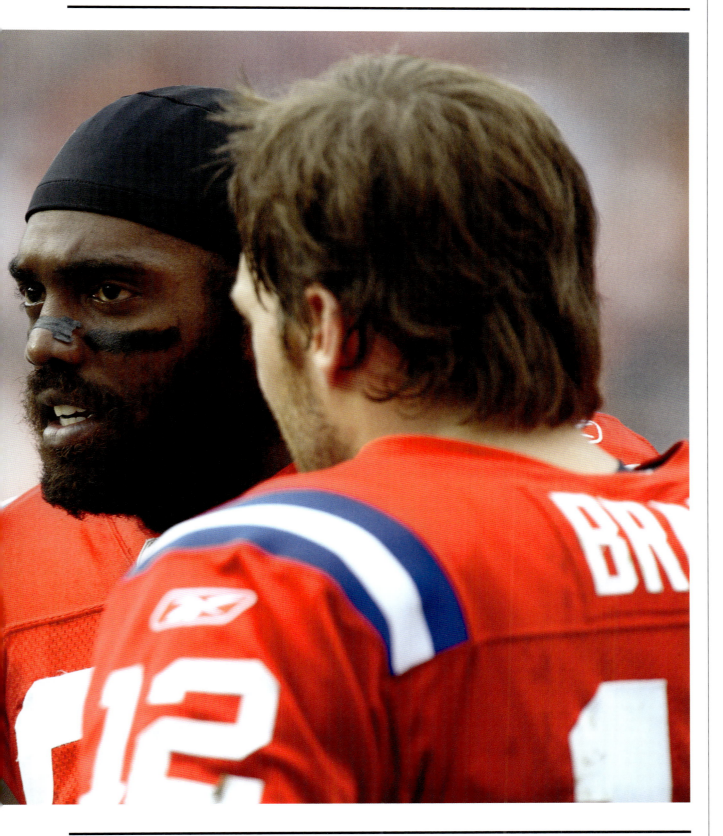

medial collateral ligament in the 2008 season opener. (Last week's sessions were for rookies, free agents and select veterans returning from injury, with Brady and his top receivers working in seclusion.) The quarterback acts and sounds as if he wished the Buffalo game were tomorrow. In his first extended interview since he got hurt, Brady told SI that his recovery is on schedule, he's running and cutting without pain or restricted movement, and he has no ill effects from two follow-up procedures to flush out a postop staph infection in the knee. In fact, calling the last eight months "the halftime of my career," Brady said, "I want to play another 10 years."

He was convincing when he said he was "as confident as anyone could be that I'll be ready to play, back to playing normally, when the seasons starts. I've done everything I could to push myself, sometimes too hard. Right now, I'm doing everything. Literally everything. There's nothing I can't do."

With his voice rising as he leaned forward in his chair, Brady said that playing 10 more seasons "is a big goal of mine, a very big goal. I want to play until I'm 41. And if I get to that point and still feel good, I'll *keep* playing. I mean, what the hell else am I going to do? I don't like anything else.

"People say, 'What will you do if you don't play football?' Why would I even think of doing anything else? What would I do instead of run out in front of 80,000 people and command 52 guys and be around guys I consider brothers and be one of the real gladiators? Why would I ever want to do anything else? It's so hard to think of anything that would match what I do: Fly to the moon? Jump out of planes? Bungee-jump off cliffs? None of that s--- matters to me. I want to play this game I love, be with my wife and son, and enjoy life."

Impassioned, fiery, a little defiant—it was a side of Tom Brady the public hasn't often seen. Truth is, the public hasn't seen much of Brady at all since the injury, save for the few images taken with the long telephoto lenses of the paparazzi—sharing an ice cream cone in Brazil with his new wife, supermodel Gisele Bündchen; strolling on the beach with his toddler son, Jack; golfing with the *Entourage* cast; catching a Celtics playoff game with Bündchen.

Brady has jealously guarded his privacy; and those close to him, including coach Bill Belichick and the rest of the Patriots staff, have helped him do so.

Last week, though, he finally opened up about what his life has been like since Sept. 7, when the helmet of Chiefs safety Bernard Pollard smashed into his knee on New England's 15th snap of last season. (Kansas City was blitzing; the hit appeared accidental and was not flagged by the officials.) Brady said he never felt anger toward Pollard ("It's football— there's no way he owes me an explanation") or bitterness over his first major injury. But he did admit to feeling "pretty empty" as he was being helped to the sideline. "You go down, they take you off the field, the ref blows the whistle, the 25-second clock starts, and they play the game without you," Brady said. "You're like, Wow. That's really what it's like. They play without you."

TO PERFORM THE operation, Brady chose a friend, orthopedic surgeon Neal S. ElAttrache in Los Angeles, reportedly against the wishes of the Patriots' medical staff; last week Brady said his choice had the full support of Belichick and team owner Robert Kraft. Two days after the Oct. 6 surgery, he defied Bündchen's pleas and his doctor's orders to stay off the leg by putting Jack on his shoulder and moving around the hospital room, playing with him. A hematoma developed in the knee, and the staph infection ensued.

"I wanted to prove I could move around and get ahead of schedule," Brady recalled, "and nothing was going to stop me. Unfortunately I did too much too soon. I was responsible for the infection. In a way it

TOM BRADY IS BACK

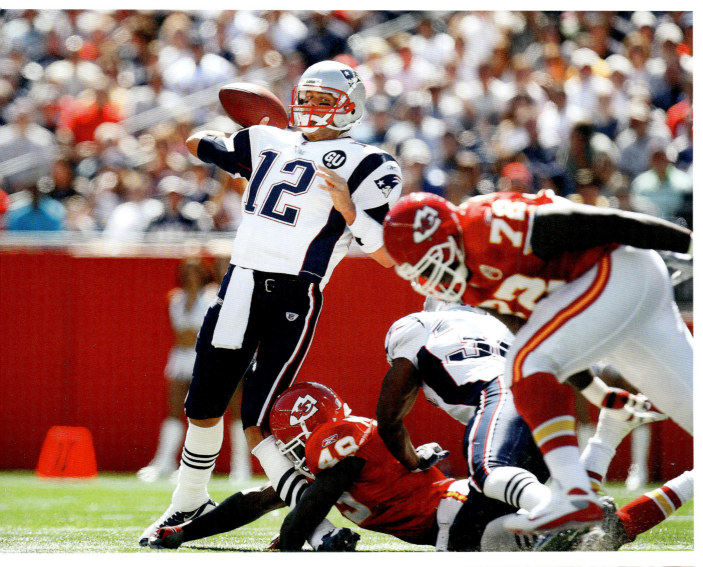

Chiefs safety Bernard Pollard crashed into Brady's knee in Week 1 of the 2008 season. The injury to the quarterback's ACL cost him the entire season.

"I want to play another 10 years," Brady said in 2009. "Why would I even think of doing anything else?"

was probably good for me—it slowed me down a little bit."

Since the two procedures to clear the infection, Brady said he's had no problems with the knee and denied a December report that he was in danger of having to undergo a second major surgery because of the two staph cleanups. He returned to Foxborough last November, commenced daily rehab at the Patriots' facility and was soon throwing a football. For the rest of the NFL season he stayed out of the public eye, watching games at his home in Boston's Back Bay. "Coach Belichick didn't want me on the sidelines for the game," Brady said. "He told me, 'Every time we'd throw an incompletion the camera would go to you on the sideline, and we don't need that.' And I didn't want to watch from a [luxury] box."

By the end of December, Brady was able to run and cut pretty well. Back at his home in Southern California, he woke up on Super Bowl Sunday, five months after the injury, and his thought was: *I'm going to play some football*. He called ElAttrache and a few other buddies, and before the Cardinals and the Steelers played for the NFL championship 2,200 miles away in Tampa, Brady threw and caught with his friends on a field at UCLA. "Running, jumping, throwing—it felt so good," Brady said. "Throwing never was a problem. I've really felt comfortable throwing since two months after surgery."

Brady said he learned much about himself during his forced layoff. "When I was playing every week, I bitched about the little things," he said. "Like, God, we've got to go outside today? It's raining! Or, why is Bill dunking the ball in soap? Or, why do we have a meeting at 7:30 to talk about everything we've already talked about. Geez!

"Then, when you're not playing, you realize you would [gladly] do any of that—whatever they wanted me to do. I saw the guys in the locker room, mid-November; I was doing rehab, and they were at the point of the season when things had slowed down, and they were bitching. I said, 'Come on, guys! It's football!' Mentally, they needed a break, but I said, 'Quit complaining!'"

Brady drew an analogy based on his parenting experience with 21-month-old Jack. "I don't see

him every day"—Brady shares custody with former girlfriend Bridget Moynahan—"and we play when I change his diaper: lifting his leg up, playing with his toes, biting his feet. There's this different appreciation. If you had him every day, you'd go, Let's just get this done. But when you get him, say, one week a month, you're like, This is so cool!

"So, this year if I hear [the Pats have] two-a-day practices? Great! Let's have three. Whatever you say, Coach. You need something from the players? Let me know, and I'll do what I can to get the players to do it."

BRADY AND BÜNDCHEN were quietly married on Feb. 26 in Santa Monica, Calif. On April 4 they held a larger ceremony for family and friends at a secluded beachfront in Costa Rica. Not surprisingly, snooping photographers also showed up. Two claimed that bodyguards for Brady and Bundchen shot at their car. "Absolute total b.s.," Brady said last week. "We found two guys on our property, and we told them to get out. Our security guys didn't even have guns. There were no shots fired."

Back in Boston now, Brady says he and Bündchen aren't harassed as much by paparazzi as elsewhere. They can move around fairly freely and can take Jack to a nearby park, where they encounter only the occasional autograph-seeker. Better yet, Brady's able to get back into the routine of the off-season, the annual buildup to another run at the Super Bowl. "I'll tell you what I'm looking forward to—practice," he said. "Screw the games; they'll take care of themselves. I want to be out there with my guys. I'm so anxious to get out there and practice."

He's thrown to Moss and Welker a dozen or so times in the last few months. "He's got me running all over the field," Welker said last Friday. "Once or twice I've been like, 'Hey, Tom, we just had a pretty long season. Let's take some baby steps here.' But he doesn't want to hear that. When you're on the field with him, you're out there *playing*."

Asked how Brady was moving, if he was struggling at all, Welker said, "Nope"—then chuckled—"he looks like the same slow guy he was before.

"Just wait, you'll see. He's the same guy." ∎

Excerpted from SPORTS ILLUSTRATED
January 9, 2012

TOM BRADY AS YOU FORGOT HIM

BEFORE HE BECAME THE PREMIER POSTSEASON PERFORMER OF HIS GENERATION,
THE PATRIOTS ICON WAS A MIDDLING COLLEGE QUARTERBACK WHO
INVITED SKEPTICISM, EVEN SCORN, FROM FANS AND HIS COACHES.
THAT WAS ALL—AND THAT WAS EVERYTHING

BY
MICHAEL ROSENBERG

THE ROAR COULD MEAN ONLY ONE THING: Tom Brady was no longer their quarterback.

On the afternoon of Sept. 12, 1998, the 111,012 fans at Michigan Stadium did not know what you know now. Even his closest friends dared not imagine that Brady, a skinny, slow, fourth-year junior, was destined for an NFL career that would include three Super Bowl victories and two MVP awards. Michigan fans just knew that their team was trailing Donovan McNabb and Syracuse in the second quarter 17–0, and that Brady was heading to the bench, replaced by freshman Drew Henson.

In the stands Brady's sisters, Maureen, Julie and Nancy, cried, more in anger than sadness. In the huddle Henson was uncomfortable. He hadn't done anything; his team was in a huge hole; and

he was being welcomed as a hero. It was Henson, not Brady, who was considered a once-in-a-lifetime athlete. At Brighton High, 20 minutes north of Ann Arbor, Henson had set national records for home runs (70), grand slams (10) and RBIs (290), all while bringing 93-mph heat on the mound. He had also thrown 52 touchdown passes in three seasons. *USA Today* named him first-team All-America—as a punter.

Henson's father, Dan, a longtime college football coach, tilted the playing field so every ball rolled toward Drew. The Hensons deftly played college football programs against major league teams to maximize their leverage, and it worked. The Yankees had drafted Drew in the third round and given him $2 million to be a part-time minor league third baseman. Meanwhile Dan told recruiters that if they wanted Drew, they could not sign a quarterback in

the class ahead of him, and Michigan coach Lloyd Carr obliged. When the 6'4", 210-pound Drew started practicing with the Wolverines, Carr told the media that "without question, he's the most talented quarterback that I've been around."

Brady, by contrast, looked like an ordinary Big Ten QB—average arm strength, limited mobility. He was a California kid who cranked the heat in his Ann Arbor apartment so high all winter that friends didn't even want to walk inside. He had been trapped in depth-chart hell for three years and nearly transferred before attrition finally provided him a chance. In his battle with Brady, Henson appeared to have every advantage. And that is why Brady would succeed.

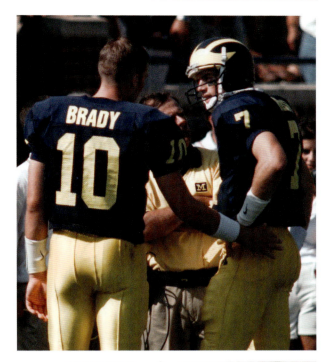

RIGHT Brady battled with Drew Henson for playing time at Michigan. **BELOW** After starting his career seventh on the Wolverines depth chart, Brady ultimately started every game of the 1998 and 1999 seasons.

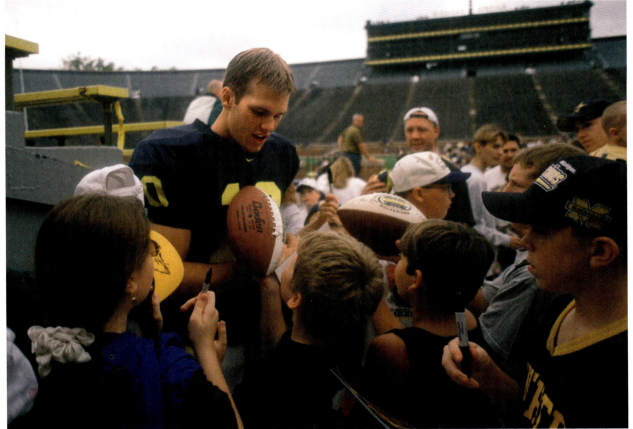

TOM BRADY AS YOU FORGOT HIM

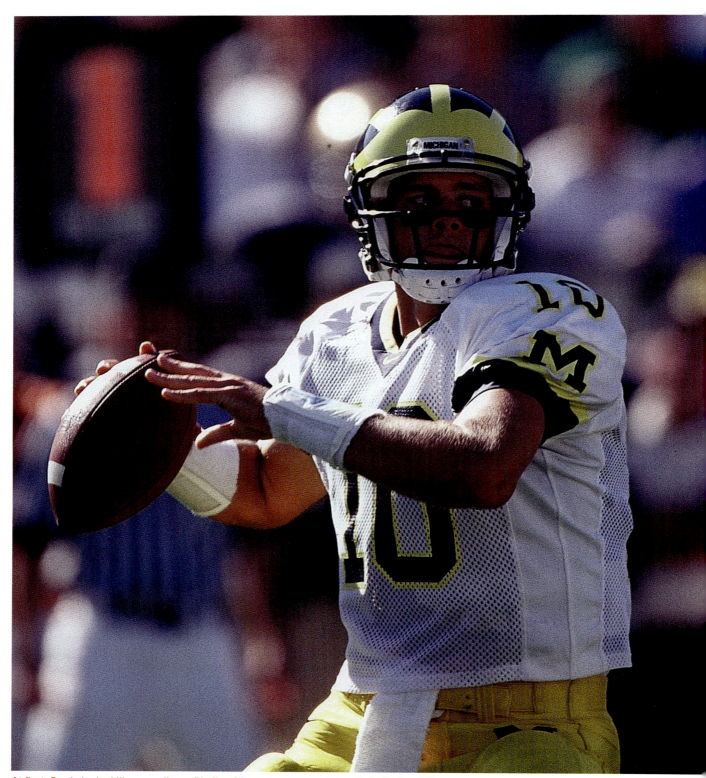

At first, Brady looked like an ordinary Big Ten QB—average arm strength, limited mobility.

TOM BRADY AS YOU FORGOT HIM

THE STORY OF Tom Brady's college career has been retold and refined so often that most of the necessary context has been lost. Most football fans know the gist: It wasn't until late in his college career that people began to form a picture of how good he would be. That included the Wolverines' coaches, who insisted that he compete with Henson for much of the two years they spent together, and NFL front offices, who allowed Brady to slip to the 199th pick.

His son's time at Ann Arbor still irks Tom Brady Sr. "It's a pretty sore spot, to be honest with you," the elder Brady told SI. "He wasn't treated very kindly by the head coach." Even Carr admits, "He had some really difficult challenges because of the position that I put him in."

But if you look at only the bones of the story,

gotta go out and worry about the way you play. Not the way the guys ahead of you are playing, not the way your running back is playing and not the way your receiver ran the route.'"

Carr didn't promise Brady anything. In fact, the only promise to come out of the meeting was from Brady: "I'm gonna prove to you that I'm a great quarterback."

"That was a recommitment to the marriage," Tom Sr. says. In the younger Brady's mind, he had forfeited the right to complain.

Still, there would be, a year later, the issue of Henson.

"Drew Henson was special," says Temple offensive coordinator Scot Loeffler, a former Michigan quarterback, a longtime quarterbacks coach and one

THE BRADY EVERYBODY SEES TODAY GREW FROM THE BRADY NOBODY BELIEVED IN AT MICHIGAN. IN ANN ARBOR HE DEVELOPED HIS STEEL FAITH IN HIS ABILITY, AND A CAPACITY TO IGNORE DETRACTORS.

you miss the heart of it. You don't recollect Brady in 1998, after that 38–28 loss to Syracuse—a struggling quarterback for an 0–2 team, hanging on to his job by a frayed thread. Many of Michigan's staunchest fans thought he should be benched. Friends today say the lack of support bothered Brady intensely.

But Brady was stuck. Early in the previous season, after Carr had chosen Brian Griese as the starter—a move that would pay off with the school's first national title in 49 years—Brady told the coach he might transfer. Carr asked Brady what his father thought, and Brady said his dad would support whatever he did.

Carr did not beg him to stay. Instead, he told Brady to stop harping on how many reps he got or whether the coaches liked him. "He said, 'You know, Tommy, you've gotta worry about yourself,'" Brady would recall of his conversation with Carr. "'You've

of Brady's best friends. "He was a freak of nature in my opinion. He had remarkable talent. *Unbelievable* talent."

Greg Harden, a longtime employee of the football program who advises and counsels Michigan players, says Henson was like Superman, Brady like Batman. Batman doesn't have any superpowers, but as Harden says, "Batman believes he can whip Superman's ass."

Brady's resolve stiffened. He went to Schembechler Hall, the team's football facility, almost every night to watch extra film. He soaked up everything: schemes, opposing players' tendencies, the minds of Michigan's defensive coaches. Slowly, a different quarterback emerged. Brady recognized defenses before the ball was snapped. He knew which receivers would be open and, in what would become his hallmark, became unshakable in the pocket, able to maintain both his concentration and his accuracy

when he was about to get hit. On the bus after games Brady could go through every incompletion in order and tell his teammates what went awry: wrong route, wrong read, bad throw, missed block. He had not yet watched film.

After that 0–2 start, Brady rallied Michigan to eight straight wins. But Carr mostly remembers a 31–16 loss to Ohio State in the regular-season finale. Brady was sacked seven times and drilled on several others. Yet he completed 31 of 56 passes, and Carr realized that with the biggest, fastest Buckeyes homing in on him, Brady never looked down.

And still, Superman lurked over Batman's shoulder.

THE FOLLOWING SUMMER, Henson, the man chasing Brady, wasn't even in Ann Arbor. He spent the spring and summer of 1999 playing third base for the Yankees' Class A team in Tampa, but his natural talent was so outlandish that when he returned to campus in August, he competed evenly with Brady.

That summer, Dan Henson attended every practice. When the season began, Carr told Dan his presence at practices could be a distraction and asked him to stay away. He did … sort of. People within the program would see Dan sitting on an embankment underneath a bridge on Stadium Boulevard, watching practice.

Before the opener, Carr made a decision: Brady would start; Henson would play the second quarter; at halftime the coaches would pick which one would finish the game. Brady couldn't complain to his teammates, who had voted him captain. He

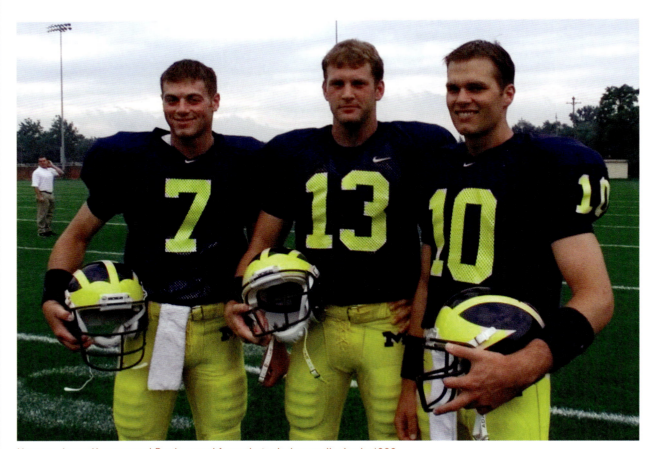

Henson, Jason Kapsner and Brady posed for a photo during media day in 1999.

TOM BRADY AS YOU FORGOT HIM

couldn't complain to his parents, who had let him make his own decisions—including the one to stay at Michigan—and expected him to live with them. He could only compete.

Brady earned the second-half nod in four of the first five games, and Michigan won all five. Asked about the unusual platoon system, he endorsed it: "It's working great for us."

He may not have realized it, but Brady was turning Carr into a believer. The coach had primarily valued arm strength and athleticism in his passers—"If you went to a coaching clinic where coaches are talking about quarterback play, you didn't hear about accuracy," he told SI—but Griese and then Brady convinced him of the importance of throwing precisely to a target. And concerns about Brady's arm strength were largely misguided. Wolverines tight end Aaron Shea says that

In November, Brady threw three interceptions against Penn State as Michigan fell behind 27–17 in the fourth quarter. He was also sacked six times, and receiver David Terrell remembers coming back to the huddle and saying to his quarterback, "'Damn, bro!' … He had a bloody face." Brady responded, "DT, just do your job." Brady did his, leading the Wolverines to a 31–27 win. He told reporters afterward, in his high-pitched voice, "I knew we weren't going to lose this game."

At the team banquet in December, Brady cracked that his parents had graduated from "the University of Northwest Airlines" after traveling to almost every game for five years. But Tom Sr. and his wife, Galynn, had a policy: "We shut our mouths." They had never attended practice or called Carr. Their son had chosen Michigan twice—once as a high school

MOST FOOTBALL FANS KNOW THE GIST:

IT WASN'T UNTIL LATE IN HIS COLLEGE CAREER THAT PEOPLE

BEGAN TO FORM A PICTURE OF HOW GOOD HE WOULD BE.

because Brady put the proper touch on his passes, he rarely threw as hard as he could.

In Michigan's sixth game, at Michigan State, the quarterback platoon fell apart. Carr chose Henson for the second half, and the offense stalled. The coach switched back to Brady, who led a spirited comeback; it fell short but was another indication of who he would become. Brady had always been impressive running the two-minute drills at the end of practice. Now he was executing when it counted.

The Wolverines lost their next game, to Illinois, when the defense blew a 20-point second-half lead. But Carr had seen enough. Brady was his quarterback.

Brady had vanquished Henson, but the two had also become friends. When Brady would break down the upcoming draft class for Henson: *I'm better than him … better than him…. He's O.K…. I like him.*

senior, and again when he thought about transferring before his junior season. Tom Sr. says, "He had to own it."

After leading the Wolverines to a 9–2 record, Brady finished his college career against Southeastern Conference champion Alabama in the Orange Bowl. As the team gathered for Christmas Eve dinner in Miami, Brady announced, "I'm gonna have dinner with the young pups tonight." He sat with the freshmen, who were away from their families for the holidays for the first time. A week later Brady completed 34 of 46 passes for 369 yards and four touchdowns to beat Alabama 35–34. The next morning, as Carr met with reporters at the team hotel, Brady walked into the room, grabbed something off a breakfast buffet, waved and walked out without saying a word. He was 22 years old and sure of where he was headed.

TOM BRADY AS YOU FORGOT HIM

A FEW YEARS ago Tom Brady Sr. walked into his son's Boston condo and was shocked. "His foot's been hanging from the ceiling, and he's got a [soft] cast on his leg," he recalls. When his son removed the cast, Tom Sr. saw "blood from groin to his ankle." Brady had never told his parents he was hurt. He never does. Tom Sr. figured the injury meant they could not go out to dinner that night. But of course they went, and of course Brady played that week.

The Brady everybody sees today grew from the Brady nobody believed in at Michigan. In Ann Arbor he developed his steel faith in his ability, and a capacity to ignore detractors. He learned that fan adulation was too elusive to chase; he focused instead on winning over his teammates.

The San Mateo, Calif., kid became one of the best cold-weather quarterbacks ever. Many college stars must adjust to the harsh NFL ecosystem, but after fighting for his job for two years at Michigan, Brady was ready. The battle with Henson no longer defines Brady's career, but it helped define who he is.

"He always believes there is someone behind him that is going to take his job," Loeffler says. "He approaches the game like he just got drafted in the sixth round."

When Brady's parents express alarm about anything, as parents do, Tom Jr. always tells them, "Everything is going to be fine."

Tom Sr. still harbors hard feelings about how his son was treated at Michigan, but that anger has limits. He had wanted his son to go to Cal, 35 miles from the family's home, but says if that had happened, "he would not have accomplished near what he has accomplished." He is glad his son went to Michigan. "He became a man there," Tom Sr. says. "When you become a man, that means you get slapped around a little bit."

When Carr retired, in 2007, the younger Brady sent him a handwritten note thanking him for his help. Tom Sr. was surprised when an SI reporter told him about that. But then he said of his only son, "I have never heard him say anything other than glowing comments about his Michigan experience. I've never heard Tommy ever once criticize Lloyd."

EVERY UNDERDOG STORY needs an overdog, and that is Drew Henson's role, now and forever: the much-hyped prospect who stood in the way of the great Tom Brady, then faded out of sight. Henson left Michigan after his junior year to play full time for the Yankees. He got one major league hit, a single, before returning to football in 2004. In his one NFL start, for the Cowboys, he threw 18 passes, then was released in '06; he threw two passes with the Lions in '08, before being cut the following season. But those are just the bones of his story.

Henson led Michigan to a share of the Big Ten title as a junior, and he finished his career with a higher college passer rating (135.5) than Brady's (134.9). He surely would have been a top 10 NFL pick the next spring. But Henson chose baseball.

The Yankees promoted him to Triple A before he was ready—they assumed that he was gifted enough to make up for lost time. Before the 2002 season, *Baseball America* ranked him as the No. 9 prospect, but Henson pressed in the minor leagues because he wanted to justify his decision to leave school.

NFL scouts never forgot about him, and when Henson kept striking out, he gave up baseball to play for another iconic American team. Dallas saw him as a potential franchise quarterback. But Henson hadn't been a football player in four years, and he had *never* been a full-time football player. He said it took him more than a year to get some of his football skills back.

"I reached the level I did as a football and baseball player really being a 50 percent athlete my whole life," says Henson. "It all works until you get to the very highest level of sports, when everybody is basically as good as you or better, but has more experience or is farther along the development line than you are, and you have to play catch-up."

He wishes he had stayed at Michigan for four years, then committed to one sport for good. But his choices were not entirely his. Drew remains on good terms with Dan, but the son says, "If I'm fortunate enough to be a parent someday, I won't try to control every situation that my child may be put into as an athlete—not try to dictate every time line or micromanage every aspect of the child's development."

TOM BRADY AS YOU FORGOT HIM

Henson is retired and living in the Dallas area, doing part-time broadcast work for ESPN and holding a stake in a money-management firm. Brady is leading New England into the playoffs for the ninth time in his 12 seasons. In the popular telling, this means Brady won. To Henson, they stopped competing long ago.

"People always try to make it out like you're not pulling for the guy," Henson says, and this bothers him because to this day, he pulls for Brady. Everybody from those Michigan days does because they remember when the seeds of a legend were planted. They were there, before the NFL found Brady, when Brady found himself. ∎

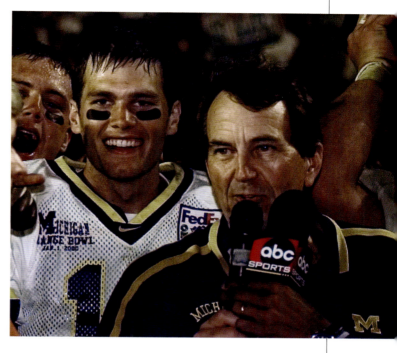

RIGHT Brady with coach Lloyd Carr after beating Alabama 35–34 in 2000. **BELOW** Brady greeted Carr warmly before a game in Cleveland in 2010.

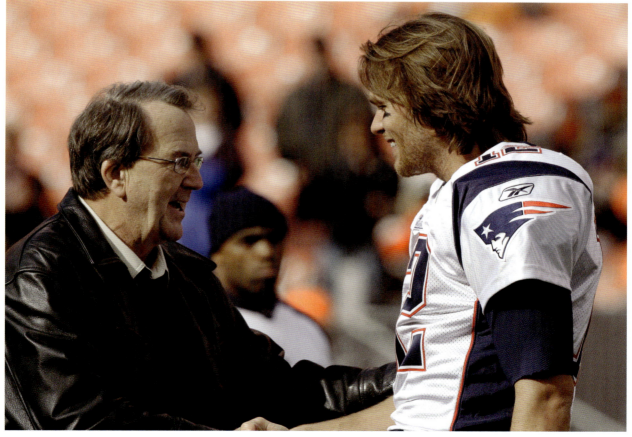

Excerpted from SPORTS ILLUSTRATED
February 9, 2015

DEFLATED TO ELATED

THE LEAD-UP TO PATRIOTS-SEAHAWKS DEFIED LOGIC (AND MAYBE SCIENCE). THE GAME ITSELF REVERSED THE LAWS OF PROBABILITY (AND MAYBE PLAY-CALLING). BUT AFTER AN INSTANT-CLASSIC WIN, THIS MUCH CAN'T BE QUESTIONED: THE PLACE TOM BRADY AND THE PATS HOLD IN HISTORY

BY
GREG BISHOP

DEEP INSIDE THE SHERATON WILD HORSE PASS IN CHANDLER, ARIZ.—past the hundreds of revelers, the open bars and the buffet stocked with beef taquitos—a smaller, quieter Patriots party carries on well into Monday morning. This is the Buzzard Room.

Tom Brady poses for a picture. He chats with old teammates, the men he won Super Bowls with a decade ago, guys like Tedy Bruschi and Deion Branch. He takes another picture. Word arrives: The rapper Rick Ross is on his way. Another picture. The QB is wearing designer blue jeans and a sweater and a white hat with SUPER BOWL XLIX CHAMPIONS across the front. Yet another picture, Brady's celebration reduced to a series of snapshots, smile after smile. It's 1:43 a.m.

Hours earlier Brady was named MVP of a Super Bowl that will be remembered among the most dramatic ever. New England had trailed by 10 at the start of the fourth quarter and then scrapped ahead by four. But as the clock displayed 26 seconds remaining, the Seahawks sat one yard—one Marshawn Lynch dive, one Russell Wilson rollout—away from a touchdown and an improbable comeback of their own. Instead an undrafted rookie cornerback from West Alabama named Malcolm Butler (Scrap to his teammates) intercepted what would have, should have been a game-winning slant pass from Wilson at the goal line. The play (a call savaged by the Twitterverse and defended to death by Seattle coach Pete Carroll) sealed far more than a Super Bowl. It bolstered the argument that Brady, already on the list of history's best quarterbacks, is in fact the greatest of all time.

DEFLATED TO ELATED

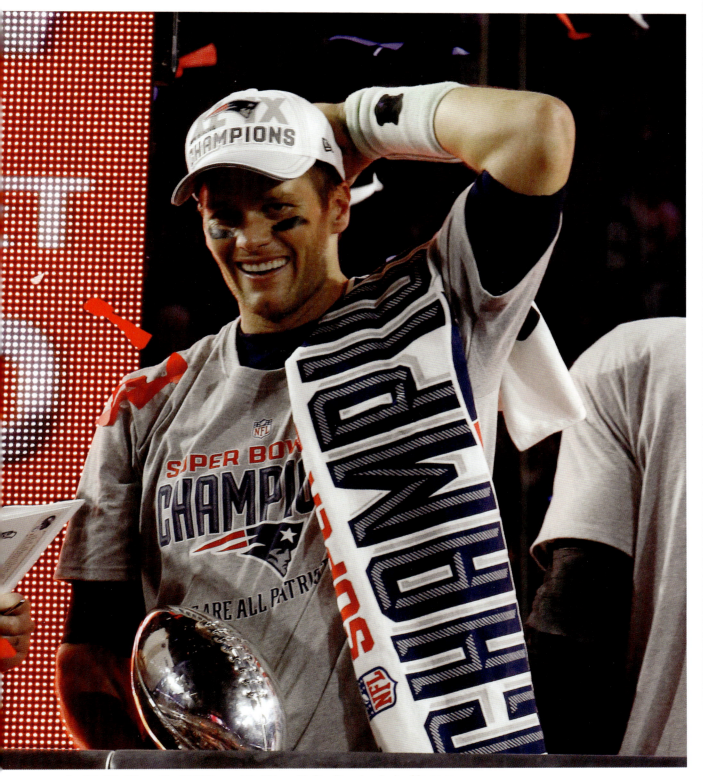

Brady's third Super Bowl MVP award tied him with San Francisco's Joe Montana.

DEFLATED TO ELATED

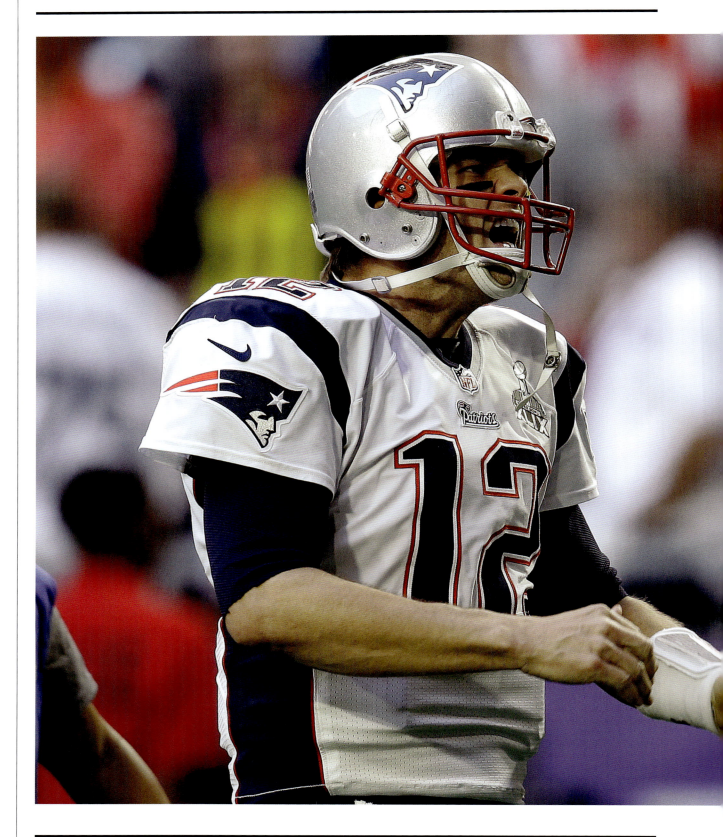

DEFLATED TO ELATED

Perhaps Brady considers that. Perhaps he thinks about how one of the darkest years the NFL has ever seen—Ray Rice, Greg Hardy, Adrian Peterson, ongoing concussion litigation—ended with a Super Bowl viewed by more people than any other, a game that overshadowed, if only momentarily, what often seems like a sport in crisis.

Maybe he doesn't.

Another photo. Outside the drama continues, but not in the Buzzard Room. These folks have been here before. No one mentions deflated footballs or Brady's record for the most completions in a single Super Bowl (37) or the Pats' 10-point rally, the NFL's largest second-half championship-game comeback as New England implausibly held on for a 28–24 victory. "Last picture and we're out," a friend says.

Snap, snap, snap, and then Brady makes his way toward the exit, past owner Robert Kraft and everyone else who navigated beyond three security guards into the VIP room. The buzzards that circled this team in late September—who suggested that perhaps Brady was nearing the end after a 27-point drubbing by the Chiefs—are long gone. In the Buzzard Room, only the loyalists remain.

Brady spies Jay Feely, a college teammate from Michigan. He was a groomsman in Feely's wedding. They embrace and Brady leans in close to kiss Feely on the cheek.

"Your ego is going to be back up here now," Feely jokes, holding his right hand above his head.

"*Awesome*, man," Brady replies. "It's awesome."

He makes his way toward the back exit and slugs down what looks like a vodka soda. He hardly speaks; teammates will do that for him. "Tom Brady is the best ever," says cornerback Darrelle Revis. He repeats himself for emphasis. "The best ever, *period*. Tom Brady. Michael Jordan. The best. Write that down."

Ten years after his third title, Brady finally led the Patriots to No. 4, throwing for 328 yards and four TDs.

DEFLATED TO ELATED

DOWN THE HALL, in the main ballroom, Darius Rucker is performing an old hit from back when he was the lead singer for Hootie and the Blowfish. This one's called "Time."

He sings: *Time, why you punish me.*

Funny thing, time. It can be measured in decades (it had been one since the Patriots' last Super Bowl triumph), years (three since their last painful loss on that stage), months (four since their season teetered near collapse) and weeks (two since another controversy, Deflategate, threatened their collective legacy).

Time, the past has come and gone.

Time can also be measured in seconds—a completion here, a miscue there, the slim margins between victory and defeat. Brady knows that as well as anyone. All six of his Super Bowls have been decided by four points or fewer. All six could have gone either way. And with 12:10 remaining in his latest appearance, time, it seemed, was running out.

The Seahawks led 24–14, but Brady methodically drove the Patriots down the field from their own 32. On first-and-goal from the Seahawks' four-yard line, he had receiver Julian Edelman open in the end zone but misfired hard and high. It seemed like a second critical mistake inside the red zone; in the first quarter, Brady had backfooted an errant attempt that Seattle's nickel cornerback, Jeremy Lane, easily picked off. But on the next play Brady found Danny Amendola in the back of the end zone. Four-yard score.

The game clock read 7:55.

Time is wasting.

The Patriots forced a punt, three and out, and got the ball back at their own 36 after only a minute. Brady threw nine times on the ensuing drive, spreading the ball among his targets. On second-and-goal, Edelman again gained separation at the line on nickelback Tharold Simon (who replaced the injured Lane and found himself in Brady's Hall of Fame crosshairs) and cut left into the end zone, toward the shallow corner. It was the same play Brady had botched earlier, but this pass sailed straight and true. The touchdown vaulted the Patriots in front, 28–24. And yet plenty of clock remained, 2:02 to be exact.

Time is walking.

You ain't no friend of mine.

The Seahawks, two weeks removed from a miracle NFC championship game comeback against the Packers, marched forward with another round of fortuitous bounces and late heroics. The game's final stretch would determine through which sort of lens Brady and his coach, Bill Belichick, would be viewed. Lose, and they'd be the pair that has fallen in three close Super Bowls. Win, and they'd join Chuck Noll and Terry Bradshaw as the only coach-QB tandems with four championship rings.

On first down from New England's 38, Wilson lofted an impossible pass deep up the right sideline. Jermaine Kearse, the same receiver who'd hauled

DEFLATED TO ELATED

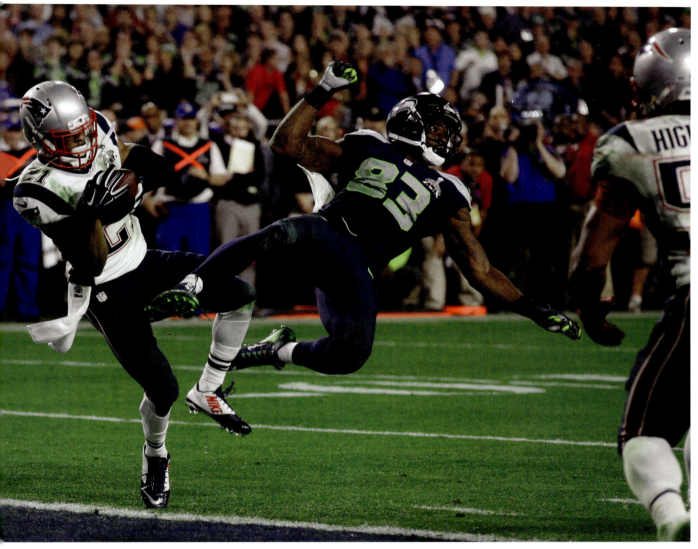

ABOVE Cornerback Malcolm Butler's interception at the goal line secured the victory for New England. **RIGHT** Brady threw two TD passes in the fourth quarter that put New England's defense in position to win the game.

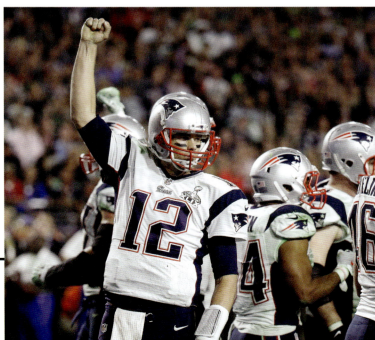

DEFLATED TO ELATED

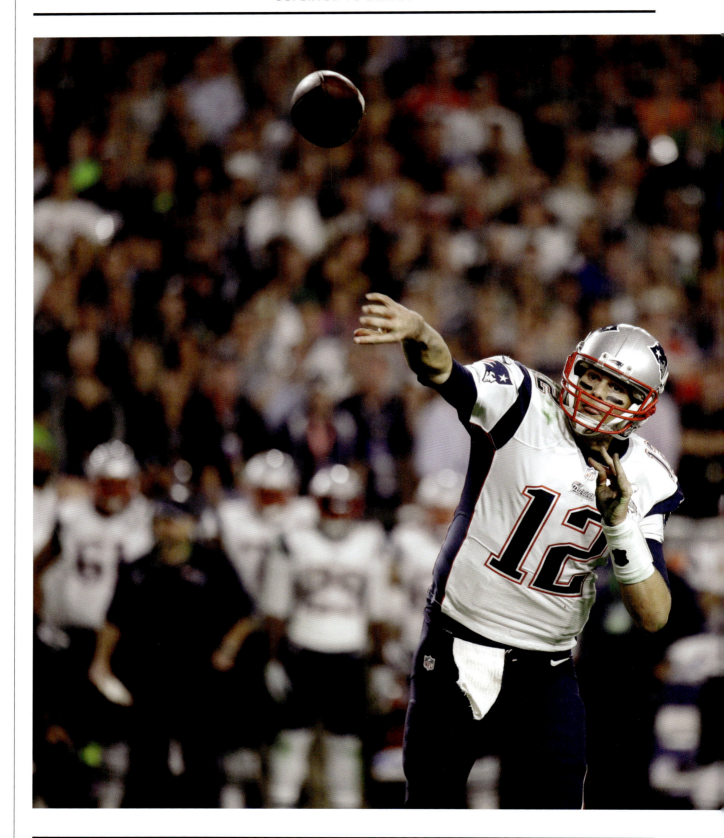

DEFLATED TO ELATED

in the overtime game-winner that beat Green Bay, tipped the ball (along with Butler, who made a near-perfect play) as he fell to the ground and, after several bounces, somehow managed to corral it as it caromed off two hands and his inner leg—a crotch grab minus the five-figure fine. The play went for 33 yards and put the Seahawks on the Patriots' five. Brady's legacy, it seemed, would be determined in part by two plays over which he had zero control, two of the most unlikely catches in postseason history: Kearse's grab and David Tyree's head-pinned catch for the Giants on the game-winning drive in Super Bowl XLII.

On the next play Marshawn Lynch took a handoff and barreled to the one-yard line. With a minute left a Seattle touchdown seemed imminent. Curiously, Belichick elected not to use either of his two remaining timeouts, the logical move to save time for a last-gasp drive by his offense—but he'd never have to explain that one. On second down, as Carroll later tried to explain, the Patriots packed the line of scrimmage with defenders, forcing Seattle into a passing play. The idea, he said, was to throw the ball away if no receiver got open, then run on the next two downs. Instead, Wilson tried to cram a pass to Ricardo Lockette on a slant route, and Scrap came down with the pick. "I'm just as surprised as everybody else," said Brandon Browner, the cornerback the Patriots had signed away from the Seahawks after last season. "You've got the best running back in the game…. Sometimes coaches get too smart."

Afterward, teammates noticed the tears that welled in Butler's eyes. He'd spotted Wilson glancing toward the Seahawks' receivers, guessed that the QB would pass and then jumped the route.

As the final seconds ticked off, Brady knelt on the field, taking a moment to himself.

Time, you left me standing there.

Brady's 37 completions set a Super Bowl record, one he'd break two years later.

DEFLATED TO ELATED

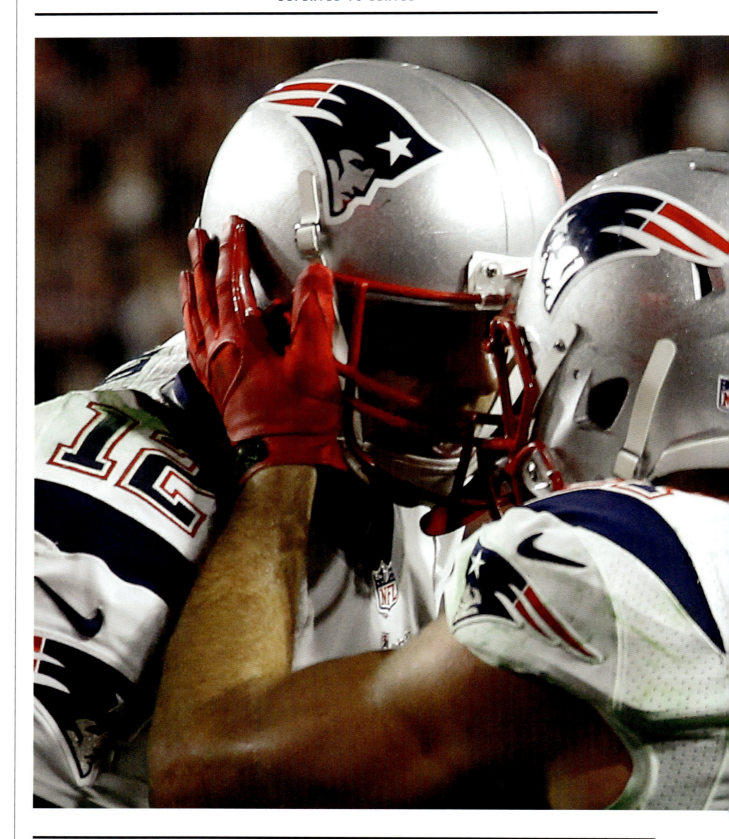

DEFLATED TO ELATED

AT THE PATRIOTS' hotel, the party rages on. The WWE wrestler Triple H mingles alongside Alex Karpovsky, from HBO's *Girls*, and UFC light heavyweight champ Jon Jones, brother of Patriots defensive end Chandler.

Gordy Gronkowski Sr. meanders by them all, through a hallway packed with Patriots jerseys and cheerleaders and acolytes. He carries a drink in his left hand and on his right wears a bracelet that blinks neon blue. He's ready to celebrate, but first, he says, "I'm looking for my boy."

What most of America considered the low point of the Patriots' 2014 season—a nationally televised 41–14 knockdown delivered by the Chiefs in Kansas City on Sept. 29—the elder Gronkowski views as the opposite. For him it was the moment New England's season changed for the better, and for good. With barely seven minutes remaining in that game, from the 13-yard line, Gronk hauled in a short pass from backup Jimmy Garoppolo and carried three defenders across the goal line. It was a meaningless touchdown in a blowout, but in the stands, the tight end's father fought back tears. "That's when I knew," he says. "That's the first time I saw Rob look the way Rob used to look."

By this he means *before the injuries*—before the twice-broken left forearm in 2012 and the torn right-knee ligaments a year later. Gordy was in the stands the day his son shredded his knee against the Browns, in December '13. "Weird things go through your mind," he says. "Is he paralyzed? Is he moving?" He was also there, 13 months ago, when Rob underwent surgery, when Rob suffered through months of rehab and his prognosis for this season seemed bleak. "Anybody else probably would have bagged the game," he says. "You had to wonder: Is he ever going to get his speed back? Is he going to be an average tight end?"

In October the swelling in Gronk's knee finally subsided. Belichick groused through a press conference after that Chiefs defeat, answering question

Brady's three-yard touchdown to receiver Julian Edelman in the fourth quarter provided the winning margin.

TOM BRADY

after question with "We're on to Cincinnati." And then Belichick's tight end proved his point: six catches for 100 yards and a TD in a 43–17 win over the Bengals the following week. On to the Bills and the Jets and the Bears and the Broncos…. The Patriots won seven straight and 10 of their last 12. Over those dozen weeks Gronk caught 69 passes for 977 yards and nine scores. In the aftermath of the Super Bowl, Belichick agreed with Gordy Gronkowski: The turning point, he said, came at halftime of that game in K.C.

"When people started going after Tom, that motivated Rob," Gordy says. "He took that personally."

The Gronkowskis arrived in Arizona early in the week, complete with their party bus, which has its own Twitter account. Whereas Rob spent the Patriots' last Super Bowl run, in 2012, under constant cross examination about the status of his sprained left ankle, this year he gleefully said things like "kittens are cool" and read aloud from a fan's erotic fiction, *A Gronking to Remember.* When someone asked why every party he attends draws such attention, he responded calmly, "Because I'm a baller."

On Sunday the Seahawks got their own Gronking to remember. Brady found him twice in single coverage against linebacker K.J. Wright, an obvious mismatch. The first time, Gronkowski settled under a fade and leaped to secure a comfortable 22-yard touchdown that gave New England a 14–7 lead.

That set Belichick on the path to his fourth Super Bowl title, tying Noll, the former Steelers coach, for the most ever. Brady, meanwhile, joined Joe Montana, his idol as a child growing up in the Bay Area, as the only QB to win three Super Bowl MVPs.

But outwardly no one celebrated quite like Gronk, who joined Gordy and Kraft onstage as Ross belted out "Ima Boss." Kraft shuffled and Gronk flailed. "In our next life, a lot of people will want to be Rob," Kraft had said earlier in the week, before

After years of battling injuries, tight end Rob Gronkowski was finally a champion after Super Bowl XLIX.

DEFLATED TO ELATED

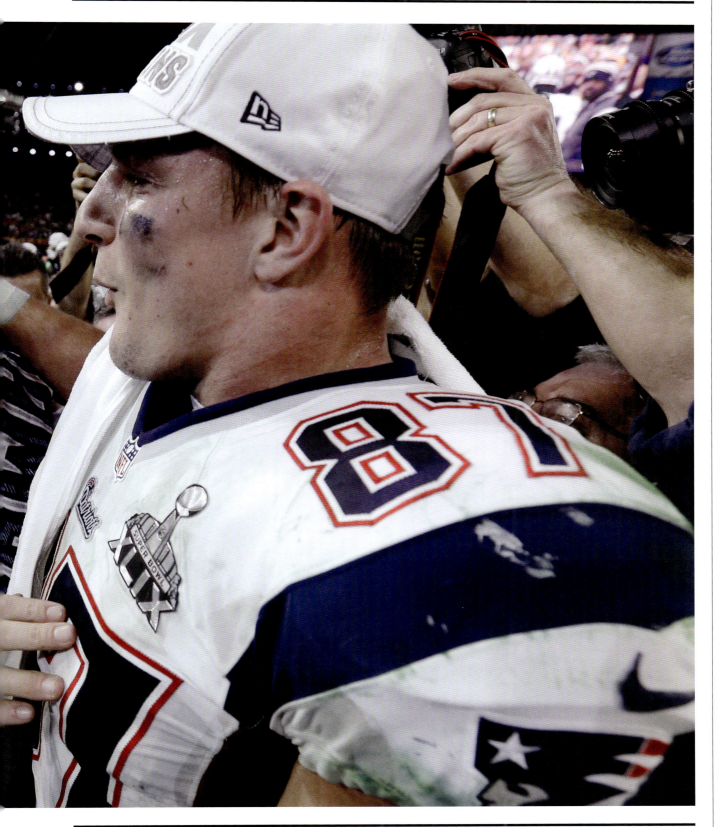

Gronk burnished that notion against the Seahawks. "He never has a bad day."

AT THE PARTY, nobody mentioned the Patriots' bad days. Their latest controversy is forgotten, or at least shelved.

Deflategate had turned Super Bowl XLIX into a remedial science class and spawned a national conversation about air pressure, atmospheric conditions and equilibriums. Those words came straight from Professor Belichick's mouth in a lecture he delivered two days before the Patriots departed for Arizona.

Belichick did not dispute what had prompted an NFL investigation, that 11 of the 12 footballs New England had used against the Colts in the AFC championship game were inflated below the league's accepted range. The Patriots' internal examination, he announced ambiguously, had found that the discrepancies resulted from the way the team prepared its footballs and from the drop in temperature between the equipment room and the field. That telling failed to explain how, under the same conditions, Indianapolis's footballs remained within the normal range, a point of contention raised by, among others, TV mechanical engineer Bill Nye (the Science Guy). "Even if you're being generous with the numbers," Nye says, "you can't make sense of Belichick's explanation."

Then things got *really* weird. Donald Trump weighed in on Twitter. "Smart, concise, truthful!" he opined of Belichick, who himself demurred that he was no Mona Lisa Vito—a reference to Marisa Tomei's scientific testimony in *My Cousin Vinny*. Kraft scolded the NFL for alleged leaks and demanded an apology should his team be cleared of wrongdoing. And way too much time was spent on a ball boy (ominously, "a person of interest") who took two bags full of footballs into a Gillette Stadium bathroom, where perhaps he was just urinating. *Saturday Night Live*, naturally, turned the whole saga into a bit.

The fuss was all a little—*ahem*—inflated, and yet it bolstered the notion of the Patriots as a team that

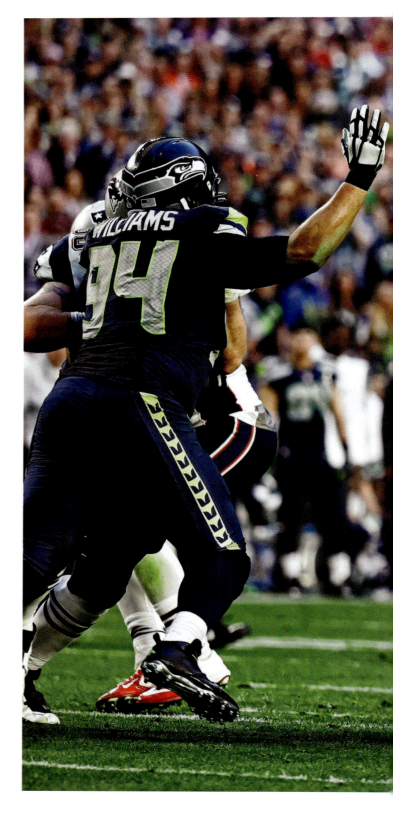

Brady became the first QB to start six Super Bowls, breaking a tie he'd held with Denver's John Elway.

DEFLATED TO ELATED

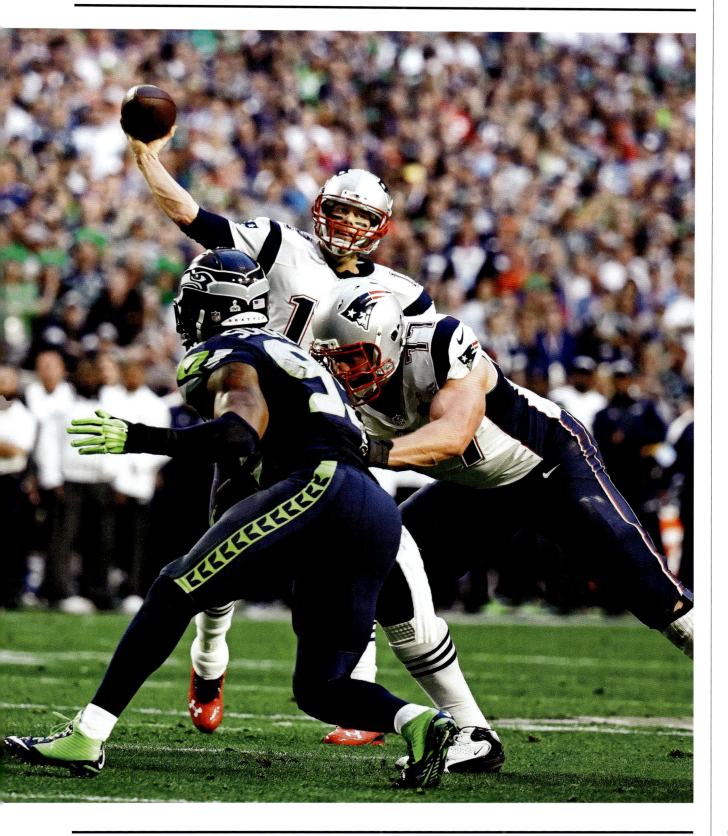

DEFLATED TO ELATED

circumvents and breaks rules ... or maybe just finds loopholes that other franchises wish they'd discovered. Here was New England, another Super Bowl in Arizona, another controversy. In 2008, Spygate had threatened their legacy in the lead-up to XLII as the late senator Arlen Specter called for congressional action over the league's investigation into the Patriots' illicit videotaping of defense signals. That ordeal cost the team a first-round draft pick and $750,000 in fines. In the end they lost that Super Bowl to the Giants.

If you love the Patriots, Deflategate simply reinforced a persecution complex, the idea that the franchise is singled out for scrutiny by opponents who are angry, envious—and defeated. If you hate them, it strengthened the notion that they are arrogant, devious. While the Patriots could cast Spygate as an isolated, misunderstood incident, Deflategate added to a perceived pattern of nefarious scheming. Last week, Slate published an analysis of fumbles lost since 2007, an area in which softer, more-grippable footballs could give a team an advantage. On average, teams lose one once every 105 plays. The Patriots: one every 187. Haters gonna ... make some good points.

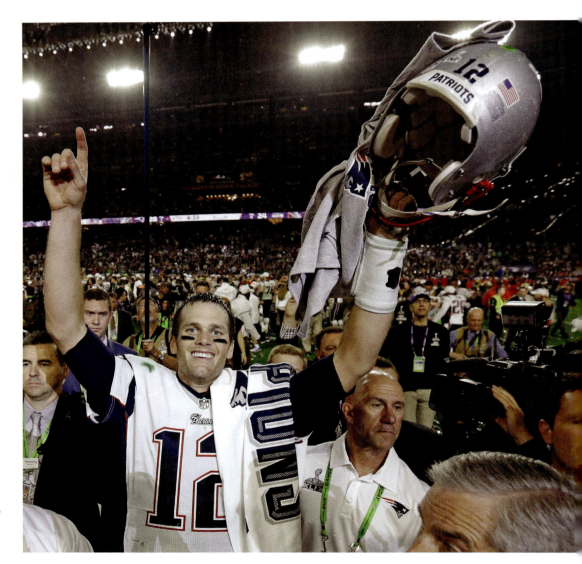

To critics who doubted Brady after Deflategate, victory in Super Bowl XLIX provided a counterpoint.

DEFLATED TO ELATED

"I always thought they were involved in some questionable things," says Mike Westhoff, an assistant for a dozen years with the rival Jets, now retired. "I never felt they won because they did any of these things. But [Deflategate] raises the level of suspicion. I know one thing: They explore every single factor. You get the impression that they think they're the smartest guys in the room.

"Enron used to think like that."

And yet the Patriots' performance on Sunday provided a counterpoint to critics. What Brady did to a Seahawks defense that had been labeled by

scored the game's first points on an 11-yard strike from Brady. It's easy, after New England becomes the sixth NFL franchise to win four Super Bowls—all under Kraft's watch—to forget the inauspicious start to this all.

Before there was such a thing as the Patriots Way, Kraft was a paper magnate and a season ticket holder since 1971. He also owned Foxboro Stadium. Kraft purchased the franchise in '94, back when no one around the league bothered to hate the Patriots. The previous owner, James B. Orthwein, wanted to move the team to St. Louis, but Kraft countered with

IN OTHER WORDS: NO TRICKS. NO STRATEGIC TOMFOOLERY. THEY WON WITH FOOTBALLS PROPERLY INFLATED, AS WE WERE REMINDED AGAIN AND AGAIN BY TV CAMERAS DISPLAYING THE WELL-PROTECTED GAME BALLS.

its players (and by others, to be fair) as one of the greatest of all time came down to a game plan. Brady threw 50 times but took only one sack, because most of his throws were short, quick and delivered with clinical precision. He threw two interceptions, but his patience and decision-making otherwise allowed New England to control the clock.

In other words: No tricks. No strategic tomfoolery. They won with footballs properly inflated, as we were reminded again and again by TV cameras displaying the well-protected game balls. "People just hate the Patriots," says Lawyer Milloy, who spent seven seasons playing safety in New England. "They don't even remember why anymore."

BACK INSIDE THE Buzzard Room, Kraft works the crowd in sneakers bedazzled with Patriots colors, his feet glowing under the dim lights. "They're amazing," Donté Stallworth, a former Patriots receiver, says of Kraft's kicks. The owner's Super Bowl–ring cuff links protrude and glisten as he carries around the Lombardi Trophy. He stops for a selfie with wideout Brandon LaFell, the Patriots' latest bargain-bin free-agent find, who

an offer of $172 million to take the franchise off his hands instead. Orthwein accepted.

Foxboro Stadium? It stunk. So did the team. Linebacker Willie McGinest, whom New England drafted in 1994, recalls the leaky roof in the training room. Hugh Millen, a backup quarterback in '91 and '92, remembers the team improving to 6–10, from 1–15 the year that he arrived, and two local columnists described that season as the most exciting in franchise history.

Kraft's Patriots did make the Super Bowl following the 1996 season, but even their success failed to mask a deep rift between Kraft and the coach that he'd inherited, Bill Parcells. "The story line of the Super Bowl," McGinest says, was "we're going to lose our head coach." They lost the game to the Packers and their coach (eventually) to the Jets, who hired Parcells a few weeks later. Pro Bowl running back Curtis Martin followed Parcells to New York one year later, delivering a major blow to the Patriots' new coach.

That man's name should sound familiar. Pete Carroll went 27–21 over three seasons in New England. It was, Milloy says, "a quantum leap

TOM BRADY | 99

DEFLATED TO ELATED

between personalities" from Parcells to Carroll. While Carroll's approach—loose, free spirited, relaxed—is credited for helping Seattle win its first Super Bowl, back then it wasn't yet fully formed. Players walked out of team meetings. They showed up late or hung over. "You have to blame it a lot on the players," McGinest says. "He was more lax, and a lot of players took advantage of it."

Kraft's handling of that hire and his next one, the authority he took from one coach and gave to his successor, would shape two NFL franchises and one college power. After being fired in 2000, Carroll turned USC into a dynasty. His successor, Belichick, would do the same for the Patriots, but only after Kraft granted him the control over personnel that he refused to cede to Carroll. "Coming off the situation I had been in, I believed in more checks and balances," Kraft says. "I probably handicapped Pete, because I was coming off a situation that I was reacting to."

Belichick took over in 2000. "As smart a person in football as I've ever met," says Charlie Weis, then his offensive coordinator. That first season they lucked into a sixth-round quarterback from Michigan. A year later, in training camp, Belichick's quarterbacks coach, Dick Rehbein, died from a heart condition. Belichick decided not to hire a replacement; instead, every week he began to meet with Brady himself to go over each opponent's defensive personnel. They still do that. Brady, of course, stepped in for an injured Drew Bledsoe during the 2001 season, and history unfolded. Weis even believes he can trace the birth of a dynasty to a single play.

Week 5. The Patriots were hosting the Chargers. New England rallied in the fourth quarter, forcing overtime. Brady—in his second year but basically still a rookie—recognized a blitz that San Diego hadn't shown all game, audibled and drew a pass-interference penalty on a deep throw that led to the winning field goal. *Elite*, Weis thought as he watched.

A few years later Carroll received a surprise phone call from Kraft. "I was wrong about you," Kraft told him.

But right, also, about Belichick.

THE LOCKER HAS no nameplate, no number, nothing to distinguish it from the other cubicles underneath University of Phoenix Stadium. And still the cameras hover, going over every inch: the handmade sign in toddler scribble, the family photo on a beach, the half-consumed smoothie, the big, black-handled scissors. Four index cards with phrases such as "Stay behind ball" and "Bend knees more on dip" written on them are arranged precisely, none overlapping, none askew. There is no occupant at this locker—not yet, at least. The pressed clothes hang still, and the video rolls, panning over this collection of inanimate accoutrements. On this night anything Tom Brady has touched is worthy of a feature film.

Eventually the quarterback appears, still in his base layer, fresh from his press conference, absent footwear. He has done his press for the night, but he's surrounded. Photographers and reporters inch in, almost imperceptibly, as Brady rests with his back to the room—and then finally a p.r. staffer decides this is too much. (It is.) "There's no reason to take any pictures!" he yells. "He's not doing anything! Let him get undressed."

This fazes no one. The rest of the locker room celebrates and the media throng silently watches. It grows impossible to even spot the QB in this fray, but there's no doubt where he sits, resting, waiting, taking a moment to digest. Brandon Bolden hops onto a chair. Shane Vereen, standing beside his fellow running back, wiggles onto his tip-toes. "Tommy! Tommy!" they yell in unison. "What's up, man?"

Brady nods. He barely says a word—just sits and smiles. Eventually he stands up, grabs his leather Dopp kit and gets escorted away. "I've got a lot of football left," he'd already told reporters.

The awkward Deflategate interview with Bob Costas, the first-quarter pick, that awful day in K.C.… Those are distant memories. Brady had sent Feely a text message as the Super Bowl–week controversy unfolded. "I have nothing to hide," he tapped.

Eventually, on this night, he ends up in the Buzzard Room. Friends, family and executives cycle in and out. Brady, unflappable, unfazed, poses for another picture.

"Enjoy the show," he says, and he heads into the night. ∎

DEFLATED TO ELATED

Few details identified the locker of the greatest quarterback in NFL history.

Excerpted from SPORTS ILLUSTRATED
January 23, 2017

ALL ABOUT CONNECTIONS

BRANCH, WELKER, EDELMAN ... TERRELL, STREETS, TOCCAGINO ...
TO CATCH PASSES FROM TOM BRADY IS TO ENTER AN EVERLASTING
CIRCLE OF ENLIGHTENMENT AND BROTHERHOOD

BY
TIM LAYDEN

EVERY WEEKEND TOM BRADY PLAYS ANOTHER FOOTBALL GAME. Every weekend he throws more passes to more receivers. The weekends are laid end to end until they become full seasons, the seasons are stacked up until they span decades, and soon enough Brady has played more football and thrown more passes, at a higher level of success, than all but a very few men. Four years in high school, five years in college, 17 years in the NFL. At least 237 total victories. (The records from his first two years in high school are spotty.) Two college bowl game wins. Six AFC championships. Four Super Bowl rings, with another in his sights after last Saturday's 34–16 divisional-round offing of the Texans in Foxborough. The end is a tiny dot on some distant horizon that only Brady, 39, can envision.

Since first pulling on the navy-colored helmet of the Junípero Serra High Padres as a backup QB on a winless freshman team in the fall of 1991, Brady has completed more than 6,600 passes to at least 120 receivers. He completed passes to teenage high school teammates who now have their own families, and to teammates at Michigan who are now coaches and entrepreneurs. He completed passes to Patriots teammates who became stars and others who scarcely played at all. He completed passes to a teammate who went to jail and was released (Reche Caldwell), and to another who went to jail and might never leave (Aaron Hernandez). He completed passes to receivers named Brown, Gray and White; he completed mostly long passes to Randy Moss and mostly short ones to Wes Welker.

This fall, despite missing the first four games of the season while serving his Deflategate

ALL ABOUT CONNECTIONS

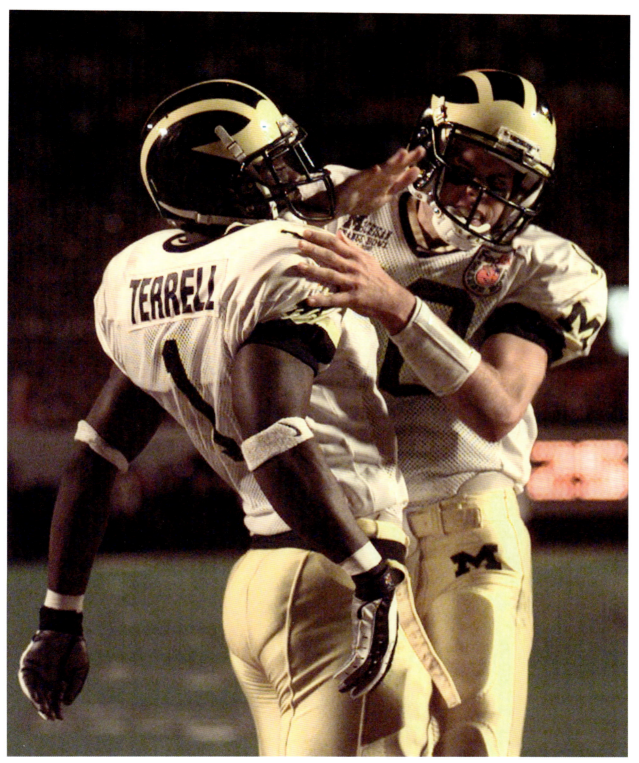

In their two seasons together at Michigan, David Terrell and Brady connected on 85 passes and nine TDs.

suspension, Brady threw for 28 touchdowns, with only two interceptions. On Saturday he was put under intense pressure by Houston's defense, tormented by Jadeveon Clowney; he completed fewer than half his pass attempts (18 of 38) and matched his season interception total. However, he also punished the Texans with six completions of more than 20 yards and two more TDs—a 13-yard swing pass to Dion Lewis in the first quarter and a sweet 19-yard parabola to James White in the corner of the end zone in the third, a dime dropped from the darkness. It was a moment's splendor on an imperfect night, and deep into January, Brady and the Patriots play on. The quarterback is at the top of his sport.

To most of those pass catchers, Brady is greatness once touched, a friend writ large and the celebrity in their cellphone. "My whole life," says Jabar Gaffney, who played in New England from 2006 through '08 and caught 70 passes from Brady, "people are going to ask me, What was it like to play with Tom? It was *everything*—that's what it was like." He is the quarterback who made them better than their dreams, who made ordinary athletes good and good athletes wealthy. "He made me way better than I was," says Welker, who caught 632 passes from Brady between '07 and '12, more than any other receiver in Brady's career. He is the most memorable connection in most of their lives.

And they are a window into his world. It was at Serra High where Brady's hypercompetitiveness first took root, where he first started banging helmets with teammates in celebration of big plays. It was at Michigan where he decided he would work from dawn until nighttime to improve himself. "Before he was the starter, we would all be walking off the field after practice and Tom is out there throwing balls into a trash can," says Wolverines teammate Tai Streets. "We'd be like, Come on, man, practice is over. Wasn't over for Tom. *Work, work, work.*" And it has been in New England, under coach Bill Belichick, that Brady has made excellence an assumption. "That franchise's identity is winning," says Austin Collie, who caught 11 passes from Brady in 2013. "That starts with Tom. They've created a whole culture that runs through one person."

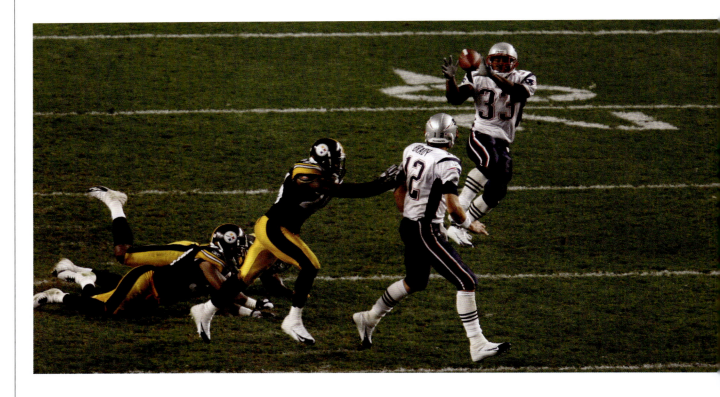

ALL ABOUT CONNECTIONS

To his receivers, Brady is a coworker, a taskmaster, a friend. There is one of him and dozens of them. He is an international celebrity with a famous wife and vast resources, yet he unfailingly returns calls, texts and emails. Some pass catchers have remained close to Brady, and some have drifted. Few are forgotten.

BRADY'S FIRST TACKLE team was the freshman squad at Serra, a private Catholic high school in his hometown of San Mateo, Calif. One of the receivers on that team was John Kirby; neither he nor Brady started that year. "I remember the first pass I caught from Tommy," says Kirby, 39. "It was in a preseason scrimmage against St. Ignatius, and we were getting our asses kicked. Tommy comes up to the line and gives me the eyebrows, like, *I'm coming to you*. Then he drops the pass right on me for a 60-yard touchdown."

Brady improved steadily, and as a senior he was being recruited by Division I colleges. Kirby could see and feel the difference in his QB's game. "Our senior year he threw me a 17-yard curl against Cardinal Newman," Kirby says. "As I turned around, I could hear the ball coming. It was making a hissing sound. It was like a missile." That 1994 Serra team won five games and lost five. Brady went to Ann Arbor; Kirby went first to City College of San Francisco and then to Hawaii, where he played briefly. The quarterback and the receiver stayed in touch, even as Brady became famous, talking and texting a few times a year.

Their relationship took on a deeper significance last summer when 20-year-old Calvin Riley, a Serra graduate and a former pitcher on the baseball team, was shot in the back and killed while playing Pokémon Go in a San Francisco park. Riley's family had moved to the Bay Area from Lowell, Mass., five years earlier, and Riley had become close friends with Kirby, who worked as an assistant football coach and substitute teacher at Serra. Shortly after Riley's death, Serra football coach Patrick Walsh texted Brady and explained the connection between Riley and Kirby; then Brady and Kirby talked. "I told Tommy about the family," says Kirby, "and Tommy asked, 'How about I write them a letter?'"

That letter arrived at Kirby's house, and the old Padres receiver hand-delivered it to Calvin's father,

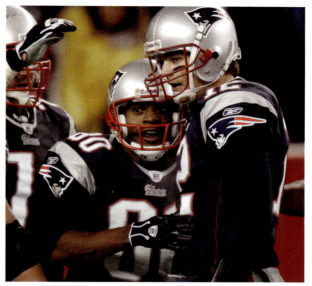

LEFT Patriots running back Kevin Faulk caught 10 of his 15 career touchdown passes from Brady. **ABOVE** Receiver Troy Brown and Brady won three Super Bowls together in New England.

Sean, about 10 days after Calvin was murdered. Sean, 41, had grown up in Lowell, a former mill town northwest of Boston, then became a high school baseball coach there. In 2011 he brought a recruit to the Bay Area and took his wife and three children as well; when their return home was delayed by Hurricane Irene, they grew more and more enamored of the West Coast. After the storm passed, Sean and Calvin stayed, even living in a car for a few days, looking for an apartment while Calvin, a freshman, began attending Serra. The rest of the family joined them later. Calvin graduated from Serra in '15 and last spring completed his first season on the mound at nearby San Joaquin Delta Junior College. Even after moving west, the Rileys remained avid fans of Boston sports teams—but most of all they cheered for the Patriots and their star quarterback. "My son loved Tom Brady," Sean says. "I can't say that enough."

Riley did not know the letter was coming. Opening the envelope, he found two pages, handwritten. "It would have been easy to [just] send a

ALL ABOUT CONNECTIONS

card or an email," he says. "It tells you what kind of human being he is." (Brady was in training camp, having just lost his final Deflategate appeal, when he wrote it.) Riley declines to share the exact contents of the letter, but when asked whether it provided comfort, he says, "Of course—it celebrated the life of my kid. Tom talked about the brotherhood of Serra, what a special community it is. That letter, it meant so much." Today the Riley family cheers harder than ever for the Patriots and their QB.

Two hours northeast of Serra High, in the small city of Elk Grove, Giovanni Toccagino Jr. works endless hours as the cook in his family's Italian restaurant, Palermo. More than 20 years ago Toccagino was Tom Brady's *other* primary receiver—"the better receiver," says Kirby—on that 5–5 team. Unlike Kirby, Toccagino doesn't have Brady's cell number or email; in fact, he can't recall speaking to his high school QB since the early 2000s, when Brady came home after his first Super Bowl win and the old teammates ran into each other at the gym. "I'm busy—I've got four beautiful kids, and I bust my ass in the family business," Toccagino says, pots and pans crashing in the background. Also this: "Tom is so busy. And I don't want to be *that guy*."

Toccagino was 6'3", 190 pounds and a three-year varsity starter at Serra; back then he went by Gianni. He then caught 37 passes for San Jose State as a true freshman, getting serious Division I run long before Brady did. But when his coach resigned, Toccagino found himself marginalized. And bitter. He transferred to San Diego State and never made an impact, then finished his career at D-III Menlo College in Atherton, Calif. "I was a good athlete, and I could get things done," says Toccagino, 40. "But I wasn't coachable; I didn't want to work hard. Tom Brady was a good athlete who wanted to get better and be great." In his mid-20s, Toccagino joined the family business that his father, Giovanni Sr., an Italian immigrant, started in 1991.

At first Toccagino resists telling Brady stories. He truly doesn't want to be *that guy*. And there are

Randy Moss became a Patriot after a draft-day trade with Oakland in 2007.

ALL ABOUT CONNECTIONS

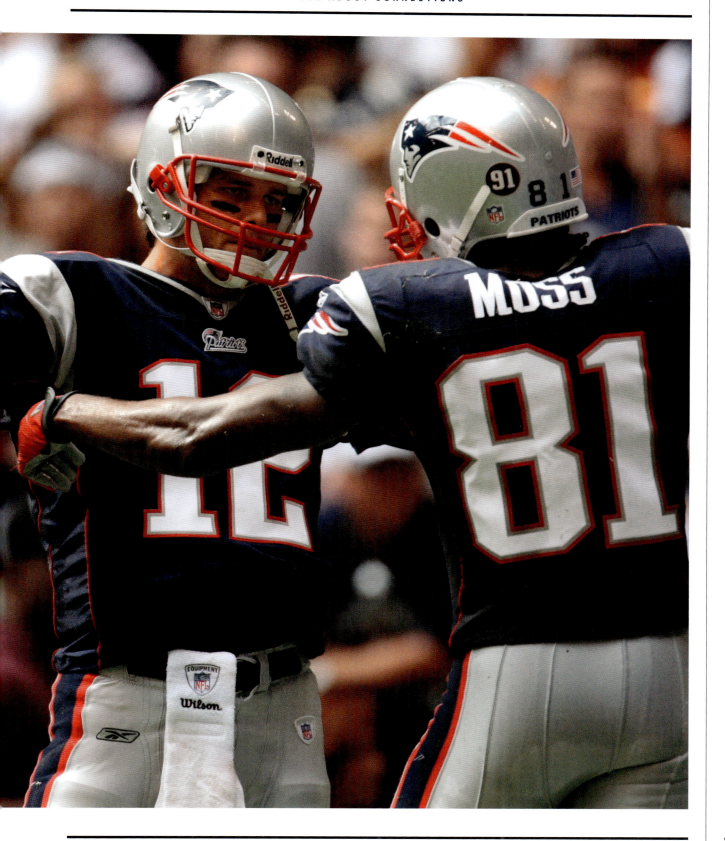

ALL ABOUT CONNECTIONS

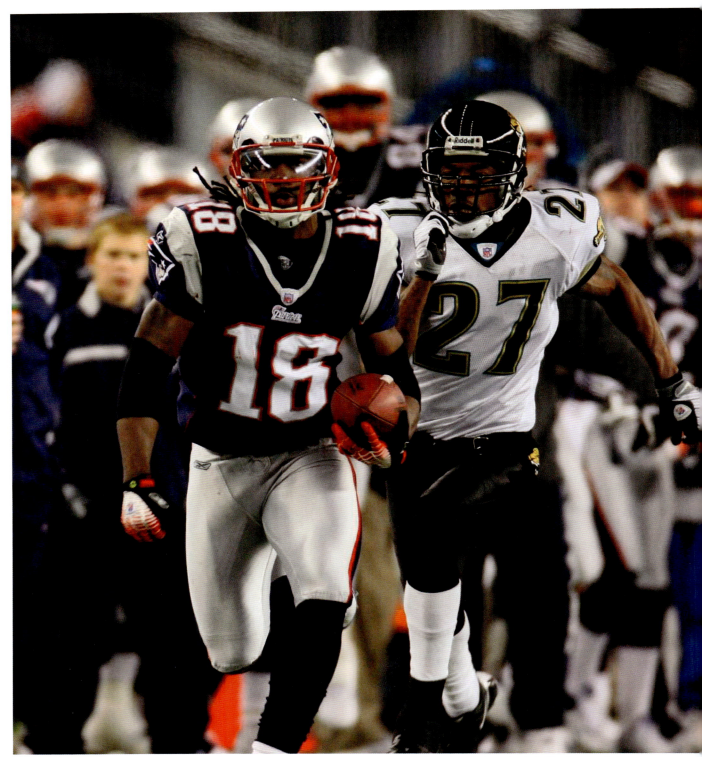

Receiver Donté Stallworth joined New England in 2007 along with Moss and Wes Welker; the trio launched the Patriots to their undefeated regular season.

ALL ABOUT CONNECTIONS

dinners to cook. But slowly he warms to the topic. "I've got a scar on my chin from his fat butt," says Toccagino, describing the time they collided on the basketball court diving for a loose ball. "Tommy always looked natural throwing a ball—and he was always *unnatural* running. Even worse back then." He tells the story of a 95-yard touchdown pass, senior year, when Brady gave him that look at the line and then fired the ball immediately against soft coverage, letting Toccagino do the rest.

And then there was this: Four years ago, when Toccagino's son, Damien, was six, he was assigned a first-grade project that involved writing a letter to a celebrity. Toccagino encouraged his son to write to Brady; when the letter was done, they mailed it to Brady's parents in San Mateo. A few weeks later, a return letter arrived containing a note and some signed pictures. "If he lived down the street, I'm sure I would just roll over there and we would connect," says Toccagino.

What does having played with Brady mean to him? "It puts a smile on my face when somebody asks about it," he says. "And when I'm coaching my kids, I can tell them: I know this guy who shows that nothing is impossible."

AMONG THE FRESHMEN arriving in Ann Arbor alongside Brady in the fall of 1995 was Aaron Shea, a tight end–fullback from Ottawa, Ill. Brady and Shea were redshirted as true freshmen, and both got spot duty over the next two years (including in '97 when Brady backed up Brian Griese for the co–national champions). The two twentysomethings shared an apartment at 824 McKinley Avenue. "I lived in the basement, and he lived above me," says Shea. "Five-thirty in the morning, you could hear the door open and close. That was Tom, going to run stadium stairs, even though the whole team was [scheduled to run] stairs at 2:30."

The roommates finally shared the spotlight in 1998, the year Shea caught his first of five touchdown passes as a Wolverine, a 26-yard wheel route from Brady to start the scoring in a 27–0 romp over Penn State. "My five-year-old son could have caught that pass, it was laid in there so perfectly," says Shea, 40. When that five-year-old, Kinzy, was born on

May 31, 2011, Aaron (who played six years in the NFL and worked six years in the Browns' front office) texted Brady and asked if he would be the boy's godfather. Brady texted back, "It would be my honor."

Brady's first game after his suspension was in Cleveland, where the Sheas have settled. After slaying the Browns, Brady met Aaron in the stadium tunnel, along with Kinzy and his two sisters. They all shared a hug, and Aaron asked, "What are you doing with that jersey?" Brady said, "It's yours, for the whole Shea family."

Tai Streets, a three-sport star from Chicago, also arrived with Brady at Michigan, but he didn't suffer the same wait to get on the field. Streets was a senior with 77 career receptions for eight touchdowns by the time Brady finally became the starter, in 1998, and that year he caught 67 more balls for 11 TDs. "We knew Tom was the real deal all along," says Streets, 39, "but we had good guys ahead of him. He was precise. All you had to do was get open. He was emotional, too, man. He threw a touchdown pass to me against Penn State, and he came running up, trash-talking the defensive back with that high voice. It was pretty funny."

Streets played six seasons in the NFL and caught 196 passes. For the last 15 years he's run an AAU basketball program in Chicago, MeanStreets (whose alumni include Derrick Rose and Anthony Davis); he also coaches the varsity hoops team at Thornton Township High in the suburb of Harvey. In 2015, when the Colts hosted the Patriots in Week 6, Streets traveled three hours south and met Brady after the game. "I'm not texting with Tom all the time," he says, "so it was cool to see him. Same old Tom, down to earth. Then they made him go get on the bus."

One day this fall Marcus Knight returns a phone call out of the blue. "I'm sorry," he says, "things are a little in turmoil right now." Knight, 38, has been the receivers coach at Northern Michigan for the last five years, but in November the Wildcats parted ways with coach Chris Ostrowsky. Knight seems unlikely to be kept on the new staff. ("You got a job for me?" he asks, jokingly. "I'll work my ass off.") Knight caught 81 passes in 1998 and '99, most of them from Brady, including the decisive TD in a 31–27 victory

ALL ABOUT CONNECTIONS

over Penn State the latter year. "Tom had a three-by-three-foot square to put that ball in," says Knight, "and that's exactly where he put it." Knight (who wasn't close with Brady) remembers that during their junior year, when Brady was the starter, coach Lloyd Carr would give freshman QB Drew Henson some series in games. "Tom won the job," says Knight, "and then he had to *keep* winning it."

Of all the big personalities in Brady's Michigan huddles, none were bigger than David Terrell's. A 6'3", 215-pound receiver from Richmond, Terrell, a true freshman in Brady's junior year, was assigned the number 1 jersey, reserved for Wolverines receivers who were expected to become stars. In their two seasons together Terrell caught 85 passes for nine TDs and displayed an ego to match the uniform digit. "Every single huddle, I'm telling Tom, 'I'm open! Throw the ball to me!'" Terrell, 37, remembers. "But Tom was a tough motherf-----, and he had that California-Joe-Montana-smooth personality. He'd be like, 'I gotcha, Dave. Chill. Next play.' In college, everybody thinks they're the s---; you're in the moment. But I look back—it was awesome, man, because Tom's personality just reverberated through the whole team."

Terrell was selected with the eighth pick, by the Bears, in the 2001 draft but lasted only five seasons in the NFL and caught just 128 passes. In '06 he was living in Southern California and arranged to bring his eight-year-old son, David Jr., to one of Brady's off-season workouts in L.A., where the QB threw to the young boy. "[My son] made a one-handed catch," says Terrell, who today co-owns a company that helps transform renters into home owners. This fall, David Jr., a senior, was the leading receiver at Loyola Academy in Chicago, which ranked No. 1 in Illinois and reached the Class 8A championship game. "I know this," says the elder Terrell: "He loves Tom Brady, and he loves the Patriots."

WHEN BRADY ARRIVED in New England in 2000 as a sixth-round draft choice and the fourth man on a three-deep depth chart, receiver Troy Brown had already been playing for seven years with the incumbent, Drew Bledsoe; Kevin Faulk, a pass-catching back, had played a season with the starter. Those two would go on to haul in 632 of Brady's NFL passes between them. But first they played while Brady watched.

"I never saw another rookie quarterback like him," says Brown. "He was fourth on the depth chart, but when he got a rep, he would not hesitate to tell veteran receivers if they did something wrong. *Typical Tom*. He just wanted to kick somebody's butt."

"Skinny kid in the huddle," says Faulk, "and he's trying to be demanding. But that attitude helped him take over the team."

In 17 NFL seasons Brady has thrown completions to 99 different pass catchers. Sixteen of those caught just a single pass from him, ranging from journeyman tight end Kellen Winslow to offensive linemen Joe Andruzzi and Logan Mankins. One of those single-pass catchers was running back Amos Zereoué, who in his seventh and final season, 2005, played three games for the Patriots. Zereoué's Brady connection was a five-yard checkdown in a 28–20 mid-October loss in Denver—not that he remembers it. "I caught a pass from Tom?" the 40-year-old asks, genuinely unaware. "I did not realize that. Makes my day. I will tell the grandchildren someday."

In 2002, Brady's first full year as a starter, Deion Branch arrived as a second-round pick from Louisville. Brady almost immediately nicknamed the rookie Tito—"because we were like brothers, right from the beginning," Branch explains. "Obviously, he's Michael Jackson, so I was Tito." As with all of Brady's most favored Patriots receivers, Branch would often line up without an assigned route. "Tom would call 65 C Option X Q," Branch says. "I would be the X, and Q meant that I had three possible routes based on the defense. We had to be on the same page."

Often they were. In New England's Super Bowl XXXIX win over the Eagles on Feb. 6, 2005, Branch grabbed 11 passes from Brady and was named MVP—and yet the former receiver's memory drifts to an incompletion that evening that bounced off his foot when Brady tried to connect with him despite calling a screen pass (to a running back) in the huddle. Afterward, Brady "came off yelling, 'Tito! Tito! I'm trying to get you the ball!'" says Branch.

When Brady won his 201st game on Dec. 4, passing Peyton Manning for the all-time victories

ALL ABOUT CONNECTIONS

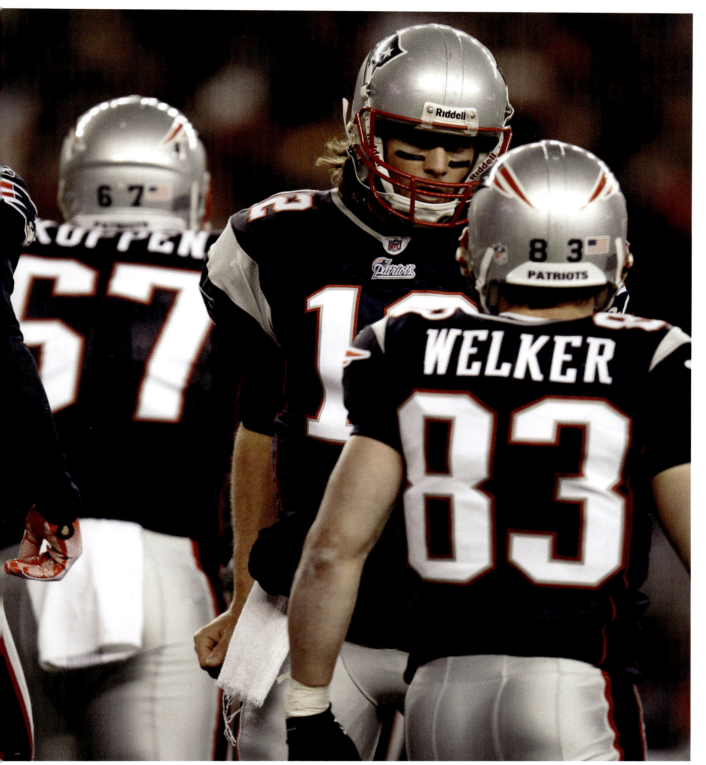

No receiver caught more passes from Brady during the QB's career than Welker.

ALL ABOUT CONNECTIONS

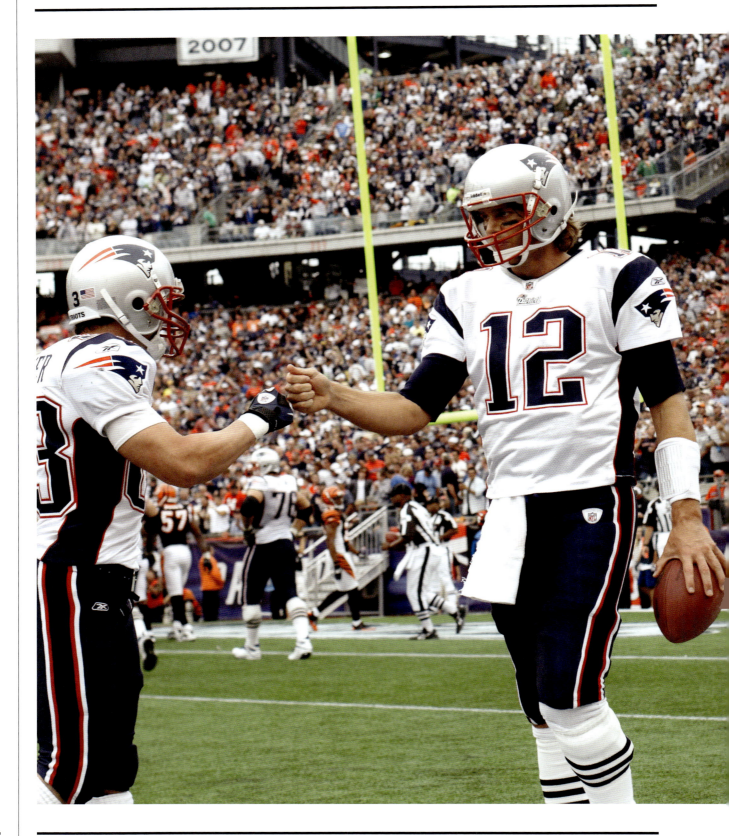

ALL ABOUT CONNECTIONS

mark, Branch texted his old QB, "It was an honor to have played some of those games with you." Brady texted back, "It was an honor to play with you."

WELKER ARRIVED THROUGH a trade with the Dolphins in 2007, along with Moss (trade) and Donté Stallworth (free agent), and that trio launched the Patriots to a 16–0 regular season. "What we played, it was almost like a controlled form of street ball," says Welker, who four times caught 100 or more passes from Brady. "Tom would see what I was going to do by my body language. He just wanted me to be decisive. If you get wishy-washy, be ready to get mother-effed [by Brady] pretty good. But then the next day, in a meeting, he would use this soft voice: *O.K., babe. On this one* … He's ultracompetitive, but he knows that the next day is not the time to yell."

Welker, 35, and Brady remain close friends. The receiver (who hasn't played since last January but who also hasn't officially retired) visited Foxborough in September, during Brady's suspension, and while he expected only to talk, Brady instead roped Welker into a throwing session. "It was like we never missed a beat," says Welker. "It's funny. I could see some changes in his motion. He's more relaxed, using his whole body, almost like a golfer."

Stallworth arrived from Philadelphia, by way of New Orleans. "One of my first practices, I dropped a ball in the end zone," he recalls. "Tom put it on the numbers, didn't lead me—but still, it was a drop, and Tom is all fuming. I'm thinking, *Great, I pissed off Brady already*. But he's like, 'F---! F---! F---! I didn't lead you enough.' I've played with some competitive people, like Ray Lewis. Brady is right up there."

Early in that unbeaten season the Patriots visited the Cowboys, who at 5–0 also entered without a loss. In the fourth quarter Brady called a play in which one wideout was expected to read the coverage and run one of three possible routes. That player was supposed to be Moss, but Stallworth was in the game instead. And that was a problem. "We're breaking

Welker knew Brady well enough to notice his teammate's evolution as he grew older: "He's more relaxed, using his whole body, almost like a golfer."

TOM BRADY | 113

ALL ABOUT CONNECTIONS

the huddle, and Brady sees I'm in the game," says Stallworth, 36. "We've both got this *Oh, s---* look on our faces because I've never practiced this route. So Brady says, 'Just go deep,' and the play ends up being a 69-yard touchdown. We literally drew it up in the sand. The guy is amazing."

ON A COLD weekday evening, Julian Edelman stands at the back of the Patriots' locker room, a California boy preparing to face the chill in a giant, hooded parka. Edelman was a seventh-round pick by the Patriots in 2009 out of Kent State, where he was an option QB with quick feet and strong instincts. He caught 78 passes in his first four NFL seasons, 415 in the last four (including a team-high 98 in '16) and now, as a top-tier receiver, is in year three of a four-year, $17 million contract. All of this, largely because of his relationship with Brady.

"He went out of his way to take me under his wing," says Edelman, 30. "I was a nobody, and I just wanted to get better. Tom worked with me." Now Edelman and Brady throw together frequently in Los Angeles during the off-season. "And it's not just [the physical element]," says Edelman. "He taught me how to be a professional, how to treat people in the workplace."

At the opposite end of the room, Chris Hogan sits in front of his locker. His route here was even more unusual than Edelman's: Hogan chose lacrosse at Penn State over football at UConn or Rutgers; and when four years of lacrosse were finished, he played a season of football at Monmouth. He was cut by the 49ers, Giants and Dolphins before spending four years with the Bills and then signing with the Patriots last spring. This season he had 38 receptions and tied DeSean Jackson for the NFL lead with 17.9 yards per catch.

The man who takes the top off defenses for Brady recounts his first day in Foxborough, when he made a point of introducing himself to the QB. "He knew exactly who I was—he knew my name, he knew I was here, he knew about me," says Hogan, 28. "Coming from where I did, the path I took, I was pretty blown away by that."

Hogan tosses two gloves into his locker, grabs a pair of street sneakers and sits down. He's in the club now, shocked to stand on the other side of the velvet rope. "I mean, think about that," he says. "*Tom Brady.*" ∎

Receiver Deion Branch caught 11 passes from Brady in Super Bowl XXXIX and was named the game's MVP.

ALL ABOUT CONNECTIONS

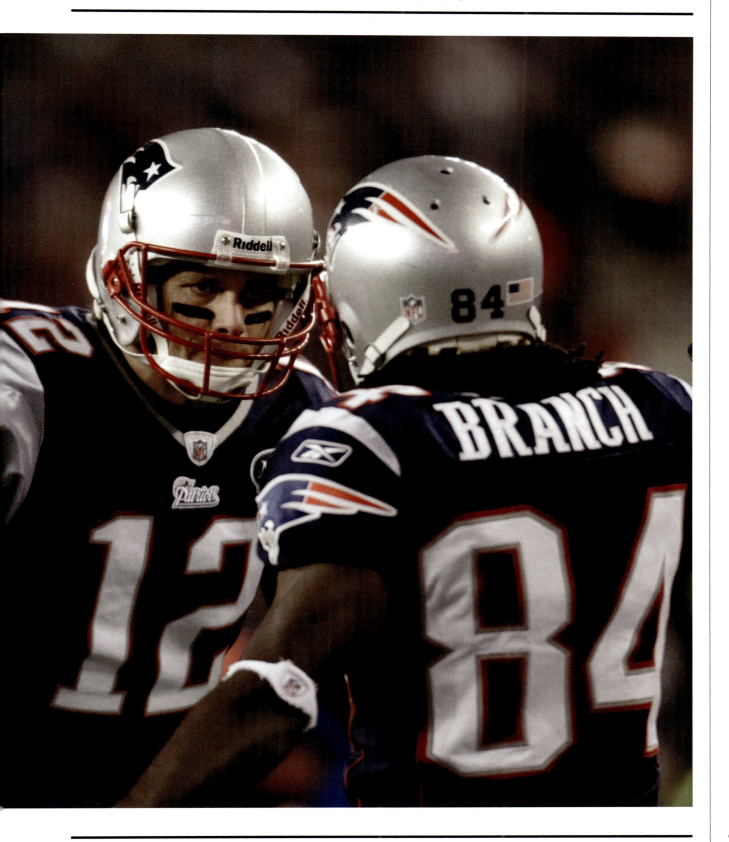

Excerpted from SPORTS ILLUSTRATED
February 13, 2017

SUSPENDED DISBELIEF

WITH ALL DUE RESPECT TO A GENIUS COACH AND HIS GANG OF MISFIT PARTS,
IT WAS TOM BRADY WHO LED A COME-FROM-WAY-TOO-FAR-BEHIND VICTORY
THAT EVEN SOME PATRIOTS PLAYERS DIDN'T IMAGINE POSSIBLE, SEALING
HIS STATUS AS THE GREATEST QUARTERBACK EVER

BY
GREG BISHOP

INSIDE THE PATRIOTS' LOCKER ROOM ON SUNDAY NIGHT, TOM BRADY SITS DOWN AT HIS LOCKER, AT ONCE SURROUNDED AND ALONE. He's oblivious to the teammates who are passing around a bottle of whiskey, emptying its contents in deep gulps, while others spray champagne until bubbly drips from their beards.

It's late at NRG Stadium in Houston as the quarterback unstraps the brace around his left knee, tugs off his sweat-drenched championship T-shirt and pauses for 30 seconds that seem to last forever. This brief meditation suggests that he's channeling some inner Zen to process what just happened: the first overtime and largest comeback in Super Bowl history, his fifth NFL championship, even the awkward congratulatory handshake with Roger Goodell, the commissioner who suspended him for the first four games of 2016 over a bunch of (possibly) underinflated game balls.

There's only one problem. Brady cannot find his jersey—the standard white number 12 that in the fourth quarter of Super Bowl LI, against the Falcons, could have been a wizard's cloak. Brady set championship game records for most passes (62), completions (43) and passing yards (466) in New England's 34–28 triumph. He accepted the MVP award. And then—*poof!*—the jersey vanished like Atlanta's second-half defense. "Someone f------ stole it," he says, grabbing a patterned gray suit and wading through the crowd toward the showers.

En route, he is stopped by Robert Kraft, who's handing out Padrón cigars from an oak box. The Patriots' owner grabs the back of Brady's head with his right hand and pulls his franchise QB in close, planting a kiss on his cheek. Brady returns the

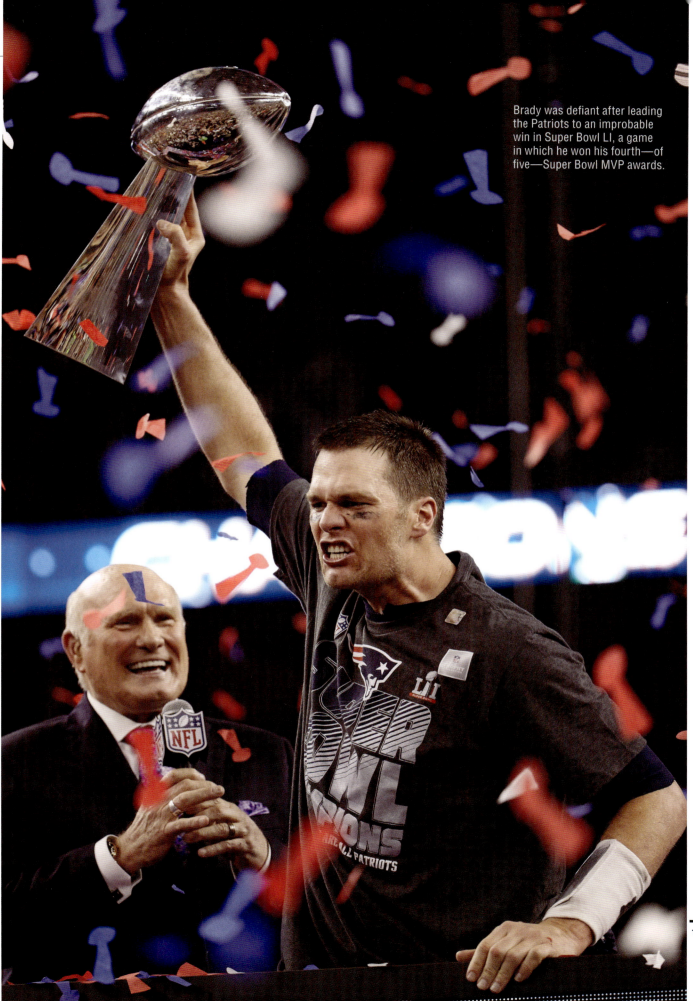

Brady was defiant after leading the Patriots to an improbable win in Super Bowl LI, a game in which he won his fourth—of five—Super Bowl MVP awards.

SUSPENDED DISBELIEF

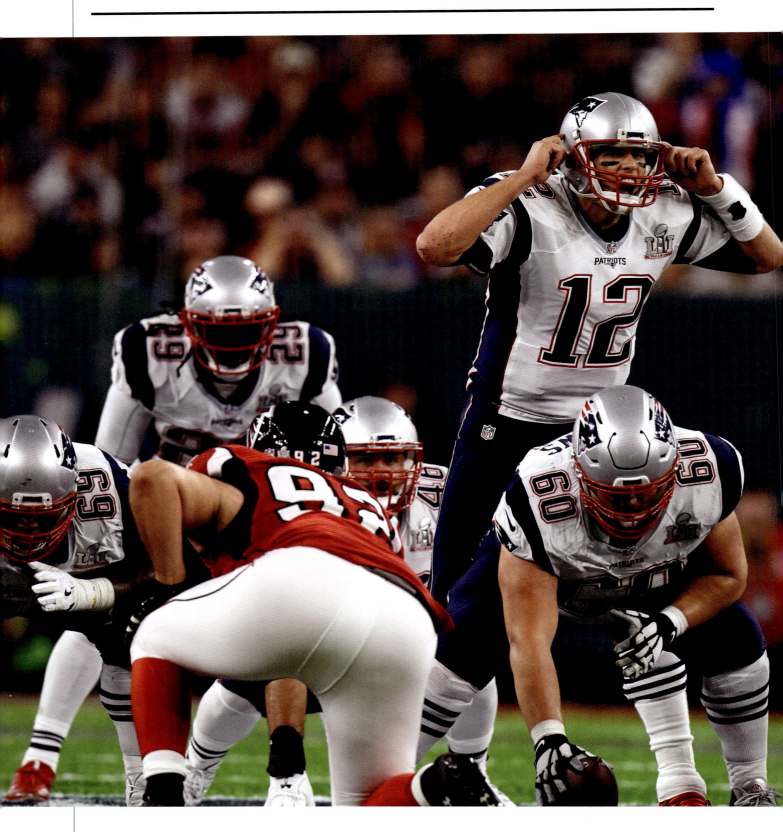

SUSPENDED DISBELIEF

gesture, whispers "I love you," and then inches away from him, toward the next well-wisher and the one after that, a series of coaches and execs and support staff who invariably tell him the same thing, that he's the best passer ever to play this game, keepsake jersey be damned.

Brady's best friend and business partner, the man who is said to spend more time with him than even his supermodel wife, stands off to the side. One year ago, on the same day the rest of the world watched the Broncos trounce the Panthers in Super Bowl 50, Brady and Alex Guerrero, the man he calls his body coach, decamped to a football field in Boston. Because the two men plan out Brady's schedule three years in advance, and because that exhaustive training regimen extends each season through Super Bowl Sunday, there they were last Feb. 7 running through a three-hour workout, Brady throwing in full pads and Guerrero catching passes.

Back then, Brady's mother, Galynn, had already been diagnosed with cancer; that was before she underwent countless hours of chemotherapy and radiation, before a panel of three federal judges affirmed Goodell's suspension and before Brady declined to pursue his final appeal. In part he backed down, friends say, because of his mother's failing health.

All along it seemed obvious that this season meant more to Brady, who, to be clear, does not lack for motivation. He's not one of those star athletes who claims that his sport does not define him; it *does* define him, always will. But this year—the revenge tour, all the emotion he couldn't suppress on Super Bowl week—was about so much more than Deflategate. It was about a quarterback who turned 39 in August and then spent September in exile, all the while traveling as often as possible to visit his mother. His father, Tom Sr., made it to one game this season, in San Francisco, near the home where he raised his son. Galynn wasn't even sure she could

Brady won his fifth ring in style, leading New England to the biggest comeback in Super Bowl history and introducing "28–3" to the sports lexicon.

TOM BRADY 119

make it to the Super Bowl until doctors cleared her last week.

The night before the game, Brady and Guerrero paused for a rare, brief moment of reflection. They contemplated this surreal season and all that another ring would signify. Twenty-four hours later, Lombardi Trophy in hand, Brady insists that this title means no more than any of the previous four—but Guerrero allows what seems obvious. "Yeah, this one means more," he says in a corner of the locker room. "This one is as special as it gets."

THE GREATEST COMEBACK in Super Bowl history began with the Patriots down 25 points, their offense discombobulated and their defense getting shredded like a stack of old credit card statements. More than a few New Englanders headed early for the exits, while reports from Washington indicated that President Donald Trump, noted Patriots supporter, had already turned the game off.

In his owner's suite Kraft looked at his son, Jonathan, and asked, knowing full well the answer, "You think Tommy has given up?"

"No f------ way," Jonathan replied.

Confidence is one thing. Delusion is another. Even Robert Kraft later acknowledged that his team's odds of finding victory had sunk to "infinitesimal" when the Falcons scored midway through the third quarter to take a 28–3 lead (win probability at this point: 0.3%). Defensive end Chris Long—new to the team, so forgive his ignorance—admitted that "naturally we had doubts." Others expressed hope, like safety Duron Harmon, who is said to have declared, "This is going to be the greatest comeback of all time."

Afterward, Patriots players insisted that their coaches simply told them to play better, choosing not to drastically change schemes. There, it helps to have Brady, who took the ball midway through the third quarter and led the offense on a 13-play, 75-yard drive, finding running back James White for the first

Julian Edelman's spectacular 23-yard catch in the fourth quarter set up the tying score in Super Bowl LI.

SUSPENDED DISBELIEF

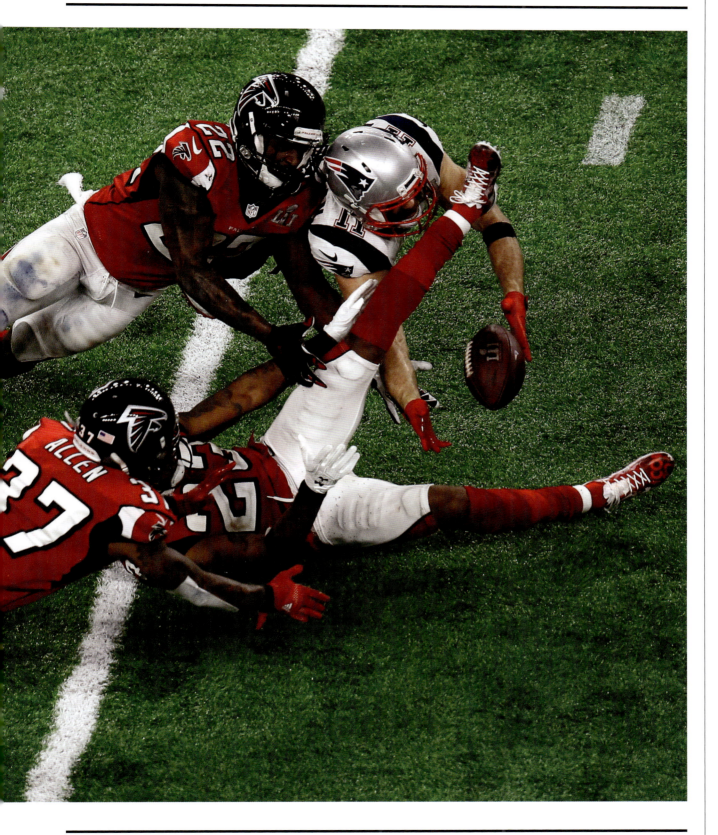

of the running back's three touchdowns. (White tied yet another Super Bowl record.) But even that score felt like a win for the Falcons, given the amount of clock it chewed up—not to mention Stephen Gostkowski's missed extra point.

Still, the vibe inside NRG Stadium started to shift from *No chance* to *It can't happen—can it?*

Atlanta punted at the start of the fourth quarter, and Brady mounted another long drive that bled further seconds from the precious clock, ending in a Gostkowski field goal. Yet again, that seemed like a Falcons win. They still led 28–12, and an offense that had scored the seventh-most points in NFL history had only 9:44 to kill.

Yet that sense of momentum shifting lingered. On Atlanta's next possession middle linebacker Dont'a Hightower barreled around left end and knocked quarterback Matt Ryan on his backside, jarring the ball loose—just as defensive coordinator Matt Patricia had drawn it up with the No. 2 Dixon Ticonderoga pencil stuck behind his right ear. Patricia wanted it to appear as if he were dropping his linebackers into coverage, then sent Hightower at full speed from the edge. Defensive tackle Alan Branch recovered at the Falcons' 25.

Brady needed only five plays to throw another touchdown, this one six yards to wide receiver Danny Amendola, and with the two-point conversion— White, again, off a direct snap—New England cut the deficit to one score.

Dot after improbable dot connected. A victory started to feel, to borrow a phrase from the league's Deflategate investigation, "more probable than not." Ryan countered with a drive of his own, only to inexplicably drop back on second-and-11 from the Pats' 23. The Falcons needed just a field goal to win, but a sack by end Trey Flowers and a holding penalty instead pushed them out of range, forcing a punt. Atlanta's defense looked tired, as evidenced by pressure percentages: 64.3 in the first half, 17.9 in the second.

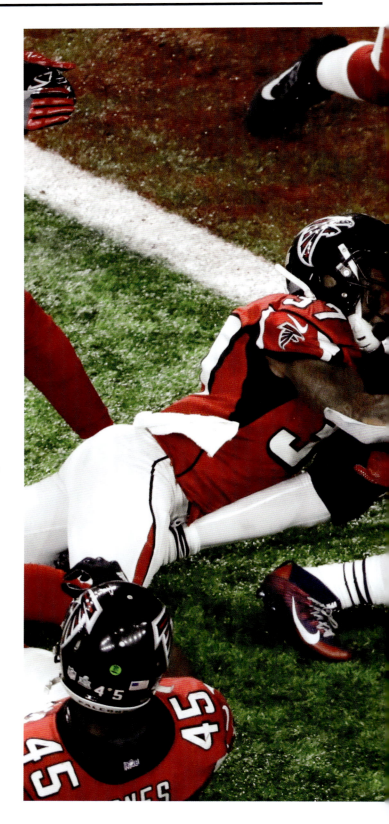

James White scored three TDs against Atlanta, including the game-winner in overtime.

SUSPENDED DISBELIEF

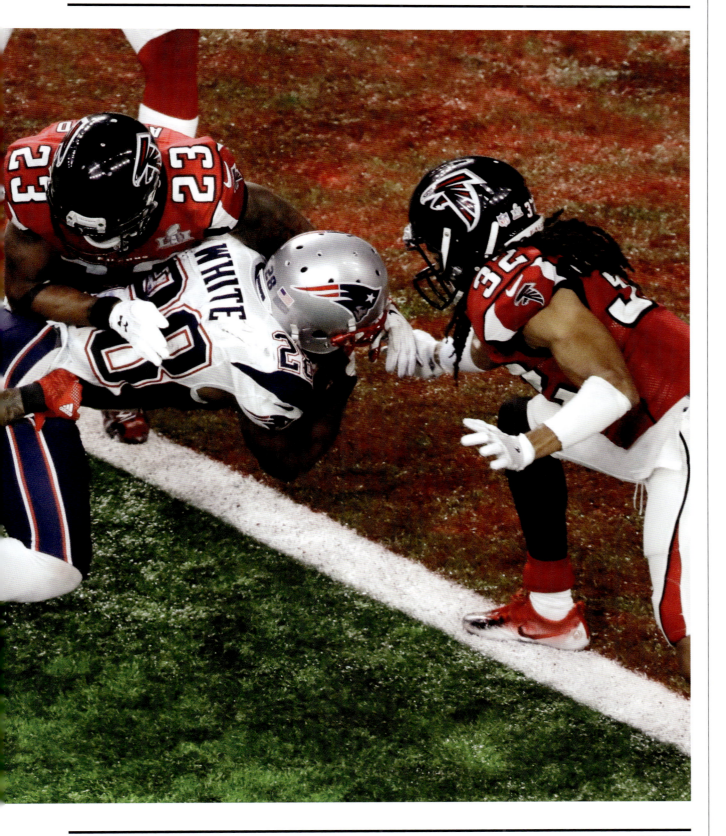

SUSPENDED DISBELIEF

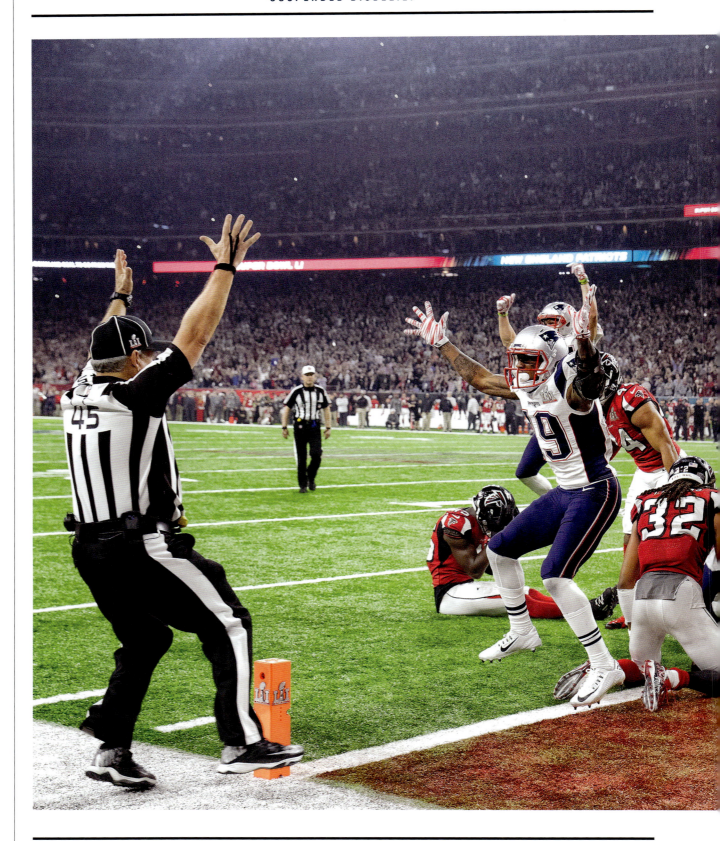

SUSPENDED DISBELIEF

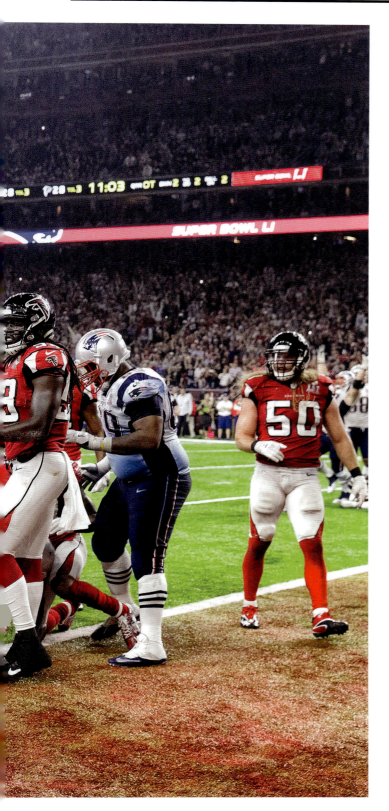

Receiver Malcolm Mitchell celebrated after White scored the championship-winning touchdown.

That set the stage for the drive that Patriots fans will tell their grandchildren about, a 10-play, 91-yard march that instantly ranks among the greatest in NFL history. Late in the second half the Falcons had switched from man coverage to zone, and wideout Julian Edelman, manipulating that bubble, made a 23-yard grab so spectacular that teammate Martellus Bennett described it as happening "between seven guys' legs."

Mouths dropped. Tears ran down faces. The irony was lost on none. A decade ago the Patriots had lost two close Super Bowls after implausible catches from Giants receivers—David Tyree's helmet snag in Super Bowl XLII and Mario Manningham's sideline ballet tip-toe grab in Super Bowl XLVI. Now the Patriots had an implausible reception all their own—the Texas Tri-Tip or the Jules Robbery, whatever you wanted to call it. Four plays later Brady handed off to White for a TD, then zipped a pass to Amendola for the tying two-pointer.

After that, Ryan could only—in his own words—untie his cleats and watch Brady do what Brady does. New England won the overtime coin toss, flew 75 yards down the field in eight plays and scored on a two-yard run by White. "Just an avalanche," Brady explained.

That same word, *avalanche*, also describes Brady in the immediate aftermath, on the field. He knelt down, a gray T-shirt slung over his right shoulder, photographers so close that their feet formed a circle of shoes around him. Brady's head remained pointed downward, so close to the turf that he could kiss it, so overwhelmed that he couldn't move. Guerrero bent down and threw an arm over his friend's back, then running back LeGarrette Blount embraced Brady, and then coach Bill Belichick. The scene ended with a group hug that was striking because, well, it was Brady and the Patriots. They weren't robots in that moment. They were vulnerable, human.

Afterward, Kraft found his QB on the field and told him, "We won that for your mom."

SUSPENDED DISBELIEF

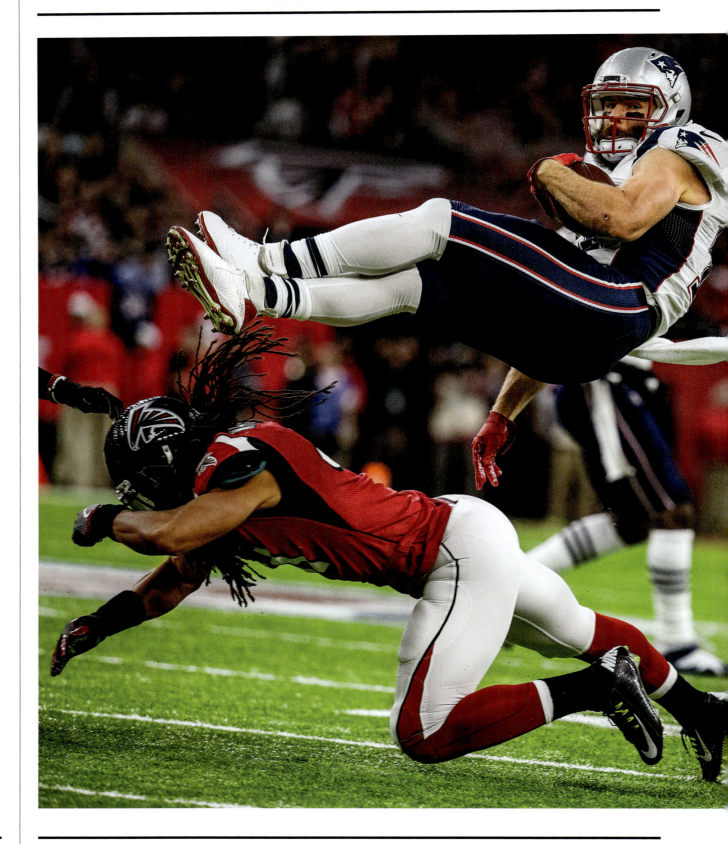

SUSPENDED DISBELIEF

BEFORE BRADY COULD launch the ultimate Super Bowl comeback, he first had to serve his punishment: four weeks of league-imposed exile. While the season kicked off without him, Brady practiced football on the same days and at the same times as his teammates. He ran through the same quarterback drills and agility exercises as before, performed the same resistance-band training. He had Guerrero hammer his arms with weighted bags while throwing to former teammates—everyone from Wes Welker, one of his favorite old targets, to Ryan McManus, a former Dartmouth wideout turned marketing exec who worked out for the Patriots last spring. "We wanted Tom to come back *programmed*," says Guerrero, who also performed the same massage work on Brady, before and after practices, that he normally would have.

Everything else about those first four weeks, however, felt unfamiliar—like on Sept. 10, one day before a Week 1 win over the Cardinals, when Brady's wife, Gisele Bündchen, Instagrammed herself catching one of her husband's passes in their backyard. A week later, longtime Michigan equipment manager Jon Falk picked up Brady at Willow Run Airport in Ypsilanti, Mich., and drove the old Wolverines QB immediately to Michigan Stadium, where he wanted to play catch with his nine-year-old son, Jack. The next morning Brady went over the Wolverines' game plan with Jim Harbaugh, played catch with the coach during warmups and addressed each of the position groups, imploring them to honor their predecessors with their play. "He could not have been more gracious," Harbaugh says.

That afternoon Michigan fell quickly behind Colorado, 21–7. Brady had planned to leave at halftime, but on the sideline he told Falk, "Big Johnny, I think I'm bad luck; you better get me out of here." And so he left. On the 20-minute drive to the airport, Brady told Falk the Wolverines would be winning by the time Falk got back to Ann Arbor. They were.

Edelman caught five passes, including one in OT, for 87 yards, and returned three punts for 39 yards.

TOM BRADY 127

SUSPENDED DISBELIEF

Thus continued Tom Brady's strange football vacation. He spent a weekend with his wife in Italy, where paparazzi snapped pictures of him sunbathing in his birthday suit, and dined inconspicuously with Gisele at Ristorante Aurora (pizza *all'acqua*, served with mozzarella and red peppers) on Capri Island. He spent four days playing golf with his father in California and flew his throwing coach, Tom House, to Boston to evaluate his mechanics and fine-tune his motion. On Sept. 30 he filmed a Beats commercial at Milton Academy, outside Boston; on Oct. 2 video of his workout at a school near his home landed on TMZ.

The Patriots went 3–1 in Brady's absence, and on Oct. 3 he returned to the team's Foxborough headquarters. Kraft had been so hurt by the suspension that he says he became "very emotional" every time he passed his quarterback's empty locker. But Brady never mentioned the ban, never so much as uttered *Deflategate*, and how he approached those four weeks says everything that he refuses even to admit thinking. His life, his career, the meticulous schedule—that's *all* process, and process is what sustains him. "In a weird way," Kraft says, "maybe [the break] was positive."

Brady has refused to say that, but consider: His favorite bit of reading is *The Four Agreements*, a spiritual guidebook by shaman Don Miguel Ruiz, and the second of those agreements—*don't take anything personally*—seemed especially applicable in September. Ruiz writes that people tend to fall into narratives that others create for them, that they're angry because they're expected to be angry, aggrieved because most others would be too. Brady—at least publicly—never blamed Goodell, never let the noise appear to influence him.

"Brady," Ruiz says, "has created his own truth."

ON STAGE FOR the Lombardi Trophy presentation, Belichick falls completely out of character. For one, he's not wearing a hoodie, his longtime fashion trademark that this season seemed to disappear from his wardrobe. For another, he's letting out guffaws so hearty that his eyes close, his amusement appearing to stem from the deafening boos lobbed at Goodell, executor of Brady's suspension, as he hands over the champions' hardware.

Then Belichick disappears—Belichick *always* disappears—while his players tuck flecks of confetti into their waistbands and pull on the requisite championship hats and T-shirts. Their coach may have concluded his ninth Super Bowl appearance and won his seventh ring—his record fifth as the football czar in New England—but his microprocessor of a mind has already turned forward. It's a staple of Belichick, who gathers, processes and disseminates information like no coach in NFL history.

"He's easily the best ever at melding the two most important qualities of a coach: foresight and insight," says Belichick's former assistant Charlie Weis. Foresight into whom to cut, whom to sign, when to retain four QBs in order to keep a sixth-round pick named Tom Brady on the roster, and insight that allows him to take away what opponents do best and exploit what they do worst.

This season marked just the latest example of that melding of A and B. Standout pass rusher Chandler Jones showed up shirtless at a police station and then got shipped to Arizona, but the Patriots still led the league in scoring defense. *Foresight*. Linebacker Rob Ninkovich missed four games after testing positive for a banned substance, so Belichick rotated in young players he'd groomed as backups. *Insight*. While Brady served his punishment, and after Jimmy Garoppolo went down injured, Belichick changed his game plan to run more with unproven Jacoby Brissett under center. *Insight*. Then he shipped linebacker Jamie Collins, whom many considered New England's best defensive player, to Cleveland in the middle of the season. The unit actually improved. *Foresight*.

That intellect was evident after both of the Patriots' losses in 2016. Their first came in Week 4, against the Bills. When Brady returned to face the Browns the next week, Belichick opened up the offense, spread his receivers wide and passed 40 times. New England cruised to four straight wins. In Week 10 the Seahawks knocked the Pats around at home, and Belichick responded by taking a more active role with the defense. Over the remaining seven regular-season games his team allowed an average of just 12.4 points. New England ran the table, not Green Bay. "We were more aggressive in

our play-calling," says Hightower. "That was Bill and Matt making adjustments."

Against the Falcons on Sunday, down 28–3 with a quarter and a half remaining, Belichick went for it on fourth-and-three at his own 46. How many NFL coaches would actually do that? Brady found Amendola for 17 yards on a drive that would produce the Patriots' first touchdown. That score went to White, another New England find, a fourth-round pick out of Wisconsin who managed 551 yards on 60 receptions this season. Most games, he ceded touchdowns to Blount. Some games, the bulk of the receiving work went to Dion Lewis. On Sunday it was White's turn, and he extended drives with quick passes out of the backfield, serving as Brady's first option at times and emergency outlet at others, catching 14 passes for 110 yards. This was, of

Goodell saw that on Sunday. As did one of Belichick's most prescient signings, a pint-sized college quarterback whom he turned into a Super Bowl hero at wide receiver.

BEFORE JULIAN EDELMAN snagged one of the greatest receptions in Super Bowl history, he grew up in Redwood City, Calif., under the watchful eye of his father, Frank. The boy would hit 300 baseballs after practice, train on camping vacations and fight any teammate he deemed lazy. "He was like Bamm-Bamm," his father says, "strong as an ox but looked like he was [far younger]—just this little baby. He'd get in fights, trouble, crying, every week." Frank pauses, thinking back to all the training. "Now I'd probably get put in jail for [how I pushed him]," he says.

BRADY NEVER USES THE WORD *LEGACY*. HE NEVER CONSIDERS HIS PLACE IN NFL HISTORY, NOT WHEN HE REACHED HIS SEVENTH CHAMPIONSHIP GAME AND NOT WHEN HE HOISTED THE LOMBARDI TROPHY FOR A RECORD FIFTH TIME.

course, the famous Patriot Way embodied. A player that few expected to dominate the Falcons at the outset made a run at Super Bowl MVP.

Belichick's approach to the fourth quarter mirrored White's ascension: Whatever works. He let Brady take control. The two have met almost weekly since Brady became the starter back in 2001, but they're not exactly the best of friends—they don't go out to lunch or dinner, or take vacations with their wives. Theirs is a pragmatic relationship built almost entirely on the technical aspects of a game that defines each of them. They're both football nerds at heart.

"Greatest modern-day football coach, period," says Lawrence Taylor, the Hall of Fame linebacker whom Belichick unleashed as the Giants' defensive coordinator in the 1980s. "All these people think he's dry, but he'll chuckle here and there, like a *Go f--- yourself* chuckle."

Edelman mixed a Brady-esque level of obsession with what at times seemed like misplaced confidence for an undersized juco product, which landed him at Kent State. That's how he became the Golden Flashes' starting quarterback after telling the incumbent, who was practicing quick kicks, "You better get used to that—it's all you're going to be doing." That's how he transformed from a seventh-round pick in 2009—one whom the Patriots weren't exactly sure what to do with—into a slot receiver savant, by catching 300 balls after practices, pestering Welker for tips and moving to L.A. in the off-season, for those times when he was deemed worthy of attending Brady's throwing sessions.

Flash forward to Sunday. Fourth quarter. Patriots down 28–20 but driving. The game, and so many legacies, at stake. On first down from the Pats' 36, Brady tosses a prayer into triple coverage, toward the 5'10", 200-pound Edelman but not quite over the

SUSPENDED DISBELIEF

reach of cornerback Robert Alford, who bats the ball unwittingly toward his receiver. As Edelman falls to the ground in a pile of three Falcons, the ball hits a defender's leg. The receiver, eyes wide as coffee-table coasters, grabs it, then bobbles it—and finally plucks it before leather meets turf. In the moment, he doesn't even know for sure whether he's caught the ball, later noting that "no one knows what the [catch] rule is." The call holds up on replay, leading Hightower to call it "the single greatest catch I've ever seen" and the reason "why we call him Julian Incredleman."

The catch, while certainly miraculous and made possible by a chain of fortuitous events, is not entirely an accident. "Jules loves Tom," says Frank Edelman. "He loves everything about Tom, he wants to be like Tom. Tom is his hero. He learned the whole system with Tom, from the bottom up."

"It's the same thing I had with Joe Montana and Steve Young," says Hall of Fame receiver Jerry Rice. "When you go out there, it's like doing a dance. You're in tune."

With his son's catch and his place in Patriots lore secured, Frank Edelman has not forgotten all the slights. He's still upset with retired wideout Keyshawn Johnson in particular, after the ESPN commentator described his son as a system receiver and said Julian wouldn't have stuck in the NFL if he'd been drafted by another team. "Keyshawn Johnson is an idiot," Frank says. "He could never play on my team. And I'm certain he squats when he urinates."

"Jules would have made it on any team," Frank continues. "But Jules doesn't fit in every system."

He fits best—like the running back known most for the punch he threw in college (Blount), like the lacrosse player turned NFL wideout (Chris Hogan), like the running back whom the lowly Browns cut loose (Lewis)—in one place.

With the Patriots.

INSIDE NEW ENGLAND'S victory party at the NRG Center, adjacent to the stadium, John Legend croons from the stage, *My head's under water, but I'm breathing fine....* Video boards display five Lombardi trophies, one for each title. Revelers snack on fish tacos, chicken-and-waffles, tater-tot casserole and sliders.

Two hours after the comeback Kraft takes the stage wearing a blue suit, pink tie and black sneakers. He starts by thanking the fans: "You got us through this difficult season. You know what I'm talking about. This one was definitely the sweetest."

Kraft mentions his coach and his quarterback, then he stirs the partisan crowd into a chant: *Bra-dy! Bra-dy! Bra-dy!* "We are all Patriots," he says as he walks off the podium and into his private party, the one with a football team's worth of security guards; the one that requires a special pass reading KRAFT LOUNGE. The 64-year-old Belichick, clad now in a black suit, makes his way into the VIP

SUSPENDED DISBELIEF

RIGHT Super Bowl LI was Bill Belichick's seventh appearance in the championship game as a head coach. **BELOW** Brady set numerous passing records during the game, completing 43 passes on 62 attempts for 466 yards.

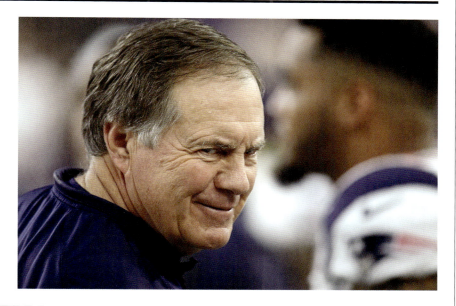

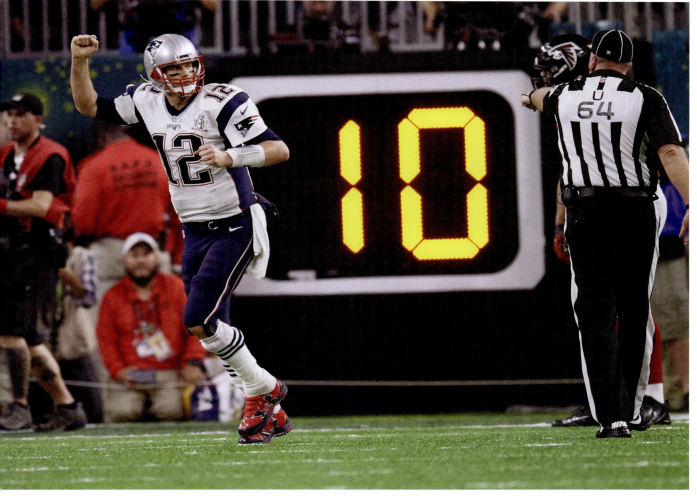

TOM BRADY | 131

room, through a gantlet of hugs and handshakes. He's almost—*no, he can't be*—emotional? He's still laughing.

It's easy to forget, especially for those outside New England, that Kraft has long clung to his own process, same as his coach and his quarterback. He hired Belichick after the forgettable Cleveland Years (five seasons, 36 wins), even when NFL insiders advised him not to. Then he gifted his new coach absolute power, and that led to finding Brady in the sixth round, Edelman in the seventh.... Those and a million other decisions led to this season, this Super Bowl.

Curtis Martin, a Hall of Fame running back who played three seasons in Foxborough, came to understand Kraft when he visited the owner's cardboard-box factory 20 years ago. There, Martin witnessed the dozens of steps it took to fashion something so simple, how product was discarded for even the slightest defect. Martin visited Israel with Kraft and became a regular at family dinners, and he says he saw how Kraft carries the same approach into football. "He should get more credit for the Patriots' dynasty," Martin says. "He's one of the main reasons they've done so well. I believe it starts with him."

Even this season, as Kraft fumed over Brady's suspension and what he saw as Goodell's overreach of power, the Patriots' owner didn't let his feelings turn into distractions. He let his coach plan and his quarterback throw. After he kissed Brady on the cheek, he said, "[Tom] was the greatest before this. He just proved it to people who didn't want to believe it."

CONFIDANTS LIKE JAY Feely, a retired place-kicker who played with Brady at Michigan, describe this season as "personal" for the quarterback. Brady may train inside a bubble of silly wealth and unfathomable celebrity, but he's also an actual person, one who friends say is fully aware that he's now as polarizing as he is popular. (According to Nielsen's celebrity indexes, Brady's "awareness" score ranked highest among NFL players this year, but his "likability" score fell into the bottom 3%.)

"He'll never say it, but this game is as important as any Super Bowl he's been in, except maybe the first one," Feely says. "Just to vindicate himself. Guys get suspended for willingly taking steroids, and we're still talking about ball deflation? After two years? That's not the lasting image he wants people to have of him."

Brady, for his part, continued Sunday with his standard deflections, saying little, answering anything even remotely controversial with "I'm a positive person" or "I've moved on" or "They're all special." But those close to him—Guerrero, Kraft, Feely, his father—knew what Sunday meant.

As the game drew closer, Brady told friends his "next ring" was his "best ring," a line he stole from Falk. After the Patriots walloped the Steelers in the AFC title game, the Michigan equipment manager sent Brady a text: *You're looking for your best ring right now.* Within 30 minutes Brady texted back in agreement.

Still, Brady never uses the word *legacy*. He never considers his place in NFL history, not when he reached his seventh championship game and not when he hoisted the Lombardi Trophy for a record fifth time. The numbers—career Super Bowl records for completions (207), passing yards (2,071) and TD passes (15)—make a compelling case for Brady as the greatest quarterback in league history, if not the single greatest player.

"I always felt Jim Brown was the best ever," says Rice. "But Tom Brady, you have to put him up there."

"No one's done it better," says Hall of Fame quarterback Joe Namath. "No one is comparable in dealing with the game, the way it's changed."

"He doesn't even need to win," Super Bowl champion Kurt Warner said before Sunday. "He's already the best."

"The greatest," says Hall of Fame cornerback Deion Sanders.

"No one better," says four-time All-Pro cornerback Darrelle Revis, a former teammate.

What's remarkable, and largely without precedent, is that Brady turned in one of his best seasons at an age when most elite quarterbacks—*cough, Peyton Manning, cough*—are floating wobbly spirals into retirement. At 39, Brady threw 28 touchdowns

SUSPENDED DISBELIEF

Brady knelt to the ground at the end of the game, perhaps overwhelmed by the moment. His performance earned him his fourth Super Bowl MVP award.

against only two interceptions; he led the AFC in passer rating (112.2); and on passes that traveled more than 20 yards in the air—the throws aging QBs struggle with—he had the highest rating of his career (121.5). "Athletes slow down as they get older, but with quarterbacks it's a little different," says Matt Hasselbeck, who retired at 40 and now commentates for ESPN. "If you're able to stay healthy, the chances of you playing your best football are better when you're in your mid-to-late 30s. But what he's doing is even more extreme. You're seeing a paradigm shift in how the league looks at the position."

Brady has his habits: meditation, a plant-based diet (no dairy, caffeine, white flour, iodized salt or white sugar), all the stretching that Feely says turned the quarterback into Gumby. That's his process, just as Edelman, Belichick and Kraft have theirs.

As Brady leaves the stadium on Sunday he refuses to speculate about his future, but the idea that he might soon retire sounds downright laughable. He lost a starting tackle, Sebastian Vollmer, for the season and his top target, tight end Rob Gronkowski, for eight games and his most versatile running back, Lewis, for nine weeks. None of that mattered. None of that ever seems to matter.

"I don't think people believed us when we said Tom could play to 45 or beyond," says Guerrero. "I still don't know if they believe. But Tommy and I, we believe it.

"I'm sure we'll be back at it in a couple of weeks." ■

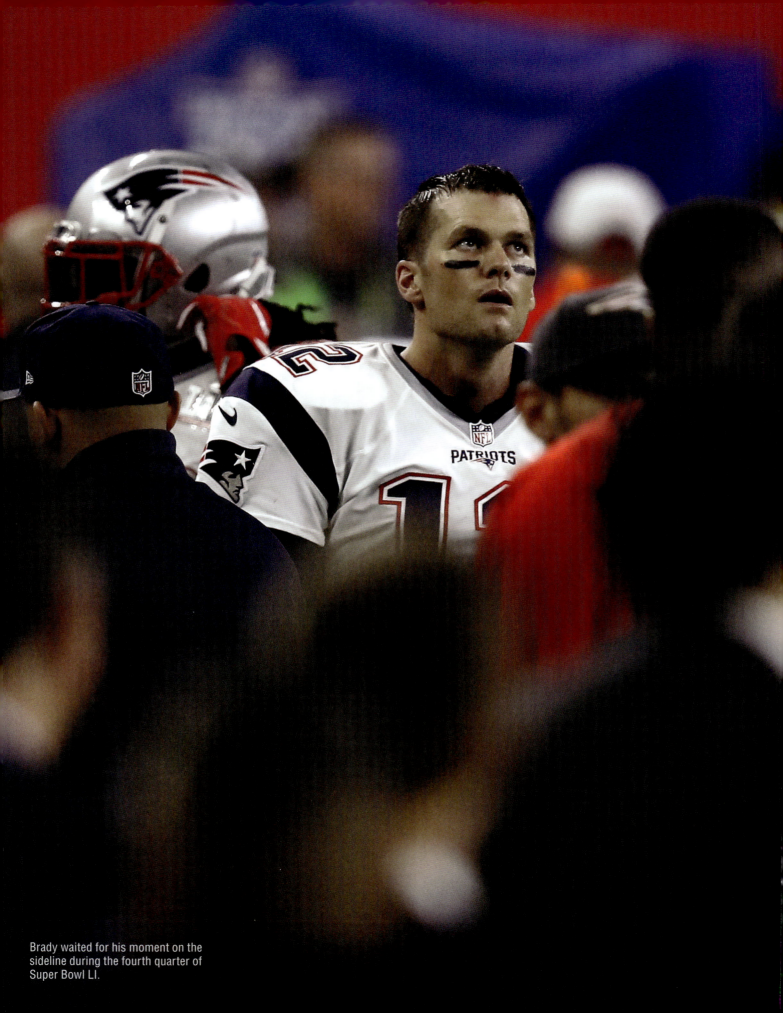

Brady waited for his moment on the sideline during the fourth quarter of Super Bowl LI.

Excerpted from SPORTS ILLUSTRATED
March 6, 2017

FIVE WILL GET YOU ZEN

IN AN EXCLUSIVE INTERVIEW, THE SUPER BOWL LI MVP EXPLAINS

HOW FIVE SUPER BOWL TROPHIES HAVE LEFT HIM FEELING IMPERVIOUS

TO STRESS, AGE, THE COMMISSIONER...

BY

PETER KING

FIVE WILL GET YOU ZEN

TOM BRADY IS A TOUGH NUT. Except for three hours on 16 or so fall and winter days, you don't see him sweat—literally or figuratively. At a podium in front of reporters, he has perfected the art of saying precious little. Even in the face of a four-game suspension last season, handed down by NFL commissioner Roger Goodell in the Deflategate controversy, Brady verbally veered whenever the subject came up. Time and again he had the chance to plant little seeds of vengeance. He didn't do it, ever.

He must be pissed off. He must want to kill Goodell. Watch him stick it to the commissioner when the Patriots win the Super Bowl.

Particularly notable to me: Brady was open and forthcoming. This was not press-conference Brady or radio-show Brady. He wanted to talk—about the Super Bowl, the dramatic touchdown-field-goal-touchdown-touchdown-touchdown finish for the Patriots, and about what makes him tick.

I found what he said so compelling because it flew in the face of what the public and the media felt he must be thinking. And who knows? Deep down, if the veneer gets stripped away three decades from now, maybe he'll spew some venom about the events of the past two years, when Goodell and the NFL convicted him without overwhelming evidence of a scheme to remove air from footballs to make them easier to grip and throw. Maybe. But I'm not

> "I GUESS THE POINT IS, WHEN YOU SUBJECT YOURSELF TO A LOT OF CRITICISM, WHAT I'VE LEARNED FROM MYSELF IS, I DON'T WANT TO GIVE MY POWER AWAY TO OTHER PEOPLE BY LETTING MY OWN EMOTIONS BE SUBJECTED TO WHAT THEIR THOUGHTS OR OPINIONS ARE." —TOM BRADY

That's what America thought. And maybe, deep down, that's exactly the way Brady feels.

Or maybe Brady's a different guy.

EXACTLY A WEEK after Super Bowl LI, I traveled to the Brady family's Montana hideaway to talk about the Patriots' historic comeback from 25 points down in a 34–28 victory against the Falcons. Brady met me in a camouflage jacket and ski pants, with a big smile. It stayed there for much of the two hours we spent talking. We sat in what he called a cabin but I'd say would pass for a Four Seasons–style luxury retreat: rustic on the outside, seemingly appointed by a Beverly Hills designer on the inside, windows in every room looking out on majestic Big Sky scenery. It was a gorgeous midwinter day, with a mountain over his left shoulder that looked as if it were painted.

so sure. As New England offensive coordinator Josh McDaniels said after the Super Bowl, Brady hasn't brought up his suspension around the team, and, from what McDaniels could tell, he hasn't even privately had a bitter moment since he walked back into the Patriots' locker room in October.

"I guess the point is," Brady began, "when you subject yourself to a lot of criticism, what I've learned from myself is, I don't want to give my power away to other people by letting my own emotions be subjected to what their thoughts or opinions are. So if someone calls me something, that's their problem. It's not my problem. I'm not going to give away my power. You can call me an a------ and I am going to smile at you probably. I'm not going to say, 'No, you're an a------.' Because that person is controlling me with what their thoughts and actions are. How can you go through life, now at this point, 17 years

136 SPORTS ILLUSTRATED

FIVE WILL GET YOU ZEN

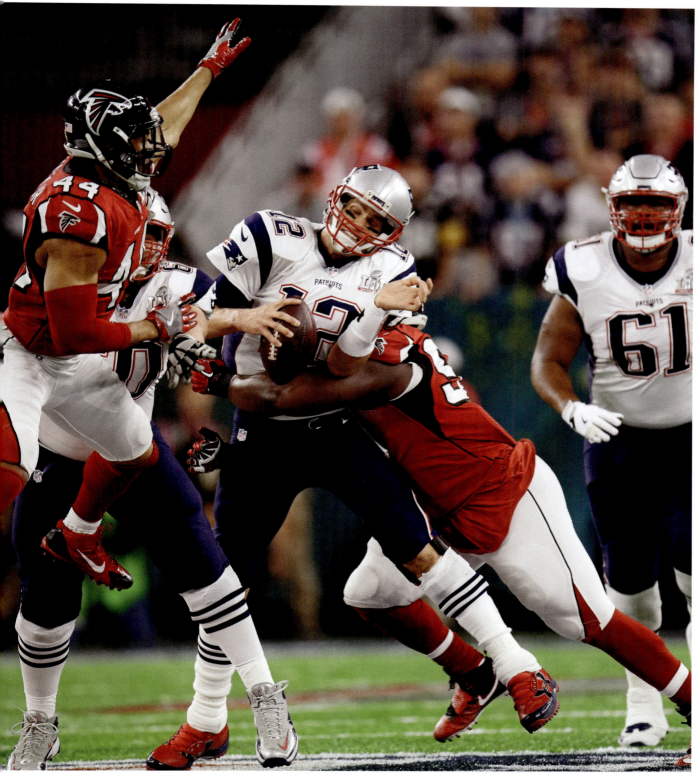

Atlanta initially held Brady and the Patriots in check, and led 21–3 at halftime.

FIVE WILL GET YOU ZEN

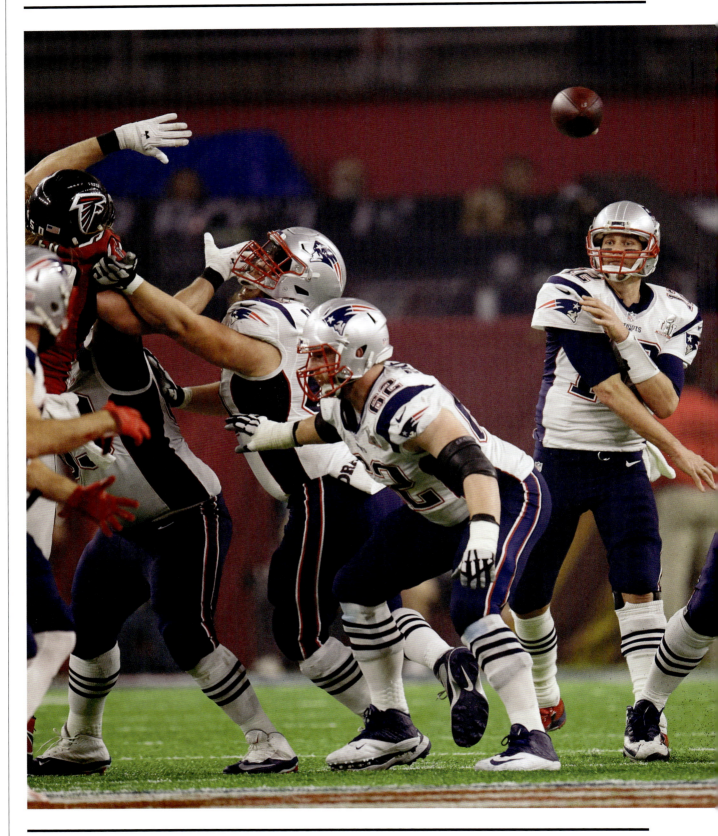

FIVE WILL GET YOU ZEN

[in the NFL], being affected all the time with what someone says?"

But, I said, the difference here was this wasn't someone calling you something. This was someone taking away what you love, for a quarter of the season.

"Well, what's the best way to fight that?" Brady said. "There's only one fight I can win, and that is how well I play.... Why let anything get in the way of that? You start giving your power away to other people, it's a tough life. I am a very positive person. I'd say I am very much an introvert, more like my mom than my dad. If it is up to me, it would just be dinner with my family and let's go to bed.... Other people's attitudes towards me aren't necessarily my attitudes. So why don't I just compartmentalize?

"Not giving away my power to anybody has been something that I've had to learn, and I've learned it the hard way."

If that comes across as a little self-helpish, a little too Tony Robbins, think of it like this: What would help Brady beat the Ravens in a big Monday-night game in December? Spending time on his drive home three nights before the game envisioning the best routes to throw to beat Jimmy Smith and Eric Weddle, or envisioning what he might say to Goodell if the Patriots end up in the Super Bowl and win it, and Brady is the MVP, and Goodell hands him the MVP trophy the day after the game?

It can't be easy to compartmentalize like that. But during our conversation, when we talked football or Deflategate or the future or his mental or physical fitness, one word came to mind: *Zen*. There was a placidity to Brady. When I brought up his lost game jersey ("stolen" is more like it; his game-worn number 12 was apparently pilfered from his equipment bag in the postgame locker room in Houston), which he apparently wanted to give to his cancer-stricken mother, he had the same even look on his face. Not

In the second half and overtime, Brady and the Patriots scored 31 points to complete a historic comeback.

TOM BRADY

FIVE WILL GET YOU ZEN

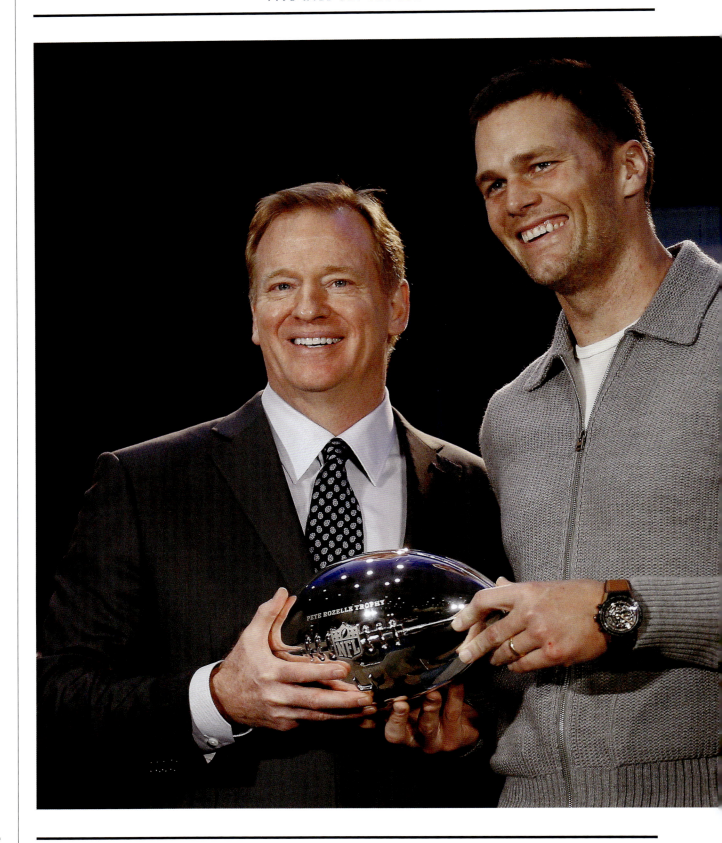

FIVE WILL GET YOU ZEN

pained, not angry. He said, "I wanted to keep that jersey, but somebody got to it. It is what it is. It's a jersey."

That's the kind of don't-sweat-the-small-stuff mentality Brady hopes he can maintain for a few more years. He told me he wants to play "until my mid-40s. Other than playing football, the other thing I love to do is prepare to play football."

He has no doubt he can, as crazy as it sounds. "I have the answers to the test now," he said. "You can't surprise me on defense. I've seen it all."

Mentally, that's Brady at 39.

PHYSICALLY, WHAT'S BRADY at 39?

The next time he takes the field, he'll be 40. (His birthday is Aug. 3.) He took a physical battering in the Super Bowl—five sacks, nine significant knockdowns or hits, including one on the game-tying drive by Falcons tackle Grady Jarrett that knocked Brady woozy. Remarkably, seven days after the game and a football season of hard knocks, he said he felt 100%, with no pain.

He attributes his physical condition to the regimen—diet, exercise, stretching—he says saved his football life. Since 2009 the Patriots have played 145 games, and Brady has started all but four of those—the ones he spent on suspension in 2016. The way he's feeling now, he hopes he can play six more seasons. That sounds crazy, and maybe it is. But try telling that to Brady after a year in which he threw 35 touchdown passes and just five interceptions.

Late in our session together we walked outside the cabin to look at the Montana majesty. We talked about fitness. "Feel my arm," he said.

He held his right arm out and flexed. The forearms of most football players, including most quarterbacks, are rock hard. Brady's was not. His was pliable. That's the way he wants it. He doesn't want his muscles to be solid; he wants them to be flexible and pliant, but strong.

Brady accepted the MVP trophy from NFL commissioner Roger Goodell, the man who had suspended him for four games after Deflategate.

"Strength is very important to [my] job," Brady said. "But how much strength do you need? You only need the strength to withstand the hits and throw the ball and make your movements of being a quarterback. You need conditioning because you need to be able to do that over a period of time, certainly a season. You need muscle pliability—long, soft muscles—in order to be durable.

"If you're a receiver and you have a great game, say you have eight catches. And you play eight games a season, and you're hurt the other eight. Eight catches times eight games is 64. That's a below-average season for any receiver. If you play 16 games with an average of eight catches, you're an All-Pro. The difference is durability.

"How do you work on durability? That's what I've figured out. I know how to be durable. It's hard for me to get hurt, knock on wood. Anything can happen in football, but I want to put myself in a position to be able to withstand the car crash before I get in the car crash. I don't want to go in there and say, 'Oh God, I know this muscle is really tight…. Let's see if it can hold up to someone falling on me who is 300 pounds.' Then someone lands on you and a rotator cuff tears. I could have told you that was probably going to happen. It's going to be really hard for me to have a muscle injury, based on the health of my muscle tissue and the way I try to take care of it. Your muscle and your body allow you to play this great sport."

He talked about pro football's obsession with building strength. When you get really strong, what do you do? Lift more weights. Get even stronger. That's not Brady's thing. What he'd like, most notably, is to play for several more years, to prove to the next generation, and the generation after that, that there's another way.

"I can be an ambassador to play this great sport of football, a contact sport, but [I can also teach] how to take care of yourself so you don't feel like you're 60

Brady returned to the locker room after Super Bowl LI to find his game-worn jersey missing; the QB had planned to give it to his mother.

FIVE WILL GET YOU ZEN

TOM BRADY

FIVE WILL GET YOU ZEN

FIVE WILL GET YOU ZEN

Brady celebrated his sixth Super Bowl victory during the team's championship parade in Boston.

years old when you're in your mid-30s," Brady said. "It's about making the right choices. It's not more effort. Everyone puts in effort. Everyone wants to do the right thing. They just don't know what it is. How sad is it to see Tiger Woods withdraw from a golf tournament? You're watching the greatest golfer I've ever seen not be able to play a sport at an age, to me, that's hard to imagine. It's kind of sad."

JOHN ELWAY WAS retired at 39. Joe Montana at 39, retired. Dan Marino at 39, retired. Brett Favre had his last great year, for the Vikings, at 40. Warren Moon was pretty decent for Seattle at 41, in his last good season. George Blanda was a part-time savior for the Raiders at 43, in 1970.

But there are no comparables for a player at this advanced an age playing multiple years at such a high level.

Montana, the man Brady is most often compared with in history, had his best three seasons in succession at 31, 32 and 33, from 1987 through '89. The Niners won two Super Bowls in those three years, and they went 35–9 in games Montana started, including playoffs. He threw 94 touchdowns and 33 interceptions in those three seasons.

In Brady's most recent three seasons, at 37, 38 and 39, the Patriots won two Super Bowls. They went 42–10 in games Brady started, including playoffs. Brady's touchdown-to-interception differential: 117 to 27. It's absolutely crazy to think that—maybe—Brady in his late 30s was as good as Montana ever was.

No one knows how long Brady has left in pro football. "I know next season's not my last year," he said. But what is? 2019, at 42? 2022, at 45? Whatever the case, it's clear that he's not going to worry too much about the future. You see it in his face on a breathtaking Montana afternoon. He's not worried about anything. ■

Excerpted from **SI.COM**
July 26, 2017

LIVING LIKE TOM

THERAPEUTIC PAJAMAS? VIBRATING FOAM ROLLERS? BRAIN GAMES?
ONE WRITER TAKES ON THE FAMED TB12 METHOD AND FINDS THAT
TOM BRADY'S LIFE ISN'T AS CRAZY AS YOU MAY THINK

BY
GREG BISHOP

THE ASSESSMENT STARTS INSIDE THE PERSEVERANCE ROOM, atop the black-leather exam table where I'm sitting as David Merson frowns. He's checking the symmetry of my ankles, hamstrings, glutes, hips and abdomen, digging his fingers into my sportswriter's not-yet-a-dad-but-already-a-dad-bod physique, telling me to lift this leg and push that one. "The way your hip moves here signifies tightness, restriction and decreased muscle activation," he says.

We're inside the TB12 Sports Therapy Center, which is located in a strip mall in Foxborough, near a Dunkin' Donuts, a Five Guys burger joint and a Menchie's frozen yogurt spot. The window signs of those establishments do not yet torture me. This is Day 1—the first hours of the two weeks I spent trying to live like Tom Brady, which is why I'm in this room with Merson, who is a body coach. Soon he will be my body coach.

Brady famously has one too, in his business partner and confidant Alex Guerrero. Together they opened the center in 2013 and hired folks like Merson to handle the other elite athletes who rehab there. That and the schlubs, like yours truly, who venture in off the street. All told, they have about 2,000 clients. I've written several times about Brady and Guerrero's process, what they call the TB12 Method. I'm here to better understand it.

"Oh, yeah, see?" Merson says, prodding into my abdomen likes he's trying to extract an intestine while motioning to Guerrero, who nods and smiles—smiles!—as I wince.

"That's from sitting at a desk all day," Merson continues. "You drink a lot of coffee, huh?"

"Little dried out?" Guerrero asks.

LIVING LIKE TOM

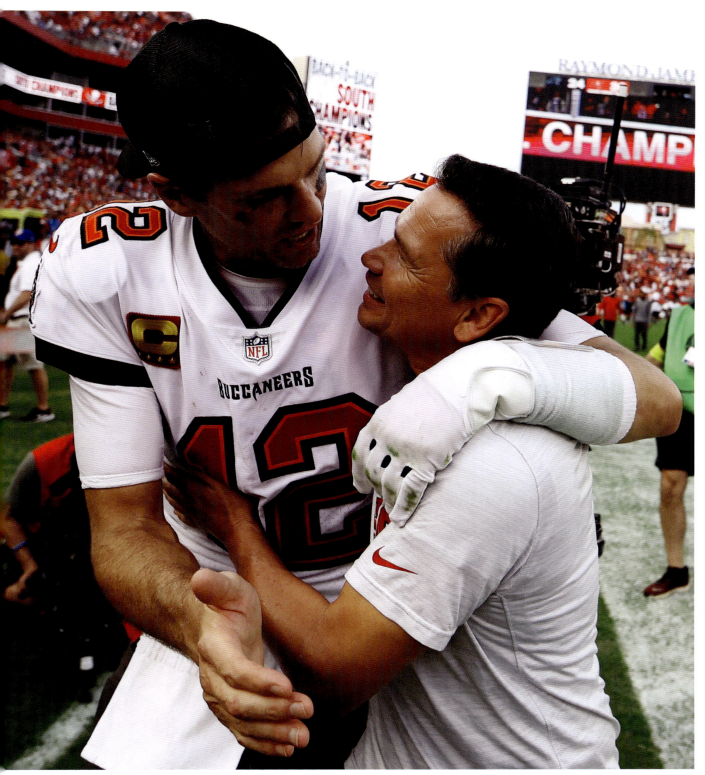

Brady walked off the field with Alex Guerrero after defeating Carolina in 2023.

LIVING LIKE TOM

LIVING LIKE TOM

Merson then hands over a water bottle adorned with the TB12 logo, which is ubiquitous around here. The water tastes like water, only a little saltier, because Merson added an electrolyte solution.

Then Merson goes to work, his hands moving up my body's kinetic chain, massaging and twisting from ankle to core. Every time he finishes in one spot, the muscles there feel better instantly—looser, less restricted and a little tingly. "When you're that good, it works that quickly," he says.

Merson talks as I grimace through what he and Guerrero call "soft-tissue performance treatment," designed to increase blood flow, improve tissue pliability and reduce tightness in muscles. "Knowing how hard Tom works and seeing what the effort is, I just don't think it's matched," he says. "I know we're going to outwork people."

Speaking of, he adds, "We have some work to do."

STILL DAY 1: We head next onto a small turf field that sits between eight therapy rooms, each with the most Tom Brady–esque name ever. The We-Got-This Room … the Grit Room.… We perform balance tests, steadying on one foot with both arms bent 90 degrees at the elbows. (I can't do this on my left side; I fractured a pinkie toe one week earlier by snagging my foot on a doorway.) Merson finds both my alignment and stability lacking, especially when balancing on an unstable surface. "You're not ready for that," he says.

We move on to planks, then resistance-band exercises, which prove harder than they appear. Merson corrects my form for each drill and expresses surprise when he notices an increase in my heart rate. Dude is used to elite athletes, I tell myself.

He hands over another water bottle and explains the TB12 philosophy on hydration. They want to turn every drink into a sports drink, like

A look inside the TB12 Performance & Recovery Center in Boston's Back Bay.

TOM BRADY

LIVING LIKE TOM

Gatorade without the sugar. "We put electrolytes in everything," Merson says. "They have trace minerals, which are what make up our muscle tissue, our nervous tissue." He suggests I down 97 ounces of water a day. Additionally, for every ounce of soda, beer, coffee or carbonated beverage consumed, he recommends taking in an additional three ounces of electrolyte-laced water, and every ounce of hard alcohol should be replaced with six ounces of high-quality H20. That's why, he says, many athletes choose not to drink.

Fancy water in hand, we go back to the Perseverance Room, where my body coach sits at a laptop and goes over my diet. He finds my regimen, which consists of things like turkey sandwiches and fruit shakes, to be lacking in protein. He says I take in too much sugar (Brady mostly abstains), way too much dairy (he doesn't eat any) and far too many carbs (another no-no). Merson describes some of the foods I'd consider relatively healthy (strawberries, tomatoes, bell peppers) as pro-inflammatory. He says they'll increase the inflammation in my body for up to 72 hours.

Merson sends me on my way, promising to review my diet options with Guerrero. He also gives me a compression sleeve to wear over my foot at night; he says it will speed the healing in my toe. Then he suggests I eat fish for dinner. I hand him what's left of my coffee as I walk out. Later that night I order a sashimi platter and edamame from the sushi spot across the street from my hotel. I put electrolytes in the water. I tug on my compression sleeve as I go to bed.

I sleep as well as I have in months.

DAY 2: To be honest, I'm skeptical. Some of what Guerrero and Brady preach is common sense. But other things—the recovery pajamas, the whole don't-eat-tomatoes thing—seem a little over the top. And yet, when I wake up and remove my sleeve, my toe is half as swollen as before. I audibly gasp.

As his career progressed, Brady was rarely far away from a TB12-approved bottle of water.

LIVING LIKE TOM

Following Merson's instructions, I eat eggs—just eggs, plus electrolyte water—for breakfast. I go back to TB12 later that afternoon and sit in the lobby, waiting for my body coach. A TV airs Fox News, and copies of SPORTS ILLUSTRATED are scattered on tables. I update Merson on my progress, the gains that have been more immediate than expected.

He asks what I've learned so far, and I cite the number of choices one has to make to live like Brady. "Holistic" is a word he uses, and that's exactly how it feels. These choices have to be made consistently, day after day, week after cheeseburgerless week.

Merson and I head back to the turf to try out a vibrating foam roller that eases muscle soreness, improving blood flow where needed. For me that means putting the roller under my feet, calves, hamstrings, back and shoulders—everywhere, basically. Those muscles feel better right away. There are three settings, ranging from something like "smooth massage" to "jackhammer mode." We try the lightest one.

Next we move on to brain games, which Brady does every day on a laptop or on his iPad. They work like this: Three balls appear; they start to move around, and then more balls are introduced; you have to point out the original balls. Another game: Twelve birds flash on the screen, one with dark wings, and you have to click on the quadrant of the screen where the dark-winged bird was located when the birds disappear. Brady cycles through 29 games that train attention, memory, brain speed, navigation, people skills and intelligence.

"This is your coffee!" Merson says, a little too enthusiastically.

The session ends. I eat a salad with chicken for lunch and a grilled bass, to-go, from a nearby restaurant for dinner. Then I sign up for the brain games online and yank on my compression sleeve. It feels a bit like I've joined a cult, the possibilities spread wide.

I am Tom Brady.

DAY 3: Guerrero meets me in the lobby in the afternoon, and we retreat to the Competition Room. The wall showed a basketball player throwing down a reverse dunk, next to a quote from Michael Jordan: Some people want it to happen. Some wish it would happen. Others make it happen. Sounds cliché, my skeptical sportswriter brain says. I want to connect my experience to Brady's everyday routine. We start with muscle pliability, all that soft-tissue work, which Guerrero describes as "the core of our message" and "the foundation of any athlete." He says this is the first thing he worked on with Brady back when the QB was in his 20s and constantly in pain from football.

In the 13 years since they met, Guerrero and Brady evolved their program until it became their way of life. They changed Brady's diet. They replaced weight training with resistance bands. A few years ago they added the cognitive training. "Most athletes are really good at taking care of their bodies," Guerrero says, "but they never look at taking care of their brains. They get annual physicals, blood tests; they check everything except their brains." Guerrero says Brady ranks in the 99th percentile on every one of those games now.

Speaking of the diet, Guerrero says straight-faced, "It's not that restrictive." He says Brady enjoys pizza and takes his children out for ice cream—not just his infamous avocado-based version. Every once in a while they'll eat cheeseburgers. (Really? When? "Probably March or April ... definitely in the off-season," he says. They would never, ever, ever eat a cheeseburger in-season.) As for the sleeve I've been wearing on my foot, Guerrero says it's made from the same material used in Under Armour's TB12 recovery sleepwear that writers so often poke fun at. "We get mocked all the time," Guerrero says, "because we are really progressive that way."

Here's how Guerrero explains the technology, which he calls a kind of infrared therapy: Far infrared is a type of energy on the electromagnetic spectrum, and some claim it (vaguely) benefits the human body. If a sleeve—or some sports jammies—contains some far infrared–emitting ceramics in the fabric, the body's natural heat reflects that energy back into the skin.

Regardless, when Brady absorbed a forceful hit from Seahawks safety Kam Chancellor last fall, he suffered a deep bruise, and Guerrero says, "I put the sleeve on his quad and then wrapped an ACE bandage around it to keep it there. Then he played every week and didn't miss a game."

LIVING LIKE TOM

"When he got tackled by Ndamukong Suh," Guerrero continues, "it was nasty, but he had that sleeve on. His ankle was huge, purple, swollen, and we worked it. He didn't even miss practice."

DAY 5: Back home in Washington now, it's time to order some TB12 merch. It takes only a few clicks to learn that living like Brady is not cheap. A jar of protein powder: $54. A 50ml bottle of electrolytes: $15. Twelve protein bars, made with ingredients like raw almonds, lemon juice powder, coconut oil and Himalayan pink salt: $50. Throw in a set of resistance bands ($154) and a vibrating foam roller ($200), and a basic TB12 starter kit costs upward of $400.

DAY 7: The bruising on my toe has disappeared, as has most of the swelling. When I step on the scale, it blinks back 182—I've lost 12 pounds. My caffeine consumption is limited to one shot of

of restaurant waiters about the ingredients in their sauces.

DAY 14: I weigh in at 178 pounds. I replace the batteries in the scale; it's not broken. I'm down four more.

I'm a walking advertisement for TB12, which is a little awkward given my status as a journalist. But it's working. I extol the virtues of electrolytes to strangers, tell friends about the diet and add "brain exercises" to my to-do list every morning. I progress to the second level with the vibrating fitness roller. I even consider buying some recovery-pajamas ... but decide against it.

DAY 21: Everything hurts. My feet scream, my legs ache. The folks at TB12 are responsible for this, and that's a good thing.

I spent Friday and Saturday in a Ragnar Relay, one of those road races that lasts more than

IN THE 13 YEARS SINCE THEY MET, GUERRERO AND BRADY EVOLVED THEIR PROGRAM UNTIL IT BECAME THEIR WAY OF LIFE. THEY CHANGED BRADY'S DIET. THEY REPLACED WEIGHT TRAINING WITH RESISTANCE BANDS.

espresso each morning. Drinking the recommended amount of water is annoying, necessitating many bathroom breaks, but the diet proves manageable: eggs in the morning, chicken salad for lunch, and fish and vegetables for dinner. The impact is immediate. I sleep better and feel more rested; I no longer require three cups of coffee to power through a day. I remain skeptical, but less so.

DAY 8: It's July 4—but no hot dogs for me. No strawberries, either. When I splurge on a couple beers, I lap up cups of water in between.

DAY 10: My toe heals enough for my less-than-triumphant return to the gym. I ride the stationary bike for 45 minutes. I no longer wear a walking boot. I'm crushing the brain games.

It feels as if I'm starting to become addicted to this routine. I eat a chicken salad at a baseball game and wave goodbye to soda. I ask annoying questions

36 hours and covers roughly 200 miles. My team ran from Blaine, Wash., up near the Canadian border, to Langley, which is 35 miles north of Seattle. Without having run since I hurt my toe—and having slept 12 hours combined the entire week before while covering the Floyd Mayweather Jr.-Conor McGregor press tour— I was responsible for three legs and 15.8 miles. I drank the electrolyte water and stuffed my foot into the compression sleeve between runs and not only did I finish but I averaged under 10 minutes per mile for my portion, without training or any stretch of sleep longer than two hours. My last leg was seven miles, more than half of it uphill, and I'm convinced I would not have finished if I had not lost the weight, followed the program or gone to TB12. Consider me a well-hydrated convert. ▪

Excerpted from SPORTS ILLUSTRATED
February 11, 2019

LET'S TALK ABOUT SIX

PUT AN OBSTACLE IN FRONT OF THE PATRIOTS—LIKE L.A.'S SUPERCHARGED
OFFENSE—AND WATCH THEM OBLITERATE IT. THEIR SUPER BOWL LIII VICTORY
MAY NOT HAVE BEEN FUN TO WATCH, BUT FOR THOSE WHO APPRECIATE
DYNASTIES, THERE WERE PLENTY OF MOMENTS TO SAVOR

BY
GREG BISHOP AND **BEN BASKIN**

INSIDE A BALLROOM AT THE HYATT
REGENCY IN DOWNTOWN ATLANTA, bass
thumps so loudly that the ground shakes.
Ludacris is onstage, rapping about greatness,
as Robert Kraft reclines on a white couch in
the VIP area. A gold chain glistening with a
jewelry heist's worth of diamonds hangs around the
Patriots owner's neck.

It's 2:35 on Monday morning. Kraft rises
and retreats to a small room, where he holds up
the chain for inspection, the word *championships*
encrusted in jewels. The rapper Meek Mill gave him
the necklace on Sunday night, after the Patriots
won another Super Bowl, 13–3 over the Rams,
earning Kraft his sixth title in 25 years of own-
ership. Some dubbed the game the Boring Bowl,
but in reality it was classic Patriots: Bill Belichick's
masterful scheme, Tom Brady's impeccable timing,

an undersized receiver's heroics and, at the end,
confetti falling on the field.

Kraft clutches the neckpiece, which weighs
at least 10 pounds, but he's in no hurry to unbur-
den himself of it. "*Championships*," he reads aloud,
drawing out the S and noting that Meek told him to
hang this on one of his trophies.

The party started hours earlier, with a few
thousand guests crammed into this ballroom, and
several dozen more of the most important members
of Kraft's dynasty packed into three rooms down-
stairs. Attendees wear silver wristbands for Brady's
private event, blue bands for Belichick's and white
bands to celebrate with Kraft. Garden hedges lead
back to the private rooms, like some sort of imperial
maze. All around the bars are open, the buttermilk
biscuits laid out, filleted Chilean sea bass on offer.
Kraft hands out 50-year-old cigars he saved for the

LET'S TALK ABOUT SIX

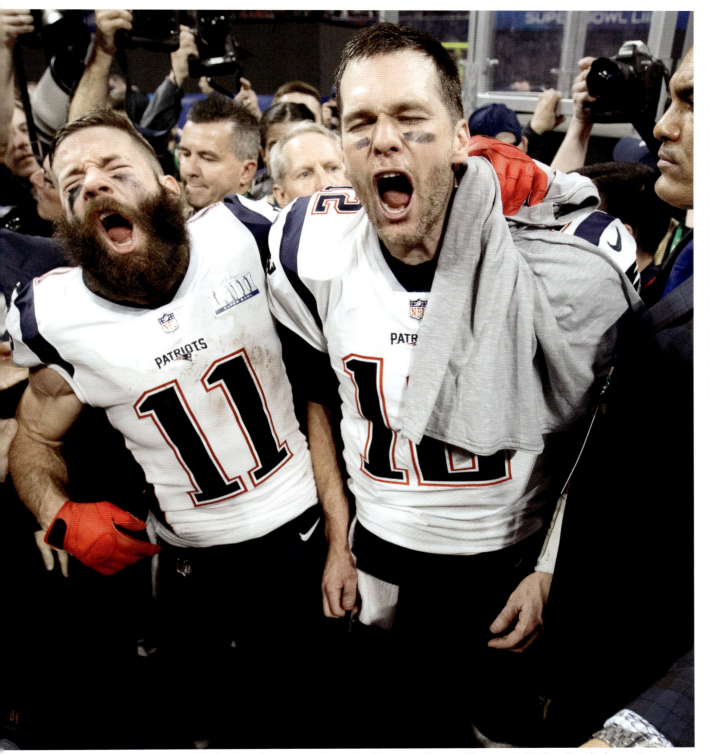

For just the second—and final—time, Brady won a Super Bowl but wasn't named the game's MVP, ceding the honor to Julian Edelman.

LET'S TALK ABOUT SIX

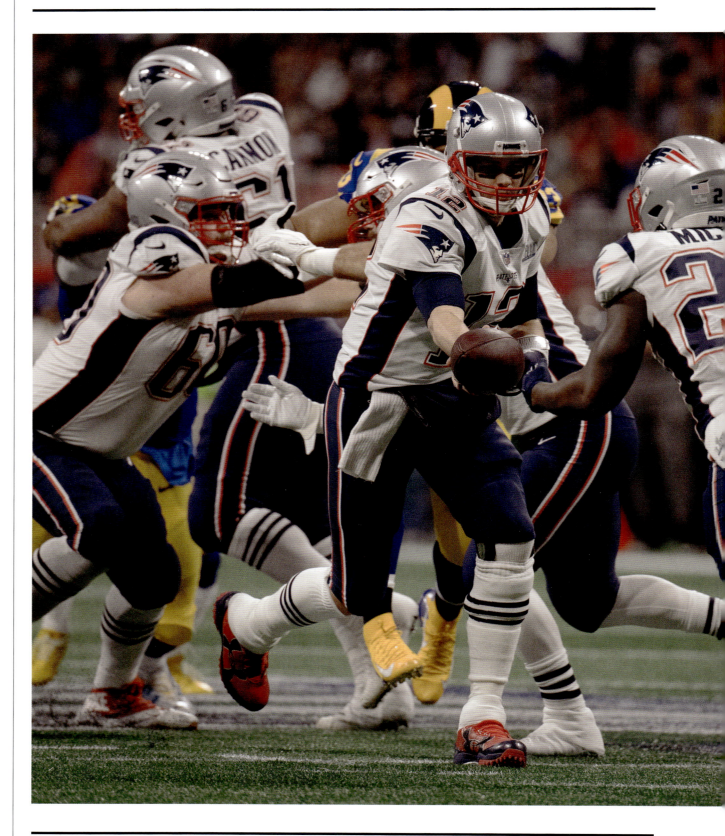

LET'S TALK ABOUT SIX

Brady relied on Sony Michel in a low-scoring game; the running back rushed for 94 yards and the game's only touchdown.

occasion. The Lombardi Trophy rests on a mantle, smudged by kisses and fingertips back at Mercedes-Benz Stadium.

Julian Edelman and his family settle into Kraft's suite. The receiver wears all black, carrying a stogie in one hand, a full glass of whiskey in the other. Chants of "MVP! MVP! MVP!" break out and someone tells Edelman that Snoop Dogg, performing onstage, has requested the presence of the 5'10" twice-star-turned receiver who caught 10 passes for 141 yards. Mic in his hand, Snoop yells, "If you think Tom Brady is the motherf------ G.O.A.T., make some noise!"

Upstairs, above the parties within the party, Kraft doesn't consider the scandals from past seasons, or the internal tension that last year threatened all he'd built. He's more focused on the totality of the franchise's accomplishments, and the underdog mentality his team adopted late in this run, going so far as to display quotes from critics on the TVs throughout One Patriot Place, emphasizing what now seems silly, this notion that the Patriots (*the Patriots!*) weren't expected to win again. It's that very totality, two decades of dominance—a run so long that his own fan base has become inured to the unprecedented success—that makes it easy to forget where all of this started. The humble beginnings. All of the factors that coalesced to create a dynasty that's comparable to any of the previous gold standards.

Of his reign, Kraft says in this quiet room outside the din, "I don't believe it will ever be duplicated. Especially in the age of parity, I don't think it will ever be done again."

TWENTY-FIVE YEARS BEFORE this latest coronation and the gaudy championships necklace, Kraft began planning not just to create a dynasty, but to *sustain* one. This was February 1994, a month after he'd purchased the Patriots for $172 million. He flew with his son Jonathan to meet with 49ers president Carmen Policy, who by then had won

TOM BRADY 157

LET'S TALK ABOUT SIX

three Super Bowls, and they spent the whole day touring the team's facilities in San Francisco. Kraft asked question after question, wanting to know everything, Policy says, "but he was really, really interested in how we maintained [success]."

The most important topic the men discussed, however, was a wrinkle that had just been introduced to the league, and that would redefine pro football: the salary cap. The Patriots, Kraft believed, could exploit the now leveled playing field to invigorate their downtrodden franchise. "Football back then was about who had the deepest pockets, and now it was going to be about who could manage intelligently," says Jonathan. "My father said, 'I like competing on those terms.'"

Six years later Robert Kraft and Policy met again. New England had experienced mixed success in Kraft's time at the helm: two AFC East titles, a Super Bowl reached and lost to the Packers, and two departed coaches. Not exactly the dynasty he had envisioned.

This time the discussion centered around a man who had been fired as the Browns' coach, who had then spent a year as an assistant in Foxborough before a tumultuous two-season stint leading the Jets' defense. Kraft needed a second opinion. Policy spoke highly of Bill Belichick, whom he considered bright and talented. But with his shaky track record, Policy considered the move risky and recommended a safer hire.

Kraft remained torn. Most NFL coaches at the time wanted to be fully removed from cap decisions, but it was obvious that Belichick firmly grasped the intricacies of the new system. Just like Kraft, Belichick thought he could manipulate it to his benefit. "My gut, my instinct, everything inside of me tells me he's the guy we're going to be able to do it with," Kraft told Policy in the end. "And we're going to do it together."

Playing in his ninth Super Bowl, Brady exhibited a level of calmness that only comes from experience.

LET'S TALK ABOUT SIX

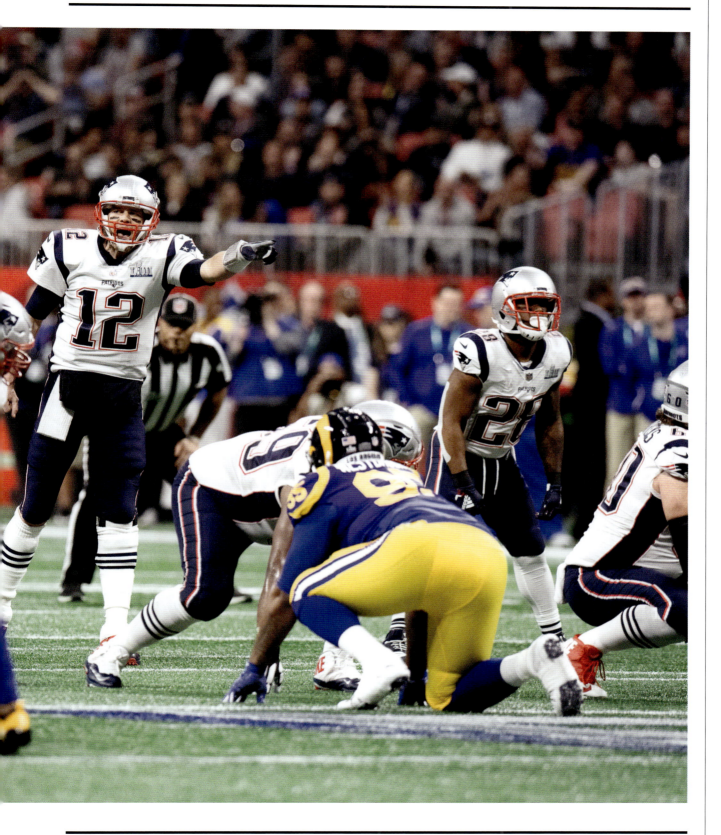

LET'S TALK ABOUT SIX

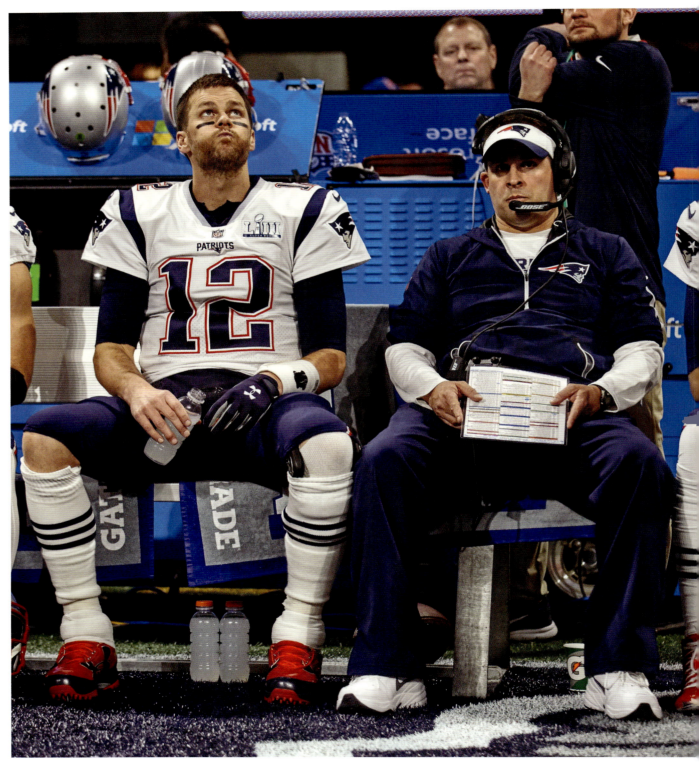

Brady and offensive coordinator Josh McDaniels helped reconfigure New England's offense, relying more on the running game and limiting mistakes.

LET'S TALK ABOUT SIX

DENIS LEARY COULDN'T believe what he was hearing. "You're kidding me," he told his friend and fellow comedian Lenny Clarke. "*Bill Belichick?*"

This was 2004, after two Patriots titles, and Belichick wanted to visit the set of the television show *Rescue Me*, on which Leary and Clarke starred. Leary, a New England native and a longtime Pats fan, warned his friend: Belichick should expect a full 12-hour day.

Clarke had met Belichick four years earlier on a cross-country flight, months after Kraft hired him, and the two had formed the unlikeliest of friendships: the famously loud, uncouth comedian and the notoriously surly, reticent coach. From Boston to Los Angeles they were seatmates while Belichick prepared for his first NFL combine with the Patriots—after which he would draft an ungainly looking QB from Michigan named Tom Brady in the sixth round. In the air, Belichick pored over binder

director? Why all these questions?" Just fascination, Belichick responded. *Process.*

It's easy—all the years and awkward press conferences later—to see Belichick as an emotionless cyborg. The guy who largely stands by himself during games. Mister *On To Cincinnati*. But his set visit showed Leary what lay deeper. "A psychological master," Leary says.

Even at 66, the second-oldest coach in the NFL, Belichick is the same insatiably curious football historian who early on hounded NBA GMs for advice on the salary cap, who argued with the clerks at hotels that didn't have a VCR on which he could watch film, who installed sensory-deprivation float tanks at Gillette Stadium after visiting the U.S. Special Forces.

Back in the fall of 2007, when the Spygate videotaping scandal surfaced, right after the season's first game, Belichick called Clarke on a Friday asking for

> YOUNG TOM DIDN'T PLAY FOOTBALL UNTIL 14, AND EVEN THEN HE DIDN'T PLAY PARTICULARLY WELL. HE WAS THE BACKUP QB ON THE FRESHMAN TEAM AT SERRA HIGH AND NEVER TOOK A SINGLE SNAP, INSTEAD MOONLIGHTING AT LINEBACKER AND TIGHT END.

after binder of notes on seemingly every prospect, each one the size of a phone book. "This guy was working like a mad f------ scientist," Clarke recalls.

On the day Belichick visited the set, he arrived at 5 a.m., signed autographs and posed for pictures. But when Leary offered him a trailer, Belichick declined. He wanted to observe. "Do you guys mind?" he asked.

They did not, and so Belichick pulled out one of those little notebooks he carries on the sideline, along with a sharpened pencil and his Blackberry. He spent the rest of the day taking notes and asking a million questions. *When do the lighting guys come in? Who's the boss? How many guys work for him?*

As the crew broke for lunch, Leary asked Belichick, "Are you thinking about becoming a

a favor. He wanted the comedian to come talk to his team, because, as Clarke says, "it was really f------ tense there." Belichick wanted to lighten the mood.

Clarke brought a video camera, and he started off by holding it up, saying, "They say a picture is worth a thousand words. Evidently *this* is worth a quarter of a million dollars. Who is the f------ idiot that didn't hit *delete*?" The room exploded in laughter. Clarke went on to roast player after player, paying extra attention to Brady, who could only shake his head and laugh at the jokes about his sex life.

"Thank you, you saved my season," Belichick said afterward, and following a win over the Chargers the next day he gave his friend the game ball. "That's his genius," Clarke says.

TOM BRADY 161

LET'S TALK ABOUT SIX

To win a sixth ring a decade later, Belichick would have to outwit a coaching prodigy half his age in 33-year-old Sean McVay. He would have to stop a No. 1–pick QB (and early-season frontrunner for MVP) in Jared Goff, and stifle running back Todd Gurley, the league's touchdown leader. He would have to stymie a Rams offense that, with its extreme flexibility and emphasis on play-action, had been credited with shifting the paradigm for how football could be played.

Instead Belichick made Los Angeles look more like the Jeff Fisher–led "7–9 bulls---" Rams who preceded McVay. Belichick and his defensive coordinator, Brian Flores, confused their opponents, swapping the man coverage they played most of 2018 with various types of zone. That switch forced Goff to hold on to the ball longer than he wanted, allowing the Patriots to sack him four times and force 19 incompletions in 38 attempts. That, says defensive end Adrian Clayborn, was precisely the plan, to rattle Goff by giving him both new and varied looks. On one third-quarter throw, Goff had Brandin Cooks wide open in the end zone. But, under duress, he floated the pass just enough that cornerback Jason McCourty was able to close in, magically covering what seemed like half the field, and bat the ball away.

McVay admitted afterward, he had been "out-coached."

ONE WEEK BEFORE Super Bowl LIII, the original Tom Brady sat in a booth on the second floor at Boudin Bakery in San Francisco, with all of Fisherman's Wharf—seagulls and crab stands—spread below, Alcatraz looming in the distance. He raised his son, the Tom Brady now famous around the world, 30 minutes south, in San Mateo. Raised him to love football and the 49ers and the sublime quarterback play that defined the preeminent NFL dynasty of the 1980s.

Young Tom didn't play football until 14, and even then he didn't play particularly well. He was the backup QB on the freshman team at Serra High and never took a single snap, instead moonlighting at linebacker and tight end. That team, the one he couldn't start for, finished 0–8–1. He was named the starter the next season, and before his first game he came home "beside himself," Tom Sr. says. He told his dad, "I don't know how to throw the ball."

"I think it's the first and only time he had stage fright," the elder Brady says all these years later.

A million things happened between then and now, transforming that Brady into this Brady, breaker of records, wearer of "recovery pajamas," consumer of the strangest diet in sports. His father wears the championship ring from New England's first Super Bowl victory, XXXVI, on his right hand. That title seems like a lifetime ago. Those 2001 Patriots were huge underdogs—*actual* underdogs—playing against a St. Louis Rams offense known as the Greatest Show on Turf.

LET'S TALK ABOUT SIX

RIGHT Edelman was named the game's MVP, catching 10 passes for 141 yards.
BELOW Brady completed 21 of 35 passes for 262 yards.

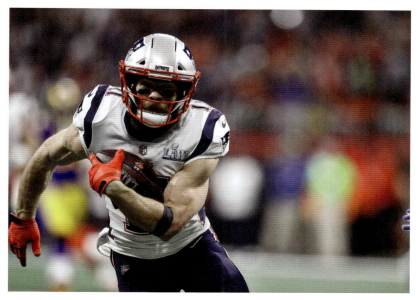

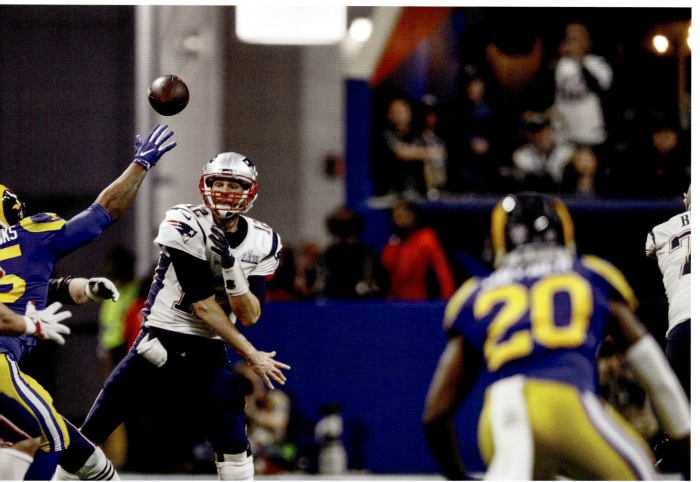

LET'S TALK ABOUT SIX

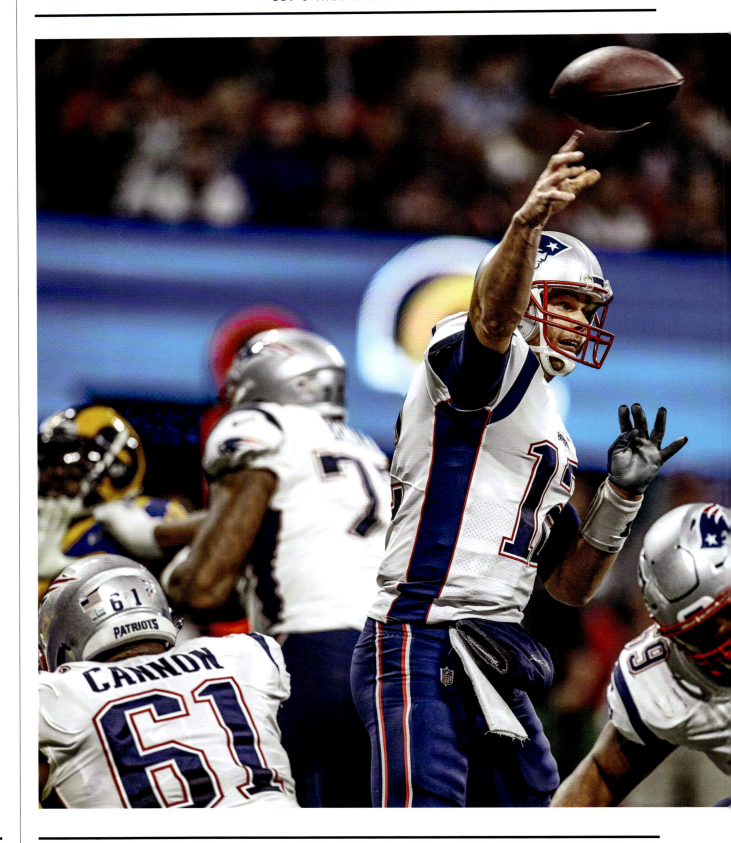

LET'S TALK ABOUT SIX

Flash forward 17 seasons, past four more Super Bowl wins (and three defeats), past the trade last season of presumed successor Jimmy Garoppolo, past the friction of the 2017 season with Belichick. Coach and quarterback came to something of a truce this year, with Belichick allowing Brady's health guru, Alex Guerrero, full access to the star and to the team facility while leaving treatment for the majority of Brady's teammates up to the Pats' medical staff.

In his last championship game, Super Bowl LII, Brady threw for 505 yards and three TDs but lost to the Eagles 41–33. Afterward he stayed up all night, analyzing what went wrong. In the months that followed he did discuss retirement, just not in the way one might think. Brady has long expressed a desire to play until he's 45, and he entertained no thoughts of moving up that timeline. Instead he debated what *retire* really means, how in other cultures many people choose not to retire at all.

The season started slowly, with two losses in the first three games, but Brady moved through it all relatively unscathed. "The thing that was hard about this year was the unevenness of the journey," says Brady Sr. "We're looking like we're missing a few cylinders, then you start to have major worries. But they weathered it." Brady did suffer a minor MCL sprain in his left knee in Week 10, on a trick play—but by the time the injury was reported, in January, it had already healed.

This Patriots season, like most Patriots seasons, gradually built until New England became the best version of itself. Brady ceded throws to a renewed run game. He saw the funk that fell over the locker room after a shocking Week 14 loss at Miami, the game decided on a miracle hook-and-ladder play. That defeat bled into the next week, when the Pats fell at Pittsburgh. Suddenly they no longer seemed invincible; they almost lost their usual playoff bye.

Yet this time Brady didn't have to cope with controversy over deflated footballs, or with a family

Brady became the first player in NFL history to win six Super Bowls, and, at age 41, the oldest quarterback to win and appear in one; the latter was yet another record he would later break himself.

TOM BRADY | 165

LET'S TALK ABOUT SIX

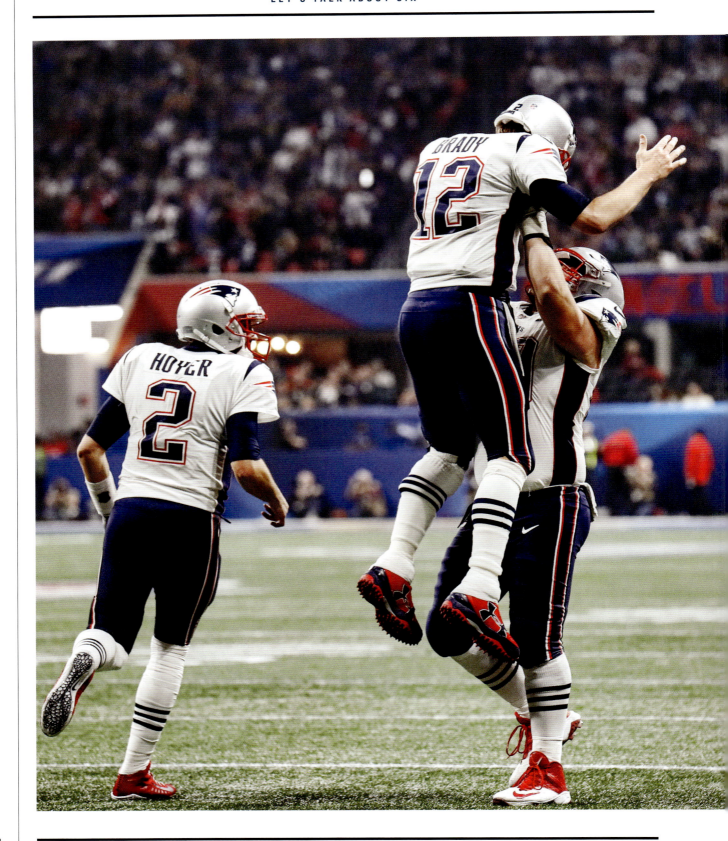

LET'S TALK ABOUT SIX

member fighting cancer (Tom's mother, Galynn, has been healthy in recent years), or with a thumb gash like last winter's, which required 12 stitches. "This run was calmer," says Guerrero. "We talked about this. Like, 'I can't believe we don't really have any issues to deal with.' Zero body issues. No emotional issues. Home life is great. Work life is great. Meanwhile, everyone's saying he's falling off a cliff!"

That feeling of Zen, that unique ability to access *the zone*, was evident in the fourth quarter on Sunday. During a night when the Rams mostly flummoxed Brady, there he was on the decisive drive, finding Rob Gronkowski twice, first hitting the tight end up the right sideline for 18 yards, then two plays later lobbing a pass down the left sideline for 29 more, to the Rams' two-yard line. *Perfect throws. Perfect timing.* On the next play, rookie running back Sony Michel plowed into the end zone, giving New England a 10–3 lead. The game's only touchdown drive went for 69 yards; Brady threw for 67, completing all four of his passes.

Yet this time victory didn't feel quite as inevitable, and the defense had to pick up the slack. It was more reminiscent of the Patriots' first Super Bowl win over the Rams, when Brady walked into the huddle, a 24-year-old sixth-rounder, and calmly told his teammates, "We are going to go down the field and win this f------ football game, and become world champs."

THE TWO COACHING wunderkinds met in 2013, when Brad Stevens, then 36, moved to Boston to lead the Celtics and quickly befriended Josh McDaniels, the Patriots' 37-year-old offensive coordinator. They played golf and sent sympathetic text messages after playoff defeats. But it wasn't all suburban-dad friendliness. They also spent countless hours debating strategy, discussing management and leadership and how best to motivate players. And here, two topics came up often: 1) how coaches

Brady and center David Andrews celebrated after the Patriots scored the game's only touchdown.

TOM BRADY 167

LET'S TALK ABOUT SIX

A victorious Brady hugged teammates after Super Bowl LIII. It would be the QB's last with New England.

should handle success at a young age and 2) how to evolve. "The best teams—*his* best teams—are always flexible," says Stevens.

For McDaniels, adaptation remains a lifelong theme, as central to his own management style as to the Patriots' Way. Growing up in Barberton, Ohio, as the son of a legendary high school coach, Thom McDaniels, Josh watched his father adjust on offense every season. Thom's teams would throw more often when a quarterback's arm warranted an air attack, or hand the ball off 30 times when the talent called for it, or maybe install the option. The key, Thom says, wasn't just to utilize his players' strengths—it was to utilize those strengths while attacking the opposing defense's weaknesses.

in Cleveland. Belichick told McDaniels: Keep evolving.

McDaniels planned to become the Colts' coach around this time last year, after Super Bowl LII. Except the Patriots lost and then, in the days that followed, something about the Indianapolis offer—some *things*—didn't feel right. He won't discuss exactly what changed his mind, but several people close to him and to Patriots ownership confirm that McDaniels met with Kraft for several hours the day after the Super Bowl, last February. Kraft told McDaniels that he desperately wanted him to stay, emphasizing the coordinator's long relationship with Brady and his importance to the franchise, offering a contract that would pay

THE FORMER COMMUNITY COLLEGE QB, JULIAN EDELMAN, TURNED PATRIOTS SPECIAL TEAMER, TURNED BRADY SYCOPHANT, TURNED BRADY BEST BUD HAD, AT THIS MOMENT, OFFICIALLY BECOME A STAR.

And that, says Josh, is "the genesis of everything we do."

McDaniels started as a grad assistant for Nick Saban at Michigan State in 1999, then worked his way up from a Patriots personnel assistant to O.C. in five seasons before being hired as the Broncos' coach in 2009. His time there lasted less than two seasons. Eleven wins and 17 losses.

After that firing McDaniels flew home to Ohio. He told his parents he'd spoken to Belichick, who asked if his mom and dad were doing O.K. Belichick also told McDaniels to learn from the experience, and so Josh created an Excel spreadsheet, lessonslearned.xls, where he reviewed everything from the length of his meetings to his roster-building approach to his development of assistants. If he ever took a head job again, he promised to implement all those changes.

McDaniels returned to New England in 2012, Belichick taking his old coordinator back, the way Bill Parcells had rehired him after five losing seasons

more like a head coach's, upward of $4 million a year.

Thus began another offensive evolution. The Patriots knew they wouldn't have Edelman, their top pass catcher, for the season's first four games after he had been suspended for violating the league's PED policy. They knew that, after trading Cooks to L.A., they lacked a deep threat, and that Gronkowski was past his explosive, transcendent prime. They needed to buy some time, to keep games close, to best utilize what they *did* have. "The Patriots," says Thom McDaniels, "basically view September as an extension of training camp."

They had reconfigured yet again. They traded for Trent Brown, the heaviest player—and one of the most physical right tackles—in the league, then moved him to the left side. They drafted Michel, a versatile playmaker from Georgia, with the 31st pick, marking only the second time Belichick has taken a back in the first round.

TOM BRADY | 169

The answer to all their concerns, says NFL analyst Trent Dilfer, "was to run the ball, use bigger linemen, utilize Gronk as a blocker, don't take a lot of risks, keep games close—and trust Brady to bring us back if we get behind."

On Sunday, after the Patriots had mustered only three points in 10 possessions, McDaniels proved adaptable once again. With the Rams' dominant D-line allowing coordinator Wade Phillips to keep extra defenders in coverage, McDaniels went big, shifting into a jumbo package with rarely used tight end Dwayne Allen. The result: the game's only touchdown drive.

Shape-shifting, just like his dad taught him.

JULIAN EDELMAN LOUNGED on a plush sectional in the living room of a friend's $5.5 million West Hollywood mansion. Feet up, shoes off, his view encompassed a chef's kitchen, a tree-lined pool and a waterfall that doubles as a projector screen. This was July 2017, five months after he made the Catch That Changed Everything—between three defenders, using the leg of one and the arm of another, plucking the ball half a millimeter from the turf in a play that spurred an epic Super Bowl LI comeback against the Falcons.

The former community college QB, turned Patriots special teamer, turned Brady sycophant, turned Brady best bud had, at this moment, officially become a star. In the previous few months he'd done the late-night talk show circuit and posed naked for the cover of *ESPN*'s Body Issue. He was also in the beginning stages of writing a sitcom based on his life, with a six-episode arc already drawn up and a tentative title, *Mr. Irrelevant*. This marked a dramatic departure for the receiver whose origin story reads like the Labors of Hercules.

"Then it fell off a cliff," says his father, Frank. "Just like that. Over."

On a routine cut in the Patriots' third preseason game that year, against the Lions, Edelman tore his right ACL. Frank, watching back at home in Mountain View, Calif., says he knew immediately that his son's season was done.

Julian was devastated after years of crawling and clawing through anonymity and rejection and heartbreak. Frank, too, was heartbroken. But he wasn't worried. After 31 years of indoctrinating Julian in "our process," as Frank calls the family way—this being a guy who suffered a heart attack in November 2016 and was back at his auto body shop fixing cars two days later—he knew his son didn't snivel, didn't quit, didn't feel sorry for himself. "Jules has will and perseverance as strong as a man could have," Frank says. "The only option we had was to move forward."

Since Julian was in grade school, Frank would sit in his office, take out a notebook and jot down his own sayings. *Frankisms*, the family calls them. Then he'd walk into his son's room, notebook in hand, and force the boy to listen. They were aphorisms that father used to motivate son through any trials, a sort of guidebook to life. (*Getting there is hard; staying there is harder*. And so on.) But after the injury, Frank didn't dust off the notebook. He didn't have to.

"All the bulls---, all those sayings, all that stuff is gone now," Frank told Julian. "Now it's just you."

As the Patriots machine rolled on without him, reaching another Super Bowl, Edelman watched other receivers fill his role, the way he once stepped in when someone else got hurt. The desperate Julian Edelman, the hungry Julian Edelman, the Julian Edelman who is so manically immersed in the game that it leaves him no time to shave, was back. His family call this mindset "the abyss."

Almost a year after the injury, as Edelman neared his return, the NFL announced his ban for the positive PED test. Right away Frank flew to Boston to console his son, who he says felt humiliated, completely removed from the team. *Unfortunately*, father told son, *there's nothing we can do*, and so Frank spent two days just hanging out in Julian's condo, watching movies.

On the Thursday of Week 4 this season, before Julian's last game away from his team, Frank flew east again. Early that Sunday father and son went to a field and worked out together, with Frank reprising his role of coach. "Full circle," he says.

When Julian uncharacteristically dropped a few passes early in his return, Frank laughed off the critiques that came. He reminded his son that he's not 22 anymore, that his gift is his quickness and

LET'S TALK ABOUT SIX

that, after his injury, he needed to play smarter. In their talks, one movie scene came up frequently, from the Tom Cruise vehicle *Days of Thunder*: Cruise's character, a race car driver returning to his sport after a vicious wreck, is driving toward another multicar pile-up, smoke billowing over the track, and he has to go full-throttle through the crash.

As the season turned from December to January and Julian started to feel more like himself, Frank told his son, "It's time, you're ready. Accelerate through the smoke."

With Sunday night turning into Monday morning in Atlanta, here was Edelman, the last Patriot left in the locker room. A cigar dangles from his mouth as he sits shirtless at his locker, fingers running through his voluminous beard. He asks a Patriots staffer if the team bus is really leaving him

only a 3–0 lead into the break. Cameras captured Brady on the bench, angrily flinging a white towel.

Gilmore eventually clinched this latest title, deep in the fourth quarter with New England up 10–3, settling below an underthrown Goff pass for an interception on the Pats' four-yard line. The pick, he says, overstating the degree of difficulty but not the significance, "was the best play of my life."

Such exploits were exactly why the Patriots spent $65 million over five years on the Bills free agent before the 2017 season. They knew he had played quarterback on the same South Carolina high school team as former No. 1 pick Jadeveon Clowney, and that South Pointe's coach, Bobby Carroll, considered Gilmore "by far the best athlete" on that team. It took almost a full season, Gilmore says, for him to grasp the complexity of New England's defense,

JULIAN ASKS A PATRIOTS STAFFER IF THE TEAM BUS IS REALLY LEAVING HIM BEHIND. (IT IS, A CONSEQUENCE OF THE ENDLESS INTERVIEWS REQUIRED OF THE MVP.) AS HE FINALLY WALKS OUT OF THE EMPTY LOCKER ROOM, THE LIGHTS SHUT OFF BEHIND HIM.

behind. (It is, a consequence of the endless interviews required of the MVP.) As he finally walks out of the empty locker room, the lights shut off behind him.

THE TRIP TO San Francisco, the salary cap wizardry, the *Rescue Me* cameo, the last-minute retention of McDaniels and the comeback by Edelman—these all coalesced into a Patriots Super Bowl victory both typical and not. It was different in that they won ugly, with defense, behind a brilliant plan that Belichick hatched last week in the basement of the Hyatt, in windowless meeting rooms with white concrete walls. It was similar in that Belichick, with a 41-year-old quarterback and just a single All-Pro, cornerback Stephon Gilmore, still devised a way to win.

The Patriots controlled the clock and the game in the first half, and yet, because of a Brady interception and a missed Stephen Gostkowski field goal and heavy pressure from the Rams' front, they carried

but it helped this year that Belichick and Flores ratcheted up the aggressiveness, playing to Gilmore's man-coverage strengths, as he finished second in the NFL with 20 passes defended. Late in the season, McCourty told Gilmore, *You're the best cornerback in the league, hands down.*

Shortly after Gostkowski kicked a late 41-yard field goal with 1:12 left, sealing the victory, Patriots players lingered on the turf, clinging to the nobody-believes-in-us theme they had invented and pushed on one another. Later an employee carted the Lombardi Trophy around the locker room. Someone grabbed a boom box the size of a small fridge and carried it around, blasting Mo Bamba at full volume, while Kraft handed out his cigars.

AFTER THE PATRIOTS won their second Super Bowl, in 2004, Kraft continued studying dynasties. He approached Troy Aikman, who'd started a

TOM BRADY | 171

LET'S TALK ABOUT SIX

second career as a broadcaster, and the two discussed how the Dallas team of the 1990s self-destructed, through a bitter rivalry between an out-front owner, Jerry Jones, and a headstrong coach, Jimmy Johnson. Aikman told Kraft that, if they could go back, Jones and Johnson might appreciate what they had created, instead of letting their egos get in the way.

Years later, on the eve of this latest championship appearance, Kraft gathered his closest friends for a private party. Meek Mill made a surprise appearance, mingling with Jon Bon Jovi and Martha Stewart. All around Kraft saw what a modern sports dynasty looks like: the celebrity friends, expensive suits, unlimited drinks. That's when he and Meek discussed the chain and all that it meant. "If they win," Meek said, "they're the best dynasty in the history of sports."

Then, again, they won. For years, Belichick and Brady had been described as the best coach and the best quarterback of all time. But their sixth title spoke to something greater—something less about any one part of how they ended up here and more about the totality of this unparalleled run.

To the surprise of no one, Brady confirmed his plans to return for another season. Gronkowski (through Instagram, of course) cast doubt on the possibility he might retire. Edelman planned his trip to Disney World, bracing for the fresh wave of interviews, starting at 6 a.m.

"I try and learn from the guys above me," Edelman finally said inside the Kraft suite. "They've been here, doing it a long time. It's unbelievable. I mean, *six* times in 25 years."

He paused, then shifted right back into Patriot Mode: "I don't know why, but I'm still in the heat of it. I'm not really thinking about those things right now. It may sound kind of bad, but I don't have time to just sit back when I still want to do more."

These are the Patriots, their dynasty both fully formed and seemingly without end. The celebration will continue well into Monday morning. Then, right back to work. ∎

Brady's mother, Galynn, healthy after fighting cancer, joined her son on the field after the game.

LET'S TALK ABOUT SIX

Excerpted from SPORTS ILLUSTRATED
December 7, 2021

2021 SPORTSPERSON OF THE YEAR: TOM BRADY

THE QUARTERBACK EARNS THIS HONOR FOR THE SECOND TIME, 16 YEARS AFTER THE FIRST, FOR A YEAR DEFINED BY VICTORY IN SUPER BOWL LV AND—IN THE MIDST OF AN MVP-CALIBER ENCORE—VICTORY OVER TIME ITSELF

BY
JON WERTHEIM

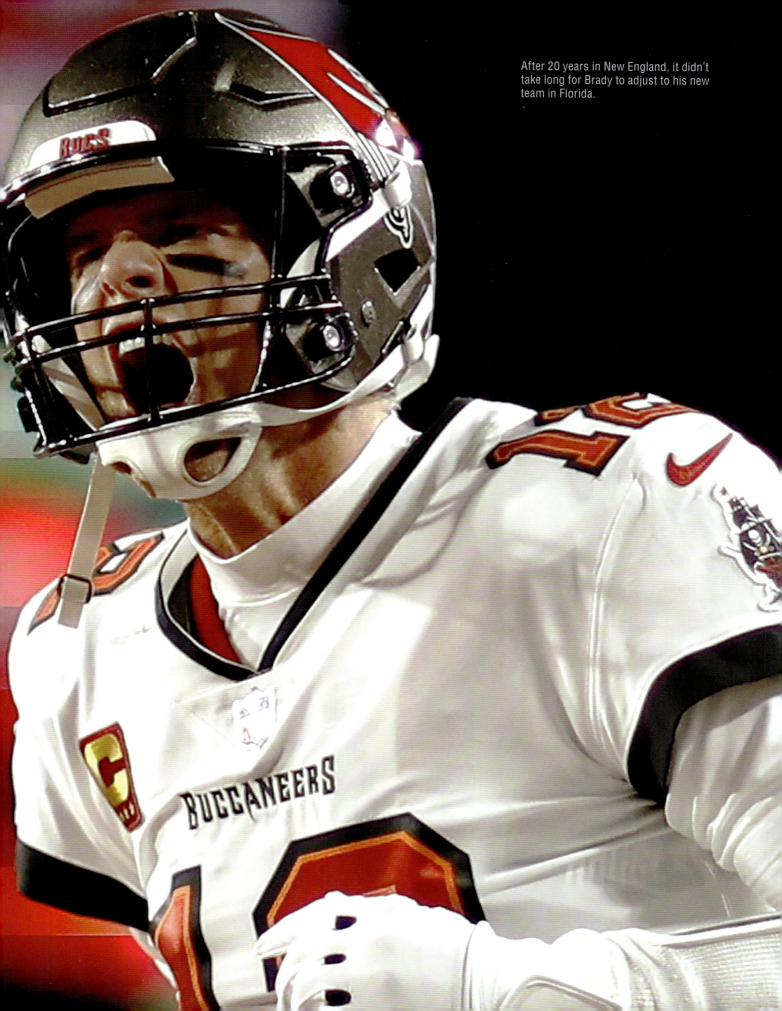

After 20 years in New England, it didn't take long for Brady to adjust to his new team in Florida.

2021 SPORTSPERSON OF THE YEAR: TOM BRADY

AGE IS JUST A NUMBER. But that number is on the move, and longevity is on its way to running up the score. According to the United Nations, in 1990 there were 95,000 people on the planet who made it to 100. Today there are more than 500,000 centenarians, and, by 2100, it's projected there will be more than 25 million. In 1980, around 382 million people were 60 and older. By 2050, that number will exceed 2 *billion*. There are some gerontologists who believe the first person to live to age 150 has already been born. Others ask: Are we so sure there are age limitations on human life?

What are fun facts and dinner-party conversation starters for us are foundational to the School of Aging Studies at the University of South Florida. It's the largest—and, appropriately, one of the oldest—school of its kind in the country. Its mission statement cites a commitment to "understanding the biological, psychological, social and public policy aspects of aging." But talk to faculty casually and it's clear that one of the core principles of the curriculum is this: to teach life hacks that help human beings get older with grace.

Located as it is in Tampa—the U.S. metro area with the densest concentration of senior citizens—the school has always had plenty of subject matter and data points nearby. But now, the campus is also within a golf-cart drive of the archetype for aging gracefully. Want to conduct a field study to see what longevity looks like in practice (not to mention in games)? Well, Tom Brady lives and works just a few miles away.

For all his manifold football gifts, Brady's true superpower is his ability to take time, stretch it out like the resistance bands he uses and then double it back. For the 44-year-old, time is a construct, measurable by ways other than revolutions around the sun.

Though some questioned Brady's signing with Tampa, he led the Buccaneers to victory in Super Bowl LV.

2021 SPORTSPERSON OF THE YEAR: TOM BRADY

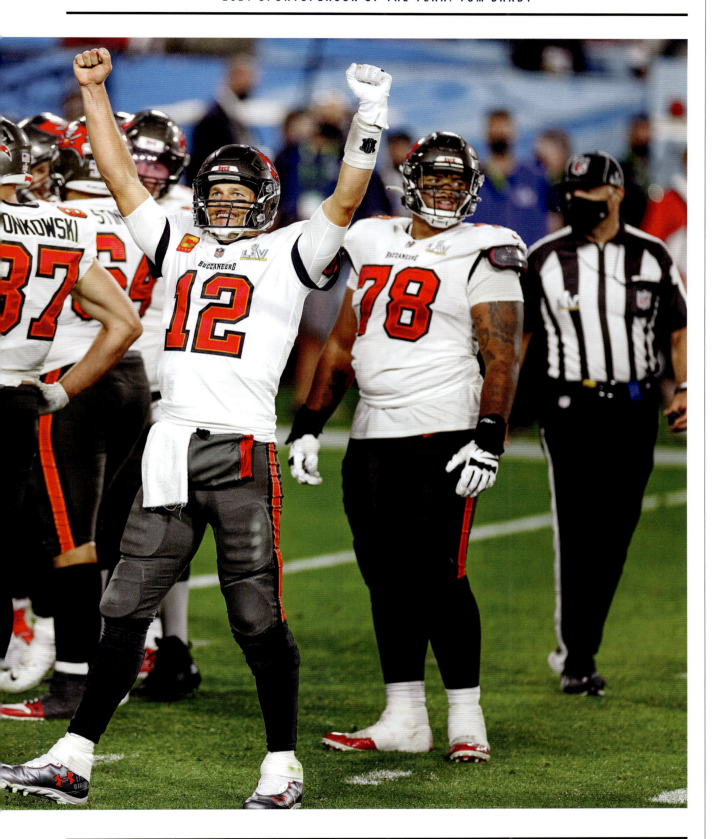

TOM BRADY 177

2021 SPORTSPERSON OF THE YEAR: TOM BRADY

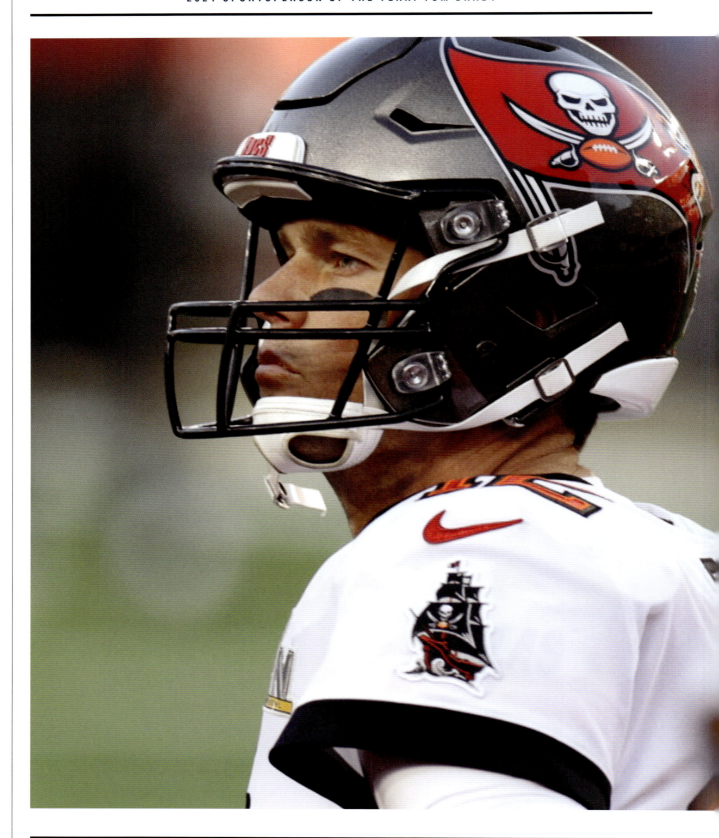

2021 SPORTSPERSON OF THE YEAR: TOM BRADY

"I'd say there are parts of me that are 55, and I think there's parts of me that are 25," says Brady. "What parts? I think I'm wise beyond my years. I think I've had a lot of life experience packed into 44 years. When I go through the tunnel and onto the field? Probably mid-30s—and I've got to work really hard to feel good. It's a demolition derby every Sunday. I feel 25 when I'm in the locker room with the guys. Which is probably why I still do it."

He explains this theory of time on a warm Tuesday in November. He's seated inside a Tampa yacht club—he's *not* a member, he's quick to point out—that looks out over Hillsborough Bay and is convenient to Brady's home. He has risen early this morning (of course). Walking with energy and purpose he enters the main dining room carrying a water bottle the size of a fire extinguisher. He is wearing designer sweats and a big, warm smile that makes his teeth look like a row of white iPod Nanos—kids, ask your parents—aligned perfectly inside his square jaw.

Back to time: How the hell is he still doing this, volunteering for those weekly car crashes for months and months, well into his 40s? It's complicated. "It's not like I wake up every day, like, *Hey, man, it's another sunny day!*" says Brady. "No, it's like, *All right, let's grind and move on.*" Then he quickly adds, "There's still joy. The competition's fun and, uh, you know, I'm still pretty good at it, too."

There's also the specter of the alternative: "I imagine not playing. And I imagine watching football on Sundays going, *These guys suck. I could do way better than that.* And then still knowing in my heart that I actually could still do it. If I stopped, I think I'd have to find something else that I'm pretty good at. And I don't think that, you know, I'm going to be able to jump into something that has the same amount of excitement."

When asked about playing at age 44, Brady said, "I feel 25 when I'm in the locker room with the guys. Which is probably why I still do it."

2021 SPORTSPERSON OF THE YEAR: TOM BRADY

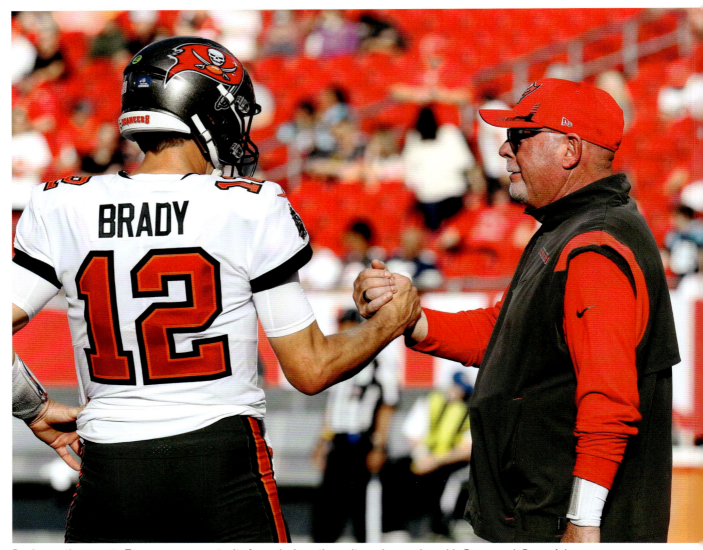

Brady saw the move to Tampa as an opportunity for an invigorating culture change alongside Bucs coach Bruce Arians.

So long as that's the case, so long as he can continue finding fulfillment, Brady will play on, thanks. He's fond of a phrase that suggests continuity, one that befits someone so committed to hydration: Why not keep drinking?

If, in the manner of Brady's career, we want to extend that analogy: It's not just that he is still drinking; he is chugging. And there's no indication he's near the bottom of the glass. He is at an age when even the finest of his peers are beyond their prime. Roger Federer (40), Serena Williams (40), Albert Pujols (41), Tiger Woods (45). Titans all, but not acclaimed for their athletic achievements in 2021.

Then there is Brady. *Still pretty good at it* warrants a 15-yard penalty for flagrant understatement. He continues to discharge his duties with his customary, clinical excellence. He still throws with precision and maneuvers deftly in the pocket. Maybe more than ever, he maintains command of himself, and by extension his team, projecting comfort, evincing poise when it matters most. And he is still winning.

Brady started the year by piloting his new team, the Tampa Bay Buccaneers, to five straight wins, one to end the 2020 regular season and four in the playoffs. The culmination came on Feb. 7, when Brady started his 10th Super Bowl. He walked away with his seventh ring and was named Super Bowl MVP for the fifth time, leaving his heel print on yet another NFL season.

Early in the off-season Brady flew to Los Angeles and "cleaned up" (his phrase) his left knee. In this season, his 22nd, he has turned in some of the most brilliant shifts of his career. Brady leads the league in touchdown passes (34), the unprecedented 600th of his career coming in October, and the Bucs lead the league in scoring (31.4 points per game). His team is 9–3, and Brady is among the favorites to be named MVP. And he has already, officially, taken this honor: Tom Brady is the 2021 SPORTS ILLUSTRATED Sportsperson of the Year.

Brady, this year, is the recipient of the 68th annual SOTY. He also—mind the gap—won the honor in its 52nd year. That was for his excellence in 2005, a time when cars ran only on gasoline, squarely in the flip-phone era. How long ago was this? In the SI article celebrating Brady there is a reference to his

cautiously but describes his passion for football: "I love it so. Just running out there in front of 70,000 people." Also, his sheepishness about standing out: "I don't need to be the showstopper, the entertainer. I'd much rather people assume I'm one of the guys."

Here, in 2021, Brady's coach, Bruce Arians, takes inventory of his quarterback, reeling off a string of superlatives but landing on a familiar turn of phrase: "He is the ultimate team player." To a man, the Buccaneers describe Brady being "down to earth."

Brady is, you might say, committed to the role. His organizing football principles are largely unchanged. Same for his leadership traits and his character. And yet in other ways Brady is a much different man than that 28-year-old bachelor. Handed the cover from 2005, he smiles. "I *think* I recognize that person," he says. "But there's so much more to me now."

He is the best-ever practitioner of the most important position in his sport—perhaps in all sports. But let's be clear: This award is not for lifetime achievement but based on Brady's body of work over the last 12 months. This is not an aging athlete admirably hanging on. This is an athlete who may never have performed better.

"TOM IS PLAYING FOR HIS TEAMMATES RIGHT NOW," ARIANS TOLD SI

IN JANUARY. "I THINK PERSONALLY, TOO, HE'S MAKING A STATEMENT.

YOU KNOW? IT WASN'T ALL COACH BELICHICK."

posing once while holding a goat. And it's describing a bizarre photo shoot—not nodding to the GOAT, the honorific that now, of course, accompanies most mentions of Brady.

Titled "The Ultimate Teammate," the story praises Brady for his work ethic ("You can see his innate ability to carry the logic of practice to the conclusion of a game") and his commitment to incremental improvement ("the grinding work of constructing football excellence that pays off in the public performance"). Brady, then in his 20s, speaks

IT HAPPENED NOT even two years ago and already it carries a historic ring, cemented into those hinge-point New England moments, deserving of its own shorthand, right up there with "Revere Rides Through Town," "Tea Dumped in Harbor" and "Sox Exorcise Curse." And, for that matter, from fall of 2001: "Backup QB Brady Thrown Into Fray."

On March 16, 2020, as COVID-19 was just ramping up in the U.S., Brady drove to the home of Patriots owner Robert Kraft to make official what he had decided privately months before. As Brady

recalled to Howard Stern, "I was crying. I'm a very emotional person." After 20 unbroken years with New England, "Brady to Become Free Agent."

Brady didn't arrive at the decision easily. He knew well that this stay-or-go athlete dilemma tends to yield mixed results. The player with whom he always will be bracketed, Peyton Manning, left Indianapolis for Denver, won a Super Bowl and never played another NFL down. That was nearly six years ago. The day Brady won his first Super Bowl, in 2002, Michael Jordan was playing, unmemorably, for the Washington Wizards. And Brady still winces when he recalls when, as a teenage 49ers fan in San Mateo, Calif., he learned that his idol, Joe Montana, was decamping late in his career to Kansas City.

Two days after Brady met with Kraft, Arians sat in his home with Bucs general manager Jason Licht. For months they had been running point on a recruiting mission they called Operation Shoeless Joe Jackson. (*Field of Dreams* ... get it?) That afternoon Brady called Arians, who passed the phone to Licht, who recalls that when Brady began the conversation, "Hey, babe," it was safe to assume the Buccaneers had their man. "It was a phone call, and it was during COVID," says Licht. "But it was one of the biggest moments in franchise history."

First came the yuks. Brady was going to Florida, because ... Florida. Where else do well-preserved Northeasterners go when it's time to throttle back? Then came the cynicism. Brady was availing himself either of the state's lack of personal income tax or the congenial weather or the Buccaneers' soft expectations. Here was a franchise that, pre-Brady, had an all-time winning percentage of .386 (267–424–1), the worst of any major men's U.S. pro team.

Brady, though, is nothing if not a pragmatist. Tampa was a market with low-intensity lighting, and still a short flight away from his son Jack, who lives in New York City. Brady is also a football pragmatist. He saw a team with a loaded defense, exceptional skill-position players and sturdy offensive line. He also saw the opportunity for an invigorating culture change. Arians, 69, was born within six months of Bill Belichick but cuts a different figure—enjoying, as he does, laughter, self-deprecation, motorcycle rides and a

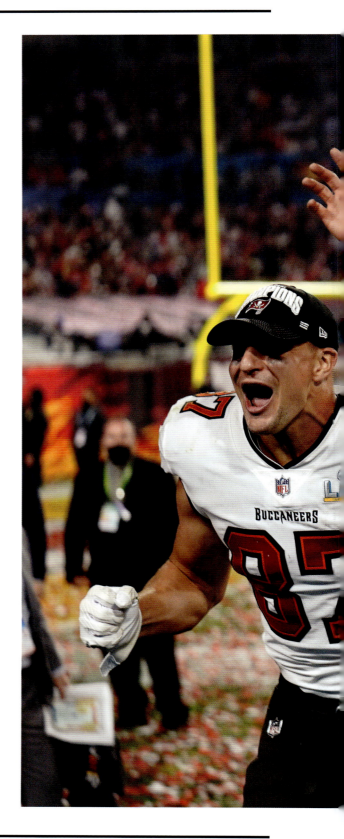

Brady and longtime teammate Rob Gronkowski connected for two touchdowns in Super Bowl LV.

2021 SPORTSPERSON OF THE YEAR: TOM BRADY

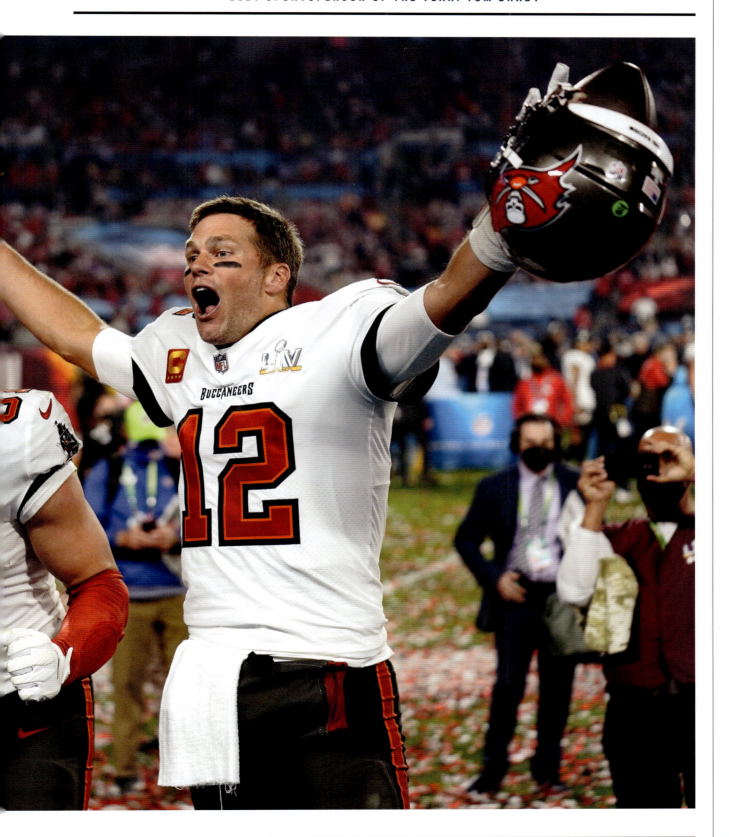

2021 SPORTSPERSON OF THE YEAR: TOM BRADY

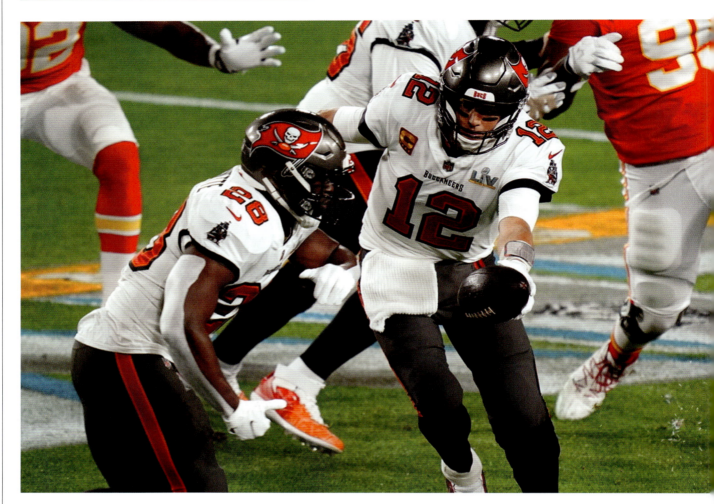

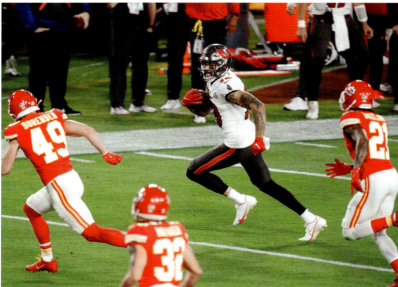

ABOVE Leonard Fournette rushed for 89 yards and a touchdown against the Chiefs. **LEFT** Mike Evans was Brady's favorite downfield target during the regular season, leading Tampa in receptions with 70.

reputation as perhaps the least autocratic coach in the NFL.

But that was only the start. Brady laughs as he plays the compare-and-contrast game: "different conference, different division, different coaches, different offense, different terminology, different players, different drive to the stadium." Determined that the divorce remains amicable, Brady gently reroutes conversation about the Pats. But this he will say: "Our team here, I think there are more voices. And it's fine. There's different ways to be successful."

With Brady, the Bucs started out 7–5. In New England this might have marked a crisis. ("Belichick always had a saying," Brady recalls. "When you win, your quality of life is better for everybody.") In Tampa it did not. The COVID-19-constricted season was supposed to be one of transition for the Bucs; in 2021, they would really be a cohesive unit. But then Tampa Bay didn't lose another game the rest of the season.

Before Super Bowl LV, Brady recognized a sort of power imbalance. He had played in more big games than the rest of his teammates, combined. So he sent a blizzard of texts to them. Some were sent individually, some to a group. Some contained motivational saws (*process over perfection*); some were concrete instructions about schemes or observations that Brady had picked up while watching film of their opponent, the Chiefs.

Licht recalls that hours before the game he took time to try to savor the moment, to drink it all in, as his quarterback might put it. One season earlier Tampa Bay was 7–9 with an offense piloted by Jameis Winston; now, with Tom Friggin' Brady under center, the Bucs were in the Super Bowl. The game was at Raymond James Stadium (even if cardboard cutouts filled two-thirds of the seats); no other host team had ever played in a Super Bowl. Brady noticed Licht, walked over, sat down beside him on the bench, smiled his smile and said simply but firmly, "Jason, it's going to be a great day." And it was.

Ask Brady about a singular moment from the game and he strokes the light stubble on his chin, trying to come up with something specific. The defense played well; the opponent did not. Brady was at his Brady-est; his best plays didn't stand out in the way they do for other star quarterbacks, but the ball always got where it had to be with virtually no mistakes. Unflustered and unhurried, he completed 21 of 29 and connected with his old buddy, tight end Rob Gronkowski, for two of his three touchdowns.

Tampa Bay, a three-point underdog, prevailed, 31–9. In the weeks before the game, Brady strenuously—and probably wisely—avoided the obvious story line, the one that traced back to New England. Arians did not. "Tom is playing for his teammates right now," Arians told SI in January. "I think personally, too, he's making a statement. You know? It wasn't all Coach Belichick."

2021 SPORTSPERSON OF THE YEAR: TOM BRADY

Brady recalled the postgame scene after the Patriots won Super Bowl XLIX in 2015: "We had beaten Seattle and we flew home to Boston, and I came home to a house that was flooding. I mean, literally, I had a broken pipe and I had a waterfall coming down. And that night you thank God. It's so glorious the night after a Super Bowl. [But] the reality? I got to fix this leak in my house."

In a sense it was a healthy reminder that the real world happens, even to Super Bowl MVPs, so it's important to savor the moments before the pipes burst. Now it comes to him: The highlight of that night, of Super Bowl LV, was when he brought his family—his wife, model Gisele Bündchen; their kids, Ben, 12, and Vivian, 9; and Jack, 14, Brady's son with actor Bridget Moynahan—onto the field to celebrate.

Imagine Brady's previous coach joking about delegating some of his duties to the charismatic quarterback.)

Brady may have, like the rest of us, binged *The Last Dance*—"That's my era!"—but his leadership style is at striking odds with that of the basketball GOAT. Michael Jordan demanded that his teammates match his intensity and humiliated those who couldn't handle his lacerating edges. Brady is all soft power. Teammates should feel seen and heard. Gaps in accomplishments and fame—and commitment levels—among players must be bridged. Experience is something to be shared.

Licht laughs when Brady introduces himself warmly to rookies and new teammates by saying, "I'm Tom Brady." *No s---, you're Tom Brady.* But the message is clear, as is the effect. "Tom is known as

> **"IF PEOPLE WANT WHAT I WANT, THEN I'M THERE TO HELP THEM. IF THEY DON'T? ALL RIGHT, LET THEM DO THEIR OWN THING. NO PROBLEM. BUT IF YOU COME TO ME AND YOU SAY, 'HEY, HOW CAN I HAVE A CAREER LIKE YOURS?' I'D BE VERY HAPPY TO HELP ANYBODY." —TOM BRADY**

THAT BRADY WAS—AND IS—a winning football player makes for something other than a news flash, especially for the men who recruited him to Florida. Even so, both Arians and Licht marvel at the full force of the Brady Aura.

Arians tells the story of watching Brady lead an early informal workout with tight end O.J. Howard and wide receiver Scotty Miller. Arians had recently told both players about the need to pump their arms on their routes. When they didn't, Brady also noticed and pointed it out to his two teammates.

Says Arians, "They look at me [when I tell them] and go, *Oh, O.K.* And when Tom tells them they go, *O.K., Tom!* And they do it." Arians then cackles, thinking of other messages he would let Brady communicate to players on his behalf. "He tells 'em to do it, and they listen!" (Pause for a thought exercise:

the greatest player of all time, and I get the sense they were expecting him to come in and want preferential treatment and have an ego—which would be well deserved," says Licht. "But he just wants to be one of the guys. He wants to earn their respect. And they think, *I don't want to let this guy down.* We all think that."

Early on Brady issued a request to his new center, Ryan Jensen. Could he apply baby powder to his backside to keep the football free of sweat? Jensen complied, then walked around the field trailed by chalky plumes, as if he were announcing the new pope. Before it could be a source of embarrassment or teasing in the locker room, Brady spoke to teammates to make sure it was taken as instructional: These are precisely the kind of small sacrifices and adjustments you make when you are fully committed to winning.

2021 SPORTSPERSON OF THE YEAR: TOM BRADY

Brady's Buccaneers became the first team to win a Super Bowl on their field, as the QB outdueled the 25-year-old Patrick Mahomes.

TOM BRADY | 187

2021 SPORTSPERSON OF THE YEAR: TOM BRADY

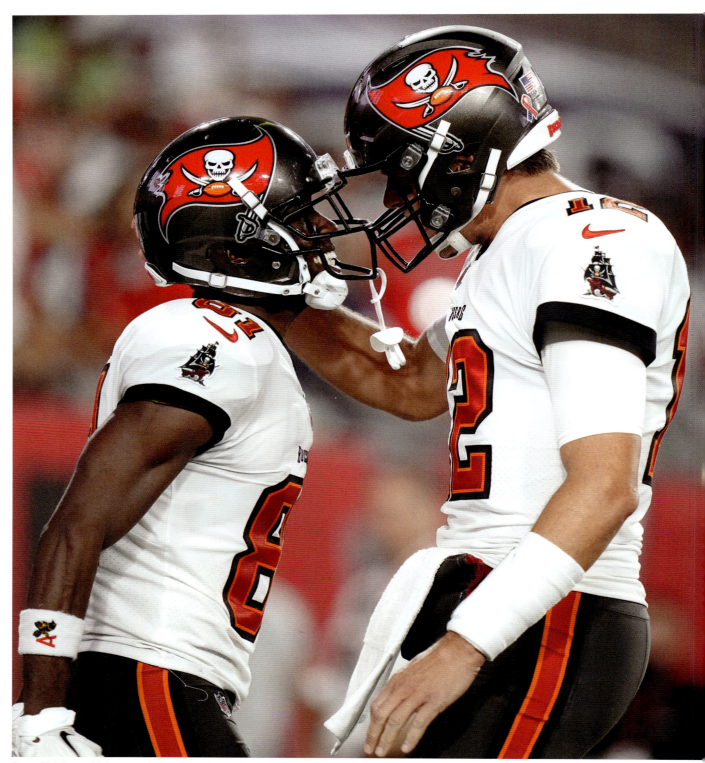

Bucs GM Jason Licht marveled at Brady's connection with his teammates, including Antonio Brown, saying, "He wants to earn their respect."

2021 SPORTSPERSON OF THE YEAR: TOM BRADY

More than ever Brady is surrounded by team-mates who entered the league with more fanfare. Mike Evans, his favorite downfield target, was the seventh pick in 2014. Tampa Bay's top running back, Leonard Fournette, went fourth in '17. Even Brady's backup, Blaine Gabbert, was the 10th choice in '11. Two decades after he left Michigan, Brady's modest draft slot of—all together now—199, still galvanizes him. "He had to work for everything," says Arians, "and he just never, *never* lets himself forget that."

But the coach noticed something else: Brady has taken a source of personal motivation and alchemized it into something to benefit his teammates. What was once about—to use the tired trope—*proving the doubters wrong* has evolved into, *Guys, if I can go from good to great, you sure as hell can, too.*

IT'S HARD TO exaggerate just how statistically outlying Brady's longevity is. The NFL's next-oldest player is Rams offensive tackle Andrew Whitworth, who will be 40 on Dec. 12. Brady is closer in age to Dan Marino, who played his last game in 1999, than he is to Chiefs quarterback Patrick Mahomes. Nearly half the NFL's coaches—13 of 32—are younger than he is. (Though Brady's own coach, pointedly, is the league's third-oldest.)

Keep going? Brady is older than 59 members of Congress. On that fateful day in 2000, when 198 other players were summoned into the NFL workplace ahead of Brady? Bill Clinton was president. There have been six presidential elections since. Remember, too: Brady's longevity-to-the-point-of-absurdity is coming in pro football, a sport in which careers are notoriously nasty, brutish and short. And there hasn't been any sign of falloff.

That's not just the eye test; advanced statis-tics bear it out too. Arians's offense attacks deeper than most—*no risk it, no biscuit* being the operative phrase. In 2020, Brady's air yards per intended pass, a measure of how far downfield a quarterback throws on average, jumped to 9.3 yards, a 22% increase from his last season in New England. Yet, despite the higher degree of difficulty, his completion rate also rose, from 60.8% to 65.7%.

He's doing it at a time when defenders have become freakish in their own right. From 2000 to '03, Brady's first four seasons in the league, 10 defen-sive linemen clocked in under 4.7 seconds in the 40-yard dash at the NFL's scouting combine. Over the past four years, 41 have done so. That has led to an emphasis in athleticism among the new class of quarterbacks. Indeed, according to Next Gen Stats tracking data, through Week 12 of the 2021 season only Steelers vet Ben Roethlisberger was covering less ground per play (7.2 yards) than Brady (8.0).

Retirement has its appeal—golf, time with the family, business opportunities—but it is outstripped by the lure of continuing to work. And so it is that Al Michaels, 77, the voice of NBC's *Sunday Night Football*, has consulted with and confided in Brady. Their pregame broadcast production meet-ings, once filled with football shop talk, now veer toward weightier topics and shared experiences. Says Michaels, "When I see Tom, I think, *Damn, you can go at that level no matter what you're doing,* and I feel like I can. It's just a cool thing, the kind of symmetry."

Michaels isn't alone in finding inspiration in Brady's longevity. UFC fighters, European soccer players, pro golfers, athletes of a certain maturity—they all try to see some version of themselves in Brady and come seeking his counsel and inspiration. Comb social media and you'll find teachers crediting Brady with their decision to get back in the class-room, pilots referencing him when they decided to stave off retirement.

Even though serving as a standard-bearer for manipulating time only adds to his pressures, Brady welcomes the opportunity. "If people want what I want, then I'm there to help them," Brady says. "If they don't? All right, let them do their own thing. No problem. But if you come to me and you say, 'Hey, how can I have a career like yours?' I'd be very happy to help anybody."

At the same time Brady readily admits that he holds no secrets; he, too, looks to others. His wife. His parents. Towering athletes—Montana, Jordan, Steve Young—who came before him. But he also turns to a sort of council of elders, who've lived well and lived long. Ageless Tom Brady might work

Joining a team that was 7–9 the year before his arrival, Brady led the Bucs to a 32–18 record during his three years in Florida.

alongside teammates half his age, but he often socializes with men twice as old, many of them successful entrepreneurs or titans of industry. They neither want nor need a selfie or comp tickets or the nimbus of Brady's celebrity. These friendships come without the whiff of transaction.

The tribal elder in this circle might be Sam Reeves. Armed with a wealth of stories he tells in a slow Southern drawl, Reeves made his fortune as a cotton merchant. He recently gave up bodysurfing but still plays 150 rounds of golf a year. He's 87, but he puts his functional age in the early 60s. "I'm not really paying attention to the chronological," he says.

Reeves recalls meeting Brady while playing golf at Pebble Beach "maybe 20 years ago," and the two have been close friends ever since. "I didn't know much about him," says Reeves, "but he was so gracious." Through Reeves, Brady has met various other wise men, including Jimmy Dunne, 65, vice chairman and senior managing principal of Piper Sandler investment bank.

When Brady is in the company of these wise men, decades older, he spends a lot of time listening. "Learning from those people is really important to me," says Brady. "I don't think you can go through life and be fixed. I was listening to someone the other day, and they said, 'The words *I don't know* are the most powerful words because they're limitless. It's limitless potential.' And as soon as you think you know something, you're fixed."

Reeves has given great thought to what makes Brady special and has come up with three bullet points:

• *He makes people feel valued*. "That could mean really listening—he's an extraordinary listener—to someone he's meeting for the first time."

• *He thrives on excellence, for himself and those around him*. "He wants you to have what he has. He wants people to be the best they can—but he'll help you get there."

• *He is a person of joy*. "Pain is inevitable—certainly in football—but misery is optional, and Tom does not accept misery. Tom runs the opposite way. He runs to joy."

Then Reeves absently adds a fourth. "Tom keeps his routines, but he is open to adventures." And … wait … catch that? It sounds like a throwaway line, but *aha*. That, as much as anything, might unlock the secret to Brady's—and, for that matter, our—longevity.

Yes, Tom keeps his routines, so much so that his fanatical habits figure prominently in the mythology. His sleep schedule and his infrared pajamas. His training and his plyometrics. We know about his hydration and his electrolyte intake. Lord knows we know about his diet and nutrition. He dares to eat a peach … and avocado ice cream. (There is a sports-media edict that says Brady cannot be discussed without a reference to avocado ice cream.) But he dares not ingest carbs, nightshades, dairy, white sugar or white flour.

2021 SPORTSPERSON OF THE YEAR: TOM BRADY

Ross Andel, director of the School of Aging Studies at USF, notes that routines and good habits are essential for optimal aging. A Bucs fan, Andel sees Brady and his defiance of time and is unsurprised. "His ability to stay disciplined is second to none," says Andel. "Other people look for a quick fix or go to extremes. He doesn't mind hard work. He holds onto his schedule. There's such a resilience."

Yet when discussing keys to graceful aging, Andel also references an opposite, even contradictory, instinct: a willingness to adapt—"I never want to be fixed" … "he is open to adventures"—to stimulate new parts of the brain and pleasure centers. In short, to evolve.

Andel points to a German study in which volunteers were taught to juggle. As the subjects picked up

as he hurled the Lombardi Trophy Frisbee-like from one boat to another during Tampa Bay's Super Bowl celebration. He then put to rest any questions about his sobriety with the unforgettable tweet, "Noting to see her … just litTle avoCado tequila."

Brady is an unapologetic capitalist. His NFL salary of $25 million is dwarfed by his various businesses and investments, from the TB12 health and wellness brand he co-founded with Alex Guerrero to his clothing line BRADY, to his 199 Productions content studio, to his stake and promotion of a cryptocurrency firm. His NFT company, Autograph, is widely considered an industry leader in digital collectibles. He's arrowing toward billionaire status, if not there already. And he's not simply slapping his name on products. He is poring over balance sheets

> AT THE SAME TIME BRADY READILY ADMITS THAT HE HOLDS NO SECRETS; HE, TOO, LOOKS TO OTHERS. HIS WIFE. HIS PARENTS. TOWERING ATHLETES— MONTANA, JORDAN, STEVE YOUNG—WHO CAME BEFORE HIM.

a new skill, brain imaging revealed changes in gray matter. As the subjects became capable jugglers and the skill was no longer novel, the gray matter reverted to its levels before the study. "The brain had nothing to adapt to, so it put the neurons elsewhere," says Andel. "It's the stimulation, the change of environment that challenges the brain and redistributes our bodily resources." That, says Andel, encapsulates Brady. "He's unbelievably adaptable."

So credit Brady for his rigidity. But his relentless success owes just as much to the opposite trait, his flexibility. Does he contradict himself? Very well then, he contradicts himself. He is large. He contains multitudes. Moving to a different franchise in a different state with a different corporate culture? That example of his adaptability is just one of many.

BRADY MIGHT, RIGHTLY, be depicted as the exponent of clean living. But there he was in February, giving new zest to the phrase *drunken fling*

and Zooming into board meetings, glimpsing his post-NFL life while still playing.

On the other hand, Brady doesn't always show fidelity to the market. His NFL salary, which does not consign him to eating ramen, still ranks ninth in average annual value among QBs. "He's never wanted to be the highest-paid quarterback," says Arians, "because [doing so] would mean not getting maybe two other good players."

As much as Brady values health, he mourns the rule changes that diminish the physical risk of football. "The game I played 20 years ago is very different from the game now, in the sense that it's more of a skills competition than it is physical football," he says. "It's like being in the boxing ring and saying, 'Don't hit your opponent because you might hurt him.' Look, we're both able to protect ourselves. I'm looking at you. You're looking at me. Let's go."

Brady made those remarks recently on *Let's Go*, the podcast he hosts with former receiver Larry

Fitzgerald and sportscaster Jim Gray each week. And this might represent the most striking example of Brady's adaptability. For most of his career he was willfully, even strategically, unknowable. Not surly or standoffish, but you might say that long before COVID-19, Brady wore a mask. As he put it this summer on HBO's *The Shop*: "What I say versus what I think are two totally different things. I would say 90% of what I say is probably not what I'm thinking."

Whatever the case, lately we're hearing from Brady more often than ever before. There he is on late-night couches. There he is in a self-effacing Subway commercial. And calling into Howard Stern. The podcast medium suits him especially well—not just his own, but others ("What did [I] major in? F------ football, man," Brady said on actor Dax Shepard's *Armchair Expert*). He's also jacked up his activity on social media, often hilariously. After a tweet surfaced comparing the TB12 Method with Terry Bradshaw's "TB 12 beers a day methods," @TomBrady issued the A-plus retweet last month, "Tomato, tomahto."

Brady accepts the premise that lately he has put himself out there. "I'm rediscovering my voice," he says, "and I'm having fun with it." The obvious correlation: Brady feels he is able to reveal himself and have this fun now that he is liberated from his coach in New England and from the tight organizational controls. He doesn't deny that.

But there's another correlation. His age. "I think there's more comfort just as an older guy, too. My give-a-s--- levels are probably a lot less. I'm kind of like, *O.K., what's it gonna be like in 10 years?* I'm *really* not going to give a s--- then."

It is, of course, irresistible to hear Brady talk about his future and not indulge in speculation about how many more times the odometer can turn over. Licht has already stoked fires (and social media accounts) when he predicted Brady would play until age 50. He doubles down with SI: "I don't see any signs of decline whatsoever."

Brady predicts that the source of his decline—whenever that may be—will be spiritual, not physical: "Regressing would be a very difficult thing for me to see. As soon as I see myself regress, I'll be like, *I'm*

out. I don't really want to see myself get bad. So it's just a constant pursuit of trying not to be bad."

Trying not to be bad? Really?

"I think if anything, the most challenging part is the emotional aspect of football for me," Brady says. "When we lose, it's depressing. When we win, it's a relief. It's not like the joy, the happiness—it's a relief. Because when we win, sometimes just winning isn't good enough for you, because you expect perfection, and when you expect perfection and it's less than perfect, you feel like there's a down part to that."

Then again, this drive, this internal combustion engine, is what keeps Brady playing at this exalted level. Winning a seventh Super Bowl doesn't dull his ambition for an eighth. Throwing a pass into a window the size of a playing card only increases his desire to deliver another one.

"It's like hitting the perfect 7-iron," he says. "You go, 'How was that?' And I go, 'That was pretty great! I want to do it again!' You just constantly keep chasing it."

It was recently put to Brady: Is there anything specific he has yet to achieve in his unrivaled career? His first answer: not really. But he did note that, in all his years and for all that success, he has never won a game on a last-second Hail Mary.

The temptation is to tell Brady that he's completed football's ultimate Hail Mary. The backup at Michigan whose 40-yard dash time could be clocked with a sundial going from the sixth round to the GOAT pasture, with seven Super Bowl rings? Whose excellence remains unabated at 44? Except that a Hail Mary implies a level of luck. The Legend of Brady is predicated on anything but fluke or chance. It's deliberate and smart and rational.

So here is a man—and a sportsperson—for all of time. And for this time. And as aging does its thing, as mitochondria begin to deteriorate, as the mortal coil unwinds, Tom Brady comes bearing lessons for us all about contorting and distorting time, if not stopping it altogether. Balance routine with new adventure. Even more than anatomy, it's attitude and character that shape destiny. Head off into the sun, not the sunset.

And if we hydrate and eat right, so much the better. ■

2021 SPORTSPERSON OF THE YEAR: TOM BRADY

On the level of comfort he discovered in Tampa, Brady said, "I'm rediscovering my voice and I'm having fun with it."

Excerpted from **SI.COM**
January 29, 2022

TOM BRADY, IN HIS OWN WORDS

THE QUARTERBACK'S TAKES ON THE GRIND OF PERFECTIONISM, LONGEVITY, TECHNOLOGY, LEAVING NEW ENGLAND AND MUCH MORE

BY
JON WERTHEIM

Brady spoke to the media in June of 2022, before what would be his final NFL season.

TOM BRADY, IN HIS OWN WORDS

IT'S NOT THAT WE MISSED TOM BRADY ALL THESE YEARS. It's just that the assessments were incomplete. Earlier in his career, he was thumbnailed as the *GQ* pretty boy who cavorted with actresses and models. Meanwhile, he was also working his ass off, rehearsing drills until they cemented into muscle memory, and developing good habits. Then, in the latter part of his career, he was cast as the football robot with the maniacally-strict diet, who went to bed around the time of Final Jeopardy. In reality, he has a lot more heart and soul and unpredictability.

Tom Brady contradicts himself. He contains multitudes. This, of course, is at odds with the times. We live in an era defined by binaries—liberal/conservative; you suck/you rock; Netflix subtitles/clean feeds. We resist complexity. Then again, Brady, too, is at odds with times. Here is a 44-year-old—full stop. Forty-four. Closer in age to Dan Marino than to Patrick Mahomes—still winning Super Bowls and mounting an MVP candidacy.

In 2021, Brady claimed the *Sports Illustrated*'s Sportsperson of the Year award for the second time in his career. As part of the honor, Brady and I sat down for what was less an interview than the kind of sprawling conversation befitting two middle-aged men.

That was in November. Now, a look at some of the outtakes from our interview, lightly edited for length and clarity.

On perfectionism:

"I think if anything, the most challenging part is the emotional aspect of football for me. Because when we win, it's a relief, and when we lose, it's depressing. It's not like, 'The joy, the happiness.' It's a relief. Because sometimes just winning isn't good enough for you, you know? You expect perfection and when you expect perfection and it's less than perfect,

Brady's sister Julie accompanied him to a WNBA game in Las Vegas in 2022. The QB said competition between the siblings was a constant during their childhoods.

TOM BRADY, IN HIS OWN WORDS

"Leaders push other people to be their best, but certainly they have to hold themselves accountable to being the best that they could be," Brady said.

you feel like there's a down part to that. I'd say if anything, that's the hardest part for me as I've gotten older. I wish I smelled the flowers a little bit more. Yeah. I wish I did. I think I live in the moment, I am very present. But at the same time, I wish I could appreciate the smaller victories."

On leadership:

"Leadership is a lot of different things to me. Leaders provide solutions. They require action. Leaders push other people to be their best, but certainly they have to hold themselves accountable to being the best that they could be. Leadership takes on a lot of different forms…I think it's…I think a curiosity toward people who I really viewed as my mentors or people that I saw and said, 'Wow, I want to be a little more like that.' It still goes on today and I think different people came into my life at different times…I don't think you can go through life and be fixed. You know, I was listening to something the other day and said 'The words *I don't know* are the most powerful words because they're limitless.' And as soon as you think, you know, you're fixed…My dad, I think was my first example of what a great father could be and what a great husband should be and what a great competitor should be."

On competition:

"There was always competition that was stoked in our family. Oh, baby. We raced home from church on Sundays. We really did. We jumped in two different cars and we'd race home. And we would have pillow fights. Everything was a competition in our family and I always wanted to win. And when I didn't, I was pretty pissed. But I think just the supportive environment in the competition—knowing that if you competed and failed, it was still O.K. It's hard to compete because sometimes you lose. And what

comes with failure is often hard to overcome ... I really enjoyed the competition and I still don't take it for granted because I want to go out there and kick people's ass every day. And when I don't, it's frustrating. There's a depression. There's moments that are very challenging, still at 44 years old."

On the decision to leave New England for Tampa:

"I was very—well, kind of—unsure what my football future would look like at that time and had to make a tough decision. And at that point I had known that I wasn't going to be with the Patriots, but I was excited about what I thought I could bring somewhere else ... How much culture shock was there? A lot. And I think, just look at this, this is [motions to view of the Bay] it's, basically Thanksgiving and it's 82 degrees out today. That's one of many other things that are quite a bit different. A different conference, different division, different coaches, different offense, different terminology, different players, different drive to the stadium. ... Two decades was great. And it came to an end and I had to make a different decision. I have a new football experience and I had to try to make the best decision I could. And I think I'm always thinking about what I think the best decision might be in a certain moment. Just like I think about football, I strategize and I gameplan. There are sleepless nights and there's early mornings. You don't always make the right decision, but I think when I look back on that decision, I'm very happy."

On New England:

"It was 20 great years. I think my answer now is going to be the same answer in five years, which was the same answer when I left. I have tremendous gratitude for what we accomplished and for everything I've learned and the experiences I had. We did everything we set out to accomplish. The highs of highs and there weren't many lows. I have nothing but gratitude for it. Was it perfect? Nothing's perfect. It's like saying how's your marriage? Well, it's pretty great. But is every day perfect? No. You got to work through moments and when things weren't perfect or great. That's what people probably would love to focus on. You know, that's what the, that's what our culture is about. Currently, you know, we're in this washing machine. Reality television and social media, social media. And it's class act versus an act. And the acts get just as much of attention as class acts, you know? Hopefully we can return to a class act and hopefully we can return to mutual respect. Hopefully we can return to kindness. Hopefully we can learn to, 'Hey, I'll respect your opinion. You gotta respect my opinion too.'"

On technology:

"I think there's more distractions out there. And I think with everything, there's a lot of good and there's a lot of bad. I think the connectivity is amazing. You know I have a relationship with [my son] who lives in New York City, I FaceTime him every day. I see his face, I see his mannerisms.

"But with that comes the constant incoming of information and, you can get distracted by different things. A guy said to me, 'Your brain, isn't the source of information. Your brain is just an antenna. So just program what you want to program it to and focus that the antenna where you want.' For us, we had TVs with antennas and you would just move the antenna. I think that's how I feel. Like, you can focus on all the s---, but why don't you focus on the good stuff?' "

On continuing to play at age 44:

"Football pushes you in ways that not a lot of other things do. You're so much in the moment. You're living this life you're so comfortable with. I think football has been very grounding for me. I would say the off-season is very challenging for me. ... The off-season is way more challenging for me than the actual football season. The football season is like a routine. I don't travel that much. It's a lot of hard work. You're up at six and you're home at six and it's *Groundhog Day*. It's a long marathon of, of a season. But there's still a lot to be gained from it.

"[In the off-season] I'm living out of home. Every two days, we're going somewhere different, living out of a suitcase. It's fun. I'm fulfilling a lot of other obligations that I don't get to do during football season."

TOM BRADY, IN HIS OWN WORDS

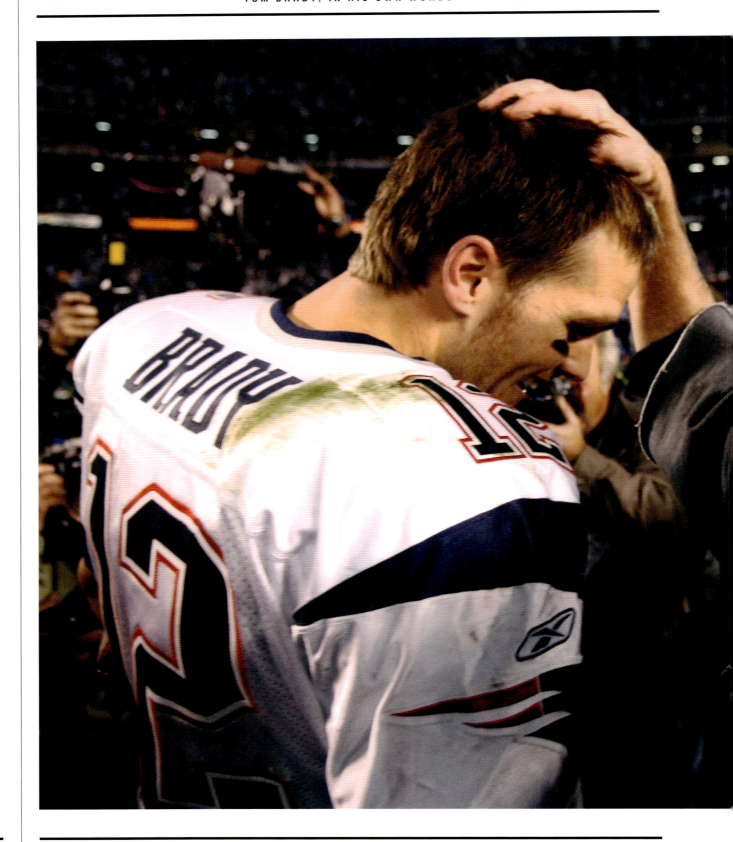

TOM BRADY, IN HIS OWN WORDS

On the perception he has put himself out there more in 2021:

"Naturally I'd say I'm very introverted, you know? I loved football. Maybe. I don't know. It didn't always love what came along with it and the expectations and having to please everybody all the time. And then I was in an environment where what the goal of our football team and the Patriots was, you know, there was one voice; and we were all gonna say the same thing; and you got to do what's best in the best interest of the team. And I think this is different. Our team here, I think there are more voices and it's fine. There's different ways to be successful too. So … I'm rediscovering my voice and I'm having fun with it. And I think there's more comfort just as an older guy, too. You know, there's, there's—my give-a-s--- levels is probably a lot less. So now I'm kind of like, 'Okay, what's it gonna be like 10 years?' I'm really not going to give a s--- then."

On fatherhood:

"This is the reason why you try to be the best you could be. Probably the best part of my football career was having Jack [Brady's 14-year-old son] at training camp with me for two weeks. And just having him every day to myself. Just a great kid. My family's so important and without them, you know, there isn't the joy of life that I have."

On winning the Sportsperson of the Year Award in 2005:

"Hard to imagine. Sixteen years went by really, it was the flash of an eye. I remember Bono from U2 had this really cool video for me. It all happens pretty quick. I'm kind of blinking hard to imagine I'm still actually playing football and still loving it as much as I always have."

On leaving the Patriots, Brady said, "We did everything we set out to accomplish. The highs of highs and there weren't many lows. I have nothing but gratitude for it."

BRADY'S

WITH HIS THROWS, INTENSITY AND COMPASSION, THE QUARTERBACK MADE A LASTING IMPRESSION ON A HOST OF TEAMMATES

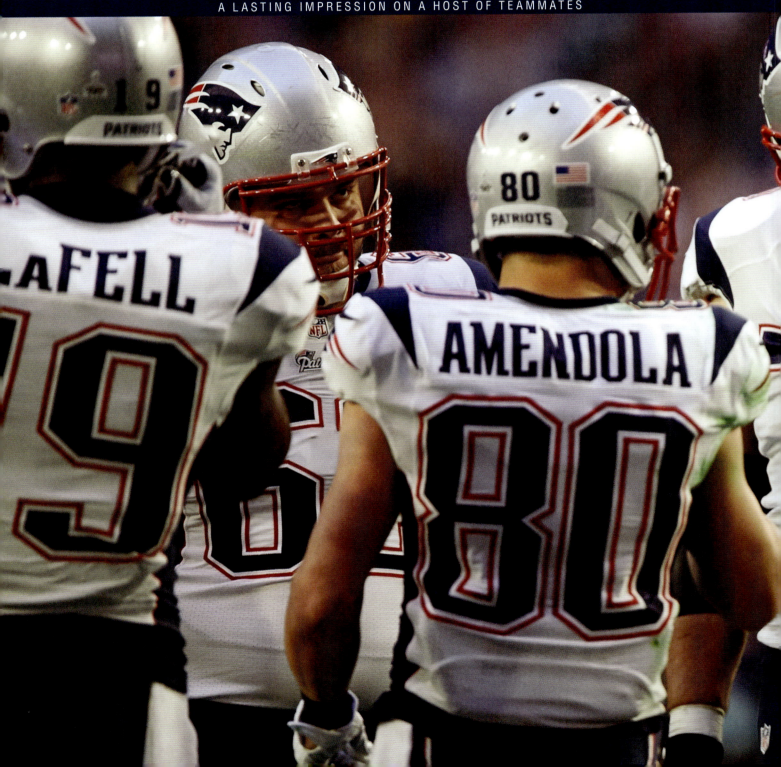

BFFs
(Best Football Friends)

Excerpted from Sports Illustrated
February 24, 2022

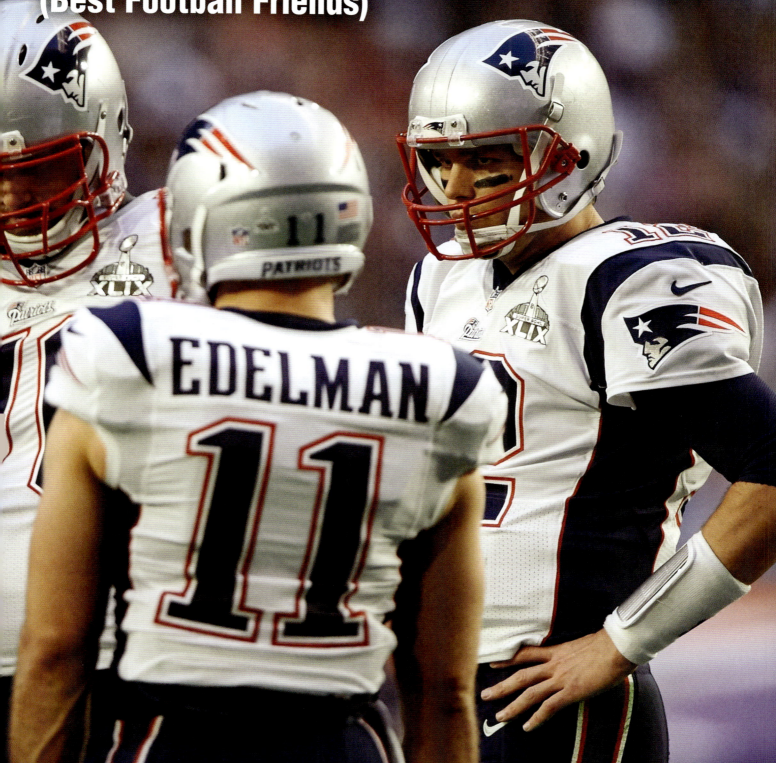

BRADY'S BFFs

GRONK!

THE GREGARIOUS TIGHT END AND BRADY MADE FOR AN ODD COUPLE, BUT THEIR RESULTS WERE UNMATCHED

BY
MARK BECHTEL

In their 11 seasons as teammates, Brady and Gronkowski had many opportunities to party: They won three Super Bowls together in New England and added a fourth in Tampa.

FOR BUCCANEERS FANS, the best thing about Rob Gronkowski's signing with Tampa Bay was that it gave Tom Brady a familiar target to look for, one he would connect with more than 100 times in two seasons. For Patriots fans, the best thing about Gronk going south was the warm sense of nostalgia that came with seeing a pair of longtime teammates reunited.

For neutrals, though, the best thing about Brady's longtime tight end target becoming a Buc was, hands down, *Tommy and Gronky*, a series of webisodes filmed outside of the team's practice facility. Sitting in lawn chairs, surrounded by plastic flamingos and a mini cannon with their feet in a plastic wading pool, Brady and Gronkowski spent each episode shooting the breeze and doing things like reading mean tweets, taking friendship tests and playing Never Have I Ever. (Turns out Brady has both gone to work hungover *and* blamed a fart on someone else.) When each new episode dropped, if you were very quiet and cupped your ear toward Foxborough, you could hear Bill Belichick gnashing his molars.

Of course we've seen Brady be silly before, hosting *Saturday Night Live*, filming a commercial with the Easter Bunny or taking part in a Funny or Die sketch. But his show with Gronk was unscripted, and he didn't have Amy Poehler on hand to provide

BRADY'S TOP TARGETS

RECEPTIONS

1.	**JULIAN EDELMAN**	**689**
2.	WES WELKER	636
3.	ROB GRONKOWSKI	620

YARDS

1.	**ROB GRONKOWSKI**	**9,275**
2.	JULIAN EDELMAN	7,674
3.	WES WELKER	7,031

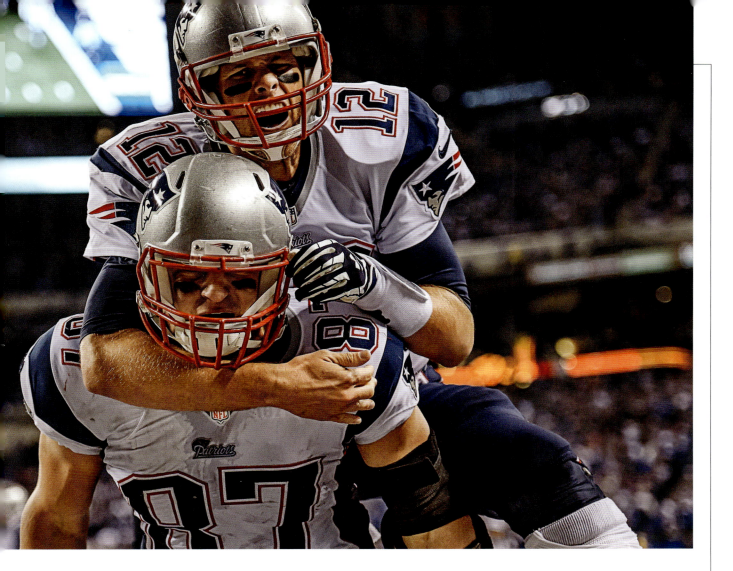

backup. A genuine bonhomie comes through, and that comedic chemistry has always been apparent on the field. For all his arm strength and touch, Brady has long preferred marching down the field making low-risk throws. Gronkowski has the perfect skill set: big, strong, athletic, great hands.

It took time for the two to jell. Brady was long established with the Pats when they drafted Gronkowksi in the second round of the 2010 draft. Brady was hard on the rookie. "But it was with good intentions," Gronk recalled in '15, "and he saw the potential in me. But it was good for me. It made me want to work harder and get the job done. About halfway through my rookie year, we started making the connection, getting the timing going and trusting each other with the pass routes. So when everything started clicking and everything started rolling between us, he got a little nicer. We're good pals and friends now."

So good that Brady coaxed Gronk out of retirement when he signed with Tampa in 2020. Late in the '21 season finale against the Panthers, Gronkowksi informed Brady, who was about to come out of the game, on the sideline that he was one catch away from a $500,000 catch bonus. ("If I don't get the seventh catch I'll have to get a real job," he joked.) Brady just nodded his head, fist bumped him and went back on the field, where he found Gronk for a seven-yard pickup on the next play. Then he went back to the bench. It was the 620th and final time they connected in the regular season. They finished with 90 regular-season touchdowns—only Marvin Harrison and Peyton Manning of the Colts connected for more. ∎

BRADY'S BFFs

IN THEIR WORDS …

WIDE RECEIVER
DANNY AMENDOLA
Undrafted out of Texas Tech in 2008, Danny Playoff spent five years with the Patriots, catching six TD passes in 13 postseason games

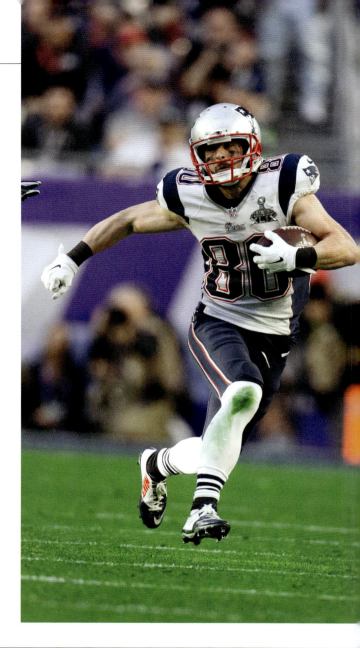

"**IT'S SCARY** because as good as a football player as he is, he's an even better friend, even better person. He's been like a big brother to me. … Whether it's been getting out to [Brady's home in] Montana or going to the [Kentucky] Derby or just having us over for dinner, he's always the same. He's always there to help. He's actually like a big brother to everyone.

"[One time] he goes, 'Jules [Edelman] said you're good at Ping-Pong. I've played a little bit myself. Let's go to the back and see what you're all about.' So we played a couple of games. I remember his fire, his competitiveness—just in Ping-Pong. For me, it kind of set the tone for what he's all about. And I remember one of the Ping-Pong paddles got broke. And it wasn't mine."

Legend from that Patriots era has always held that Amendola beat Brady, turned and heard a whistling go by his ear, followed by a loud smack. It was Brady's paddle, missing Amendola's head by a few inches.

"I was like, 'Wow, man, this guy hates to lose. And I love that. I love that I'm on his team.'"

OFFENSIVE COORDINATOR
CHARLIE WEIS
The longtime coach nearly died after gastric bypass surgery in 2002. He was in the hospital when Brady, who had just finished his second season, stopped by

"**WE'RE FROM** New Jersey, and we're up in [the hospital in] New England. We don't know anyone like that—to be there for my wife, with the kids. We've got two kids, one with special needs. They're both young. It's a disaster. I went in on Friday and was supposed to get out by noon on Saturday, so it wasn't like you were calling the reinforcements to come up [from Jersey]. Who do you think sat with her the whole time?

"Number 12. He was the one who got [my wife, Maura] through until reinforcements got up there. If he's doing it for me in '02, imagine what he's doing for people that he's known for a long time. That's why all these players that are around him for the first time feel like that."

Every night before camp started that summer, Brady stopped by Weis's house and spent about 45 minutes with him.

"There are a lot of people who have their Tommy stories. But he earned card-carrying Weis family status."

CENTER
DAN KOPPEN

Few players spent more time in close quarters with Brady than Koppen, his center from 2003 through '11

WIDE RECEIVER
JULIAN EDELMAN

Another unheralded player (he was a seventh-round pick) who thrived with Brady, the former college QB had four 90-catch seasons

IN 2005 Brady shot a Visa commercial and insisted that his offensive linemen be a part of it.

"It was fun for him, but also he realized these guys are gonna get some extra cash, and they deserve it. ... The pressure's gotta be incredible, with how many directions [Brady is] pulled in. I'm sure it got to him at times, and there were probably some changes [in him] over the years. That's just natural. But the fact that he's still the same guy off the field that he always was as a friend is kinda cool. And that just speaks to how he was raised, and who he is and what a great person he is."

"**HE WENT OUT** of his way to take me under his wing. I was a nobody and just wanted to get better. Tom worked with me."

After the 2012 season, the Pats lost four of their five top targets. Edelman stepped up with a 105-catch season.

"And it's not just [the physical element]. He taught me how to be a professional, how to treat people in the workplace."

WIDE RECEIVER
DONTÉ STALLWORTH

Before the 2007 season Stallworth joined the Pats as a highly touted free agent who had spent five years in the league, with the Saints and the Eagles

"**ONE OF MY** first practices, I dropped a ball in the end zone. Tom put it on the numbers, didn't lead me—but still, it was a drop, and Tom is all fuming. I'm thinking, Great, I pissed off Brady already. But he's like, 'F---! F---! F---! I didn't lead you enough.' I've played with some competitive people, like Ray Lewis. Brady is right up there."

Early in the 2007 season the Patriots visited the Cowboys, who were 5–0. In the fourth quarter Brady called a play in which one wideout was expected to read the coverage and run one of three possible routes. That player was supposed to be Randy Moss, but Stallworth was on the field instead.

"We're breaking the huddle, and Brady sees I'm in the game. We've both got this Oh, s--- look on our faces, because I've never practiced this route. So Brady says, 'Just go deep,' and the play ends up being a 69-yard touchdown. We literally drew it up in the sand. The guy is amazing."

TOM BRADY | 207

Excerpted from SI.COM
February 1, 2023

TOM BRADY ANNOUNCES RETIREMENT

NFL WORLD REACTS TO TOM BRADY'S RETIREMENT ANNOUNCEMENT

BY
JOSEPH SALVADOR

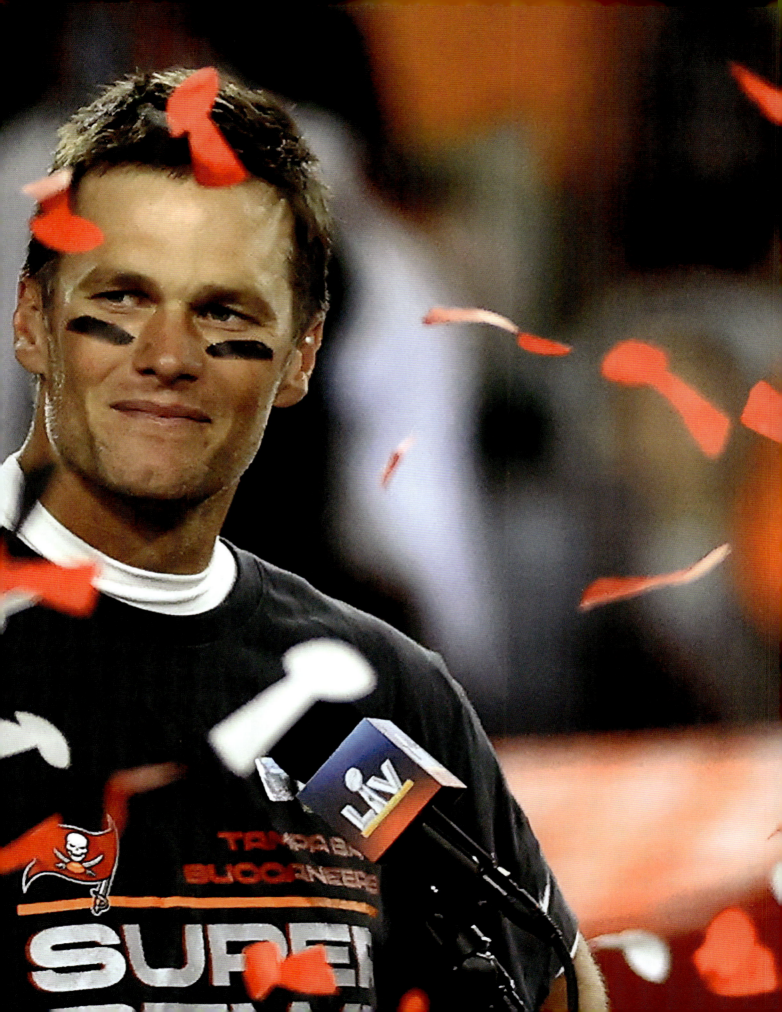

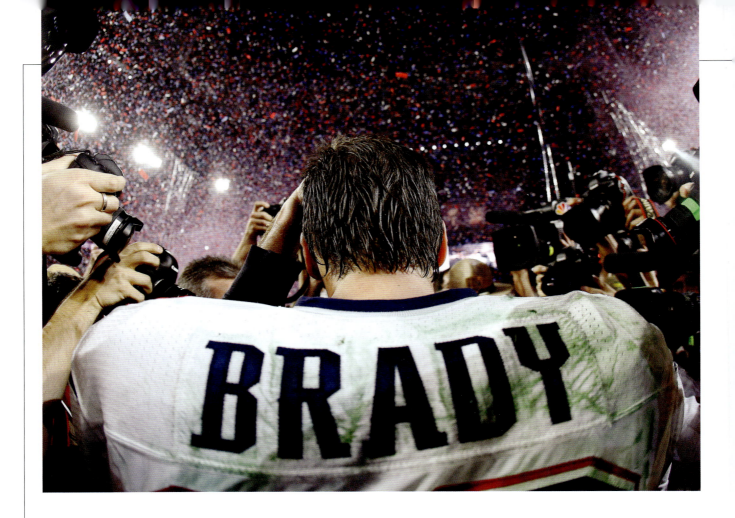

THE BIGGEST STORY OF THE OFF-SEASON may have come early on Wednesday when Tom Brady shocked the sports world with news of his retirement. The seven-time Super Bowl champion decided to switch things up from last year's retirement announcement and posted a video that was less than a minute long on Twitter.

"Good morning guys, I'll get to the point right away: I'm retiring. For good," Brady said. "I know the process was a pretty big deal last time, so when I woke up this morning I'd figured I'd just press record and let you guys know first."

Brady's first retirement lasted less than two months last year, but this time he appears to finally be ready to move on from football.

 Tom Brady
@TomBrady

Truly grateful on this day. Thank you 🙏❤️

7:12 AM • Feb 1, 2023

210 SPORTS ILLUSTRATED

TOM BRADY ANNOUNCES RETIREMENT

Excerpted from SI.COM
February 1, 2023

IN RETIRING, TOM BRADY MADE YET ANOTHER SHREWD CHOICE

THE GREATEST QUARTERBACK OF ALL TIME ALWAYS KNEW HOW TO MAKE THE CORRECT DECISION ON THE FIELD. SO IT'S NO SURPRISE THAT HE ENDED HIS CAREER AT PRECISELY THE RIGHT MOMENT

BY
MICHAEL ROSENBERG

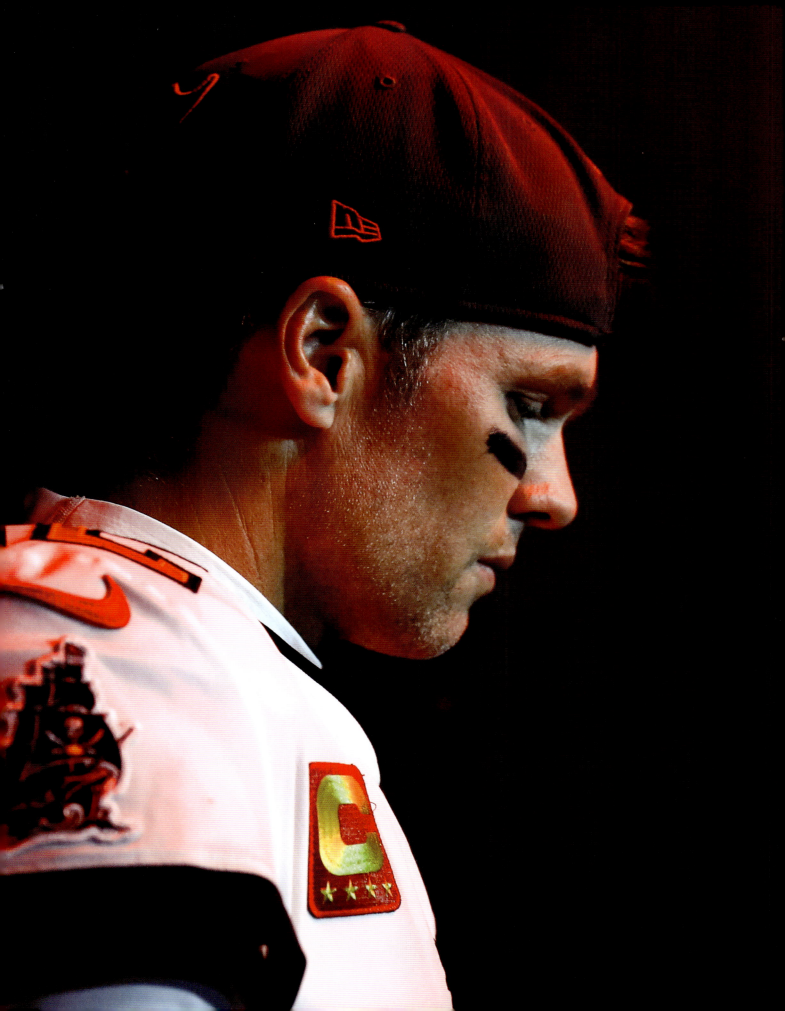

IN RETIRING, TOM BRADY MADE YET ANOTHER SHREWD CHOICE

TOM BRADY'S DEFINING FOOTBALL CHARACTERISTIC WAS HIS ABILITY TO MAKE THE CORRECT CHOICE: to change the play before the snap, to throw to the right receiver, to get rid of the ball when nothing was there, to manage end-of-game situations in real time. It is appropriate, then, that he ultimately retired at precisely the right time, too. After the longest career of any non-kicker in history, Brady stuck the landing.

If Brady wanted to keep playing, to squeeze a little more football out of himself—to lick the bottom of the bowl, as my colleague Jon Wertheim has written of the Roger Federer/Rafa Nadal/Novak Djokovic triumvirate—then that was his right. There would have been a market for him. But it almost certainly would not have been pretty.

It became clear this past season that Brady was no longer playing like a star. Some of his numbers were still impressive, and he still had that incredible late-game poise. But he also missed more receivers than he did even a year ago. The Buccaneers were injured and offensively dysfunctional, but there were also too many plays when a better version of Brady would have made something work. If you forgot that he was the most accomplished player in NFL history and just compared him to other players in the league, you would have seen Tom Brady, in 2022, as just an average starting quarterback.

So these were his options if he chose to keep playing:

1. Go back to Tampa, and trust that a new offensive coordinator (Byron Leftwich got fired last month), better health and a few personnel changes would make the Bucs contenders again.

2. Sign with another team as a free agent. The Raiders, coached by Brady's former coordinator Josh McDaniels, always felt like the most likely option. The Jets made some football sense, though not emotional sense. The 49ers, his childhood team, always

Brady congratulated Dallas quarterback Dak Prescott after the Cowboys defeated the Bucs in Brady's final game.

IN RETIRING, TOM BRADY MADE YET ANOTHER SHREWD CHOICE

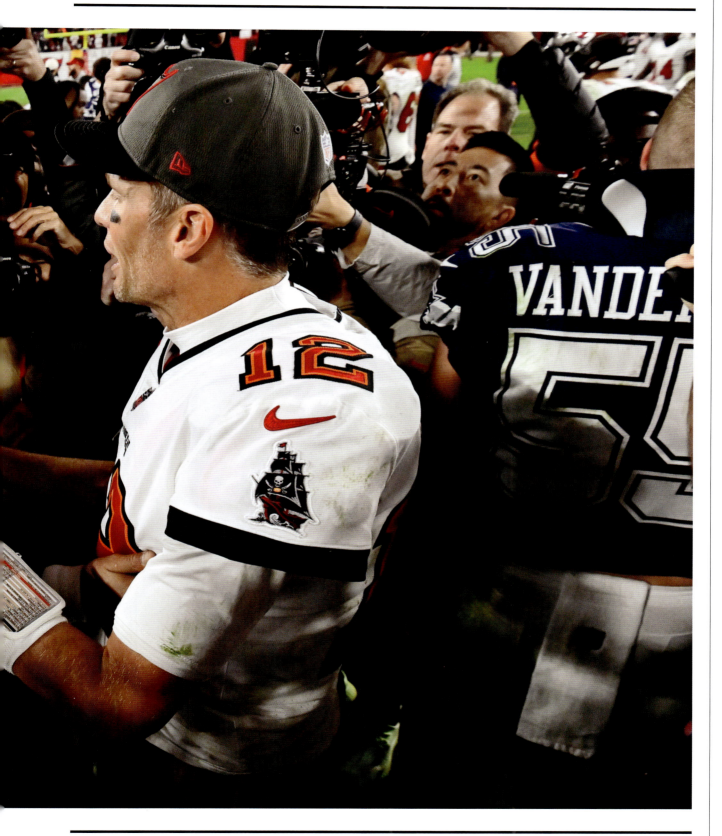

IN RETIRING, TOM BRADY MADE YET ANOTHER SHREWD CHOICE

held sentimental appeal. Maybe another suitor would have emerged.

Neither of these options were all that great. I don't know how anybody could have watched the Bucs this year and envisioned another boat parade next year, even if the whole team was injury-free. As for the Raiders and Jets: who really thinks Brady was going to emerge from an AFC pack that includes Patrick Mahomes, Joe Burrow, Josh Allen, Trevor Lawrence, Justin Herbert and Tua Tagavailoa? And if the 49ers even wanted Brady this off-season, then he would have faced the very real possibility of fearless Kyle Shanahan benching him in favor of Brock Purdy.

Going to another team was the worse of those two options, because at least if he stayed in Tampa, we would always remember that he won a Super Bowl there. Imagine Brady slogging through a 7–10 season in Las Vegas. "Brady with the Raiders" would have replaced "Willie Mays with the Mets" as the overused-but-obvious example of a player staying on too long.

And yet … Tom Brady did not become who he is by doubting himself. It would have been so easy for him to blame Leftwich for his own decline, to convince himself he was still the best there is, to keep chasing rainbows. Drew Brees was physically beaten when he retired. Peyton Manning was nowhere near his former self. Brady was just good and healthy enough to see whatever he wanted to see in the mirror.

He retired anyway. Smart move, after a lifetime of smart career moves. He chose to play in college at Michigan even though it was far from home, and stayed there even when the coaches seemed more enamored of other quarterbacks. He competed like a starter in New England when there was no indication he would start, and he handled the public scrutiny of the Drew Bledsoe competition like a 10-year vet. He managed to earn more than $300 million in his career while always ensuring that his

Though fans at Raymond James Stadium didn't know it, Brady had walked off the field for the last time.

IN RETIRING, TOM BRADY MADE YET ANOTHER SHREWD CHOICE

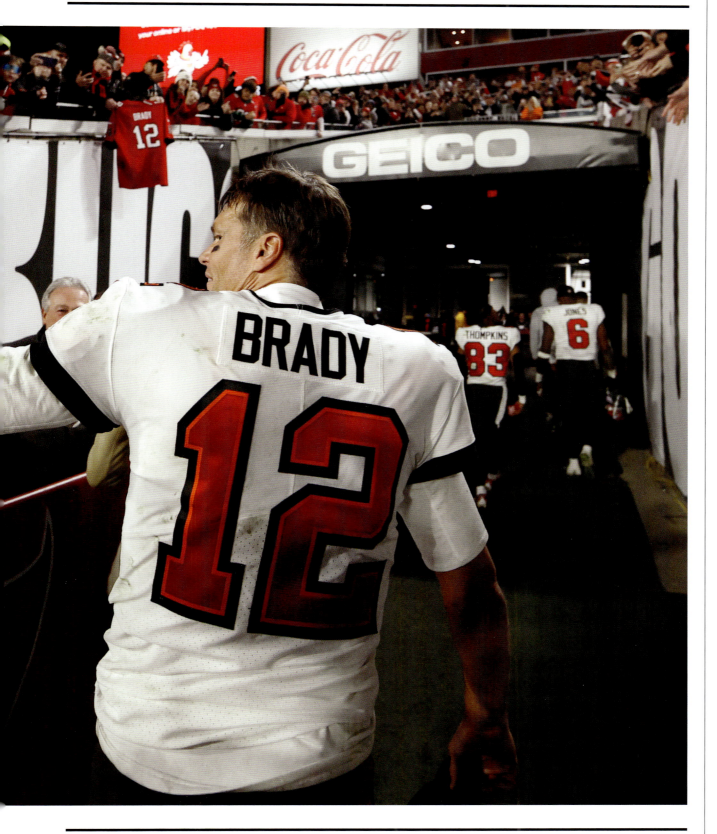

IN RETIRING, TOM BRADY MADE YET ANOTHER SHREWD CHOICE

IN RETIRING, TOM BRADY MADE YET ANOTHER SHREWD CHOICE

contract allowed the Patriots to build a championship roster around him.

Most impressive of all: Brady stayed in New England until the exact moment when it was time to leave, and then he chose the perfect landing spot when it was not obvious. That required adept planning (he and agent Don Yee convinced the Patriots to sign him to a deal where they could not franchise-tag him after the 2019 season) and composure during a season of speculation. And in going to Tampa, he found a team with a roster that was ready to win but had not won, giving him a chance to win the Super Bowl (which he did) without any risk that people would say he ruined a Super Bowl contender.

Brady made a rare public misstep when he retired and unretired last year. But whatever his reasons for doing that, coming back was probably the right call, if only because it gave him a chance to decline a little more. That must have eliminated lingering questions in his head about whether he could have won another Super Bowl. Brady got exactly what he wanted out of his Tampa experience. But he wasn't going to get any more.

So what now? After last year, there will be some skepticism about his announcement, understandably. I believe he is retired "for good," as he says, because in 25 years of watching Brady, I rarely saw him make the same mistake twice.

I am skeptical on another front: Until Brady is actually in a booth calling games for Fox, I won't really believe it. I don't think either Brady or Fox fully thought that deal through when they signed it. But signing with a network is not like signing with a team; if Brady bails, he won't anger a fan base. All he really did when he signed with Fox was give himself an appealing option if he wanted it. Tom Brady, deft to the end. ∎

The QB moved quickly onto other projects, attending the premiere of *80 for Brady* in Los Angeles.

TOM BRADY 219

BY THE NUMBERS

THANKS TO TOM BRADY, THE NUMBER 12 WILL FOREVER BE ASSOCIATED WITH GREATNESS. HERE ARE A FEW OTHER DIGITS THAT DEMONSTRATE HIS EXCELLENCE

286 Career wins, including postseason, the most of any NFL quarterback in history.

43 years, 188 days Tom Brady's age on the day of Super Bowl LV. He's the oldest quarterback to win a Super Bowl, breaking his own record set two years earlier.

6 Players who have won at least three MVP awards: Brady (three), Jim Brown (three), Brett Favre (three), Peyton Manning (five), Aaron Rodgers (four) and Johnny Unitas (three).

3 Teams Brady has never lost a game to: the Bucs, Patriots and Vikings.

0 Teams Brady has never beaten.

BY THE NUMBERS

198 Players—including six quarterbacks—picked before Brady in the 2000 NFL draft. Oakland Raiders kicker Sebastian Janikowski, who retired in 2019, had the second-longest career in the draft class.

89,214 Career passing yards for Brady, an NFL record. He also holds career marks for passing TDs (649), attempts (12,050) and completions (7,753).

44,470 Career passing yards for the six QBs taken ahead of Brady in 2000, led by Marc Bulger's 22,814.

58 Regular-season game-winning drives led by Brady, an NFL record.

14 Game-winning drives in the postseason, including in six of his seven Super Bowl victories.

117.2 Passer rating for Brady during the 2007 regular season, when New England went a perfect 16–0.

111 Consecutive starts made by Brady from Sept. 23, 2001, through Sept. 7, 2008, when he suffered a torn ACL and MCL during a game against the Chiefs.

TOM BRADY

BY THE NUMBERS

REGULAR SEASON + POSTSEASON

Passer Rating
BEST
1. JAGUARS (9 GAMES)	113.1
2. FALCONS (12)	111.2
3. STEELERS (16)	110.5

WORST
1. PATRIOTS (1)	70.8
2. CARDINALS (3)	76.3
3. RAVENS (13)	81.0

Passing Yards Per Game
MOST
1. EAGLES (9)	314.8
2. FALCONS (12)	314.7
3. WASHINGTON FOOTBALL TEAM (7)	314.3

FEWEST
1. PACKERS (8)	230.8
2. DOLPHINS (36)	238.8
3. LIONS (7)	241.7

TD Passes
MOST
T-1. BILLS (36)	72
T-1. DOLPHINS (36)	72
3. JETS (39)	64

FEWEST
1. PATRIOTS (1)	0
T-2. CARDINALS (3)	4
T-2. 49ERS (4)	8

PLAYOFFS

SUPER BOWLS
2002 • 2004 • 2005 •
2008 • 2012 • 2015 • 2017
• 2018 • 2019 • 2021

AFC CHAMPIONSHIPS
2002 • 2004 • 2005 •
2007 • 2008 • 2012 • 2013
• 2014 • 2015 • 2016 •
2017 • 2018 • 2019

NFC CHAMPIONSHIPS
2022

DIVISIONAL PLAYOFF
2002 • 2004 • 2005 •
2006 • 2007 • 2008 • 2011
• 2012 • 2013 • 2014 •
2015 • 2016 • 2017 • 2018
• 2019 • 2021 • 2022

MOST-VIEWED GAME

AFC CHAMPIONSHIP GAME
JANUARY 24, 2016
CBS; 29.3 RATING

BY THE NUMBERS

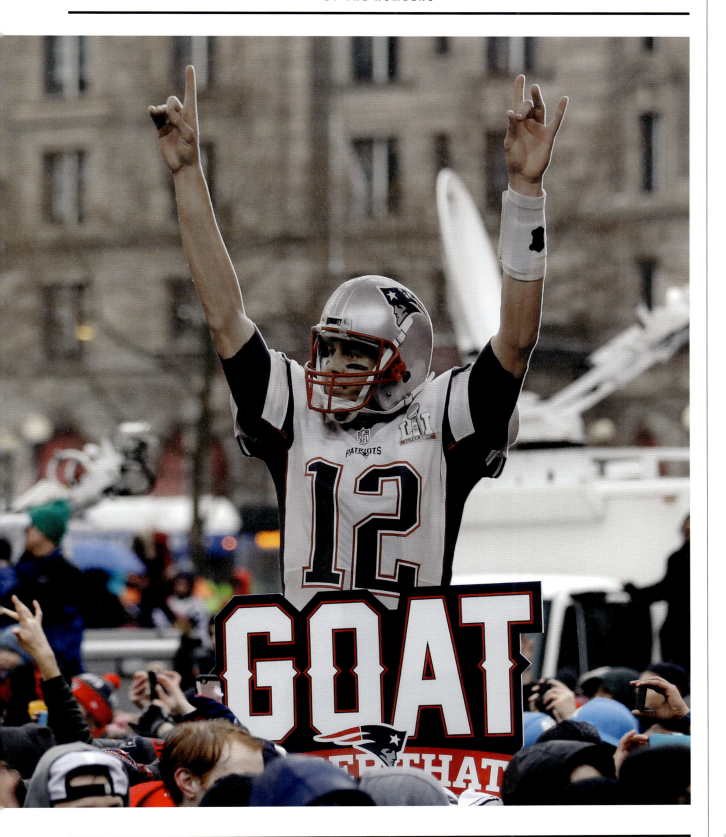

THE COVERS

IN THE PAST 20 YEARS, BRADY HAS GRACED THE FRONT OF Sports Illustrated 25 TIMES, MORE THAN ANY OTHER FOOTBALL PLAYER

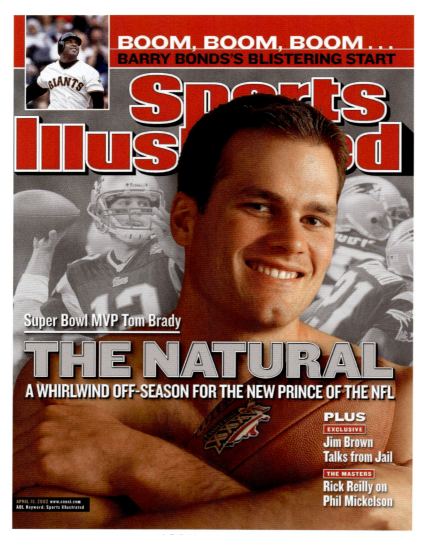

APRIL 15, 2002

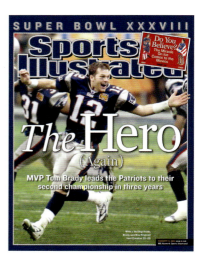

FEBRUARY 9, 2004

SEPTEMBER 6, 2004

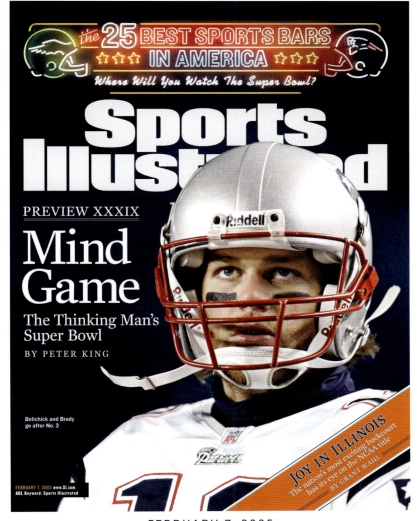
FEBRUARY 7, 2005

OCTOBER 18, 2004

NOVEMBER 7, 2005

DECEMBER 12, 2005

OCTOBER 22, 2007

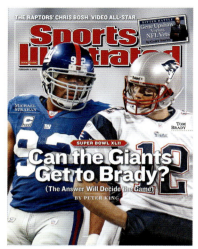
FEBRUARY 4, 2008

SEPTEMBER 1, 2008

JUNE 1, 2009

SEPTEMBER 20, 2010

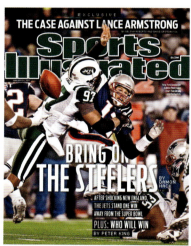
JANUARY 24, 2011

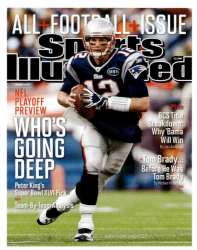

JANUARY 9, 2012

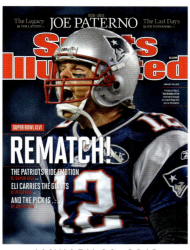

JANUARY 30, 2012

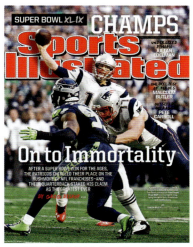

FEBRUARY 9–16, 2015

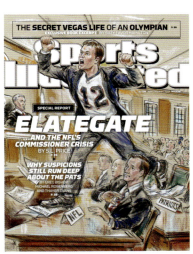

SEPTEMBER 14, 2015

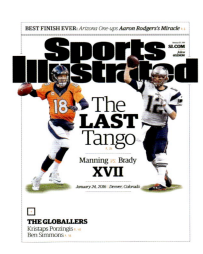

JANUARY 25, 2016

FEBRUARY 1, 2016

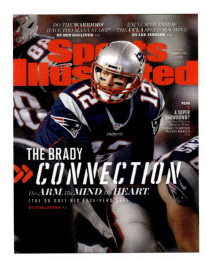

JANUARY 23, 2017

JANUARY 30, 2017

SEPTEMBER 4–11, 2017

TOM BRADY 227

JANUARY 29–FEBRUARY 5, 2018

FEBRUARY 11, 2019

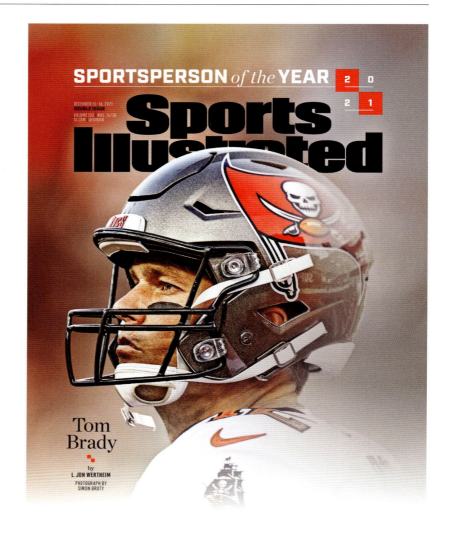

DECEMBER 15–16, 2021

Photo Credits

Page 1: Walter Iooss Jr.; Page 4: Billie Weiss/Getty Images; Page 7: Mike Ehrmann/Getty Images; Page 8: Bill Frakes; Page 11: Ben Margot/AP Photo; Page 12: Heinz Kluetmeier; Page 13: Simon Bruty; Page 15: John Biever; Page 17: Michael Dwyer/AP Photo; Page 18: Tim Sloan/AFP via Getty Images; Page 21: Doug Mills/AP Photo (top), David E. Klutho (bottom); Page 22: John Biever; Page 25: Walter Iooss Jr.; Page 27: John W. McDonough; Page 28: Bob Rosato; Page 31: Bob Rosato; Page 32: Gary Rothstein/Icon SMI; Page 35: David J. Phillip/AP Photo; Page 36: Al Tielemans; Page 37: Terry Schmitt/UPI; Page 39: Tom DiPace/AP Photo; Page 40: John W. McDonough; Page 43: John Iacono; Page 44: Damian Strohmeyer; Page 46: Al Tielemans; Page 49: Peter Read Miller; Page 51: Ezra Shaw/Getty Images; Page 52: Charles Krupa/AP Photo (top), Winslow Townson/AP Photo (bottom); Page 55: Charles Krupa/AP Photo; Page 57: Lynn Johnson; Page 59: Robert E. Klein/AP Photo; Page 60: David E. Klutho; Page 63: Winslow Townson/AP Photo; Page 64: Heinz Kluetmeier; Page 69: Damian Strohmeyer; Page 71: Heinz Kluetmeier; Page 73: Damian Strohmeyer; Page 74: Damian Strohmeyer; Page 77: Julian H. Gonzalez/ZUMA Press (top), Gabriel B. Tait/ZUMA Press (bottom); Page 78: Peter Read Miller; Page 80: Carlos Osorio/AP Photo; Page 83: Daniel Mears/Detroit News (top), Amy Sancetta/AP Photo (bottom); Page 85: Kevin Terrell/AP Photo; Page 86: Matt Rourke/AP Photo; Page 89: Kathy Willens/AP Photo; Page 90: David Goldman/AP Photo; Page 92: Kevin Terrell/AP Photo; Page 95: David J. Phillip/AP Photo; Page 97: Simon Bruty; Page 98: David J. Phillip/AP Photo; Page 101: Perry Knotts/AP Photo; Page 103: Daniel Mears/AP Photo; Page 104: Bill Frakes; Page 105: Elise Amendola/AP Photo; Page 107: Bill Frakes; Page 108: Damian Strohmeyer; Page 111: Damian Strohmeyer; Page 112: Damian Strohmeyer; Page 115: Damian Strohmeyer; Page 117: Al Tielemans; Page 118: John W. McDonough; Page 121: Ezra Shaw/Getty Images; Page 123: Charlie Riedel/AP Photo; Page 124: Simon Bruty; Page 126: Simon Bruty; Page 131: Simon Bruty (top), Robert Beck (bottom); Page 133: Simon Bruty; Page 134: Elsa/Getty Images; Page 137: Robert Beck; Page 138: Robert Beck; Page 140: Bob Levey/Getty Images; Page 143: Kevin C. Cox/Getty Images; Page 144: Billie Weiss/Getty Images; Page 147: Mike Ehrmann/Getty Images; Page 148: Kevin Mazur/Getty Images; Page 151: Cliff Welch/Icon Sportswire; Page 155: Rob Tringali; Page 156: John W. McDonough; Page 158: David E. Klutho; Page 160: Simon Bruty; Page 163: Simon Bruty (top), David E. Klutho (bottom); Page 164: Simon Bruty; Page 166: David E. Klutho; Page 167: Rob Tringali; Page 168: Rob Tringali; Page 173: Simon Bruty; Page 175: Mike Ehrmann/Getty Images; Page 177: Simon Bruty; Page 178: Simon Bruty; Page 180: Cliff Welch/Icon Sportswire; Page 183: Steve Luciano/AP Photo; Page 184: Erick W. Rasco; Page 187: Erick W. Rasco; Page 188: Erick W. Rasco; Page 190: Simon Bruty; Page 193: Simon Bruty; Page 195: Cliff Welch/Icon Sportswire; Page 197: Ethan Miller/Getty Images; Page 198: Maddie Meyer/Getty Images; Page 200: Kirby Lee/Getty Images; Page 203: Robert Beck; Page 205: David E. Klutho; Page 206: Simon Bruty (top), Chuck Solomon (bottom); Page 207: Damian Strohmeyer (top, left), Rob Tringali (top, right), Damian Strohmeyer (bottom); Page 209: Mike Ehrmann/Getty Images; Page 210: Tom Pennington/Getty Images; Page 213: Kevin Sabitus/Getty Images; Page 215: Julio Aguilar/Getty Images; Page 217: Mike Ehrmann/Getty Images; Page 218: Axelle/Bauer-Griffin/FilmMagic; Page 221: Erick W. Rasco; Page 223: Fred Kfoury III/Icon Sportswire.

Copyright © 2023 ABG-SI LLC. Used under license.

No part of this publication may be reproduced, stored in a retrieval system, or transmitted in any form by any means, electronic, mechanical, photocopying, or otherwise, without the prior written permission of the publisher, Triumph Books LLC, 814 North Franklin Street, Chicago, Illinois 60610.

Library of Congress Cataloging-in-Publication Data available upon request.

This book is available in quantity at special discounts for your group or organization.
For further information, contact:
Triumph Books LLC
814 North Franklin Street, Chicago, Illinois 60610
(312) 337-0747
www.triumphbooks.com

ISBN: 978-1-63727-514-6